the photographs of
Margaret Bourke-White

the photographs of
Margaret Bourke-White

Edited by Sean Callahan

Introduction by Theodore M. Brown
Foreword by Carl Mydans

New York Graphic Society

International Standard Book Number
0-8212-0462-9
Library of Congress Catalog Card Number
72-80415
© 1972 Estate of Margaret Bourke-White
©1972 Time Inc.
Book designed by Edward A. Hamilton

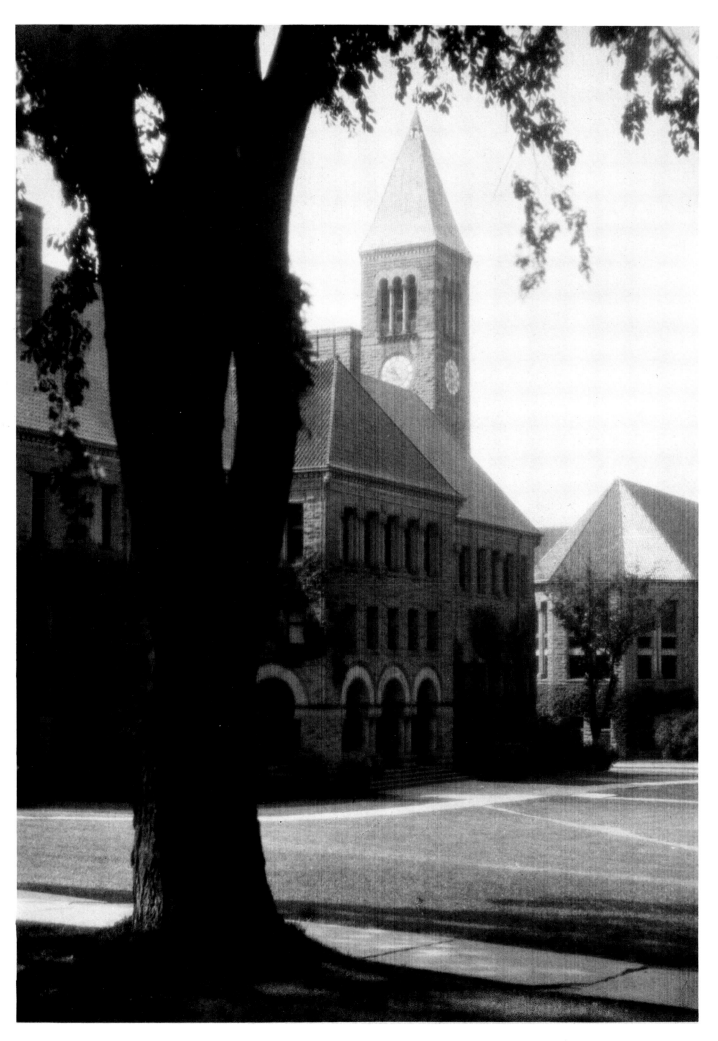

A Legend That Was Largely True

by Theodore M. Brown

Margaret Bourke-White, one of the most prolific photojournalists of the twentieth century, was a reflective witness to world events during the traumatic decades of the nineteen-twenties through fifties. And inevitably, legends blossomed around the life of such an adventurous and forceful figure; thus one has difficulty separating fact from fiction in the examination of her dramatic career. Yet, the most amazing aspect of the Bourke-White legend to emerge from a study of her life is that, although unreliable in some respects, it is largely true.

She was born June 14, 1904, in New York City, daughter of Joseph and Minnie (Bourke) White. Her father was a successful engineer-designer, working in the printing industry; her mother was a largely self-taught person who eventually worked in the field of publication for the blind. Margaret's earliest interests were in biology and technology, but at no time did she seem to be a very highly motivated student of anything.

Beginning college at age seventeen, in 1921 she attended summer school at Rutgers, and went on to Columbia, where she took a course at the Clarence H. White School of Photography. She also attended the University of Michigan, Purdue, and Western Reserve, before matriculating at Cornell as a senior, graduating in 1927. During her student days Bourke-White made an impressive photographic record of the idyllic campus life. As a freshman at Michigan she began taking pictures for the yearbook and the following year produced a portfolio that led to an offer of the photo editorship. But she had a better offer from Everett Chapman, a graduate engineering student, and married him in June, 1924, forsaking the camera to work at the marriage for the next two years. When it failed, she found herself alone at Cornell with a Ica Reflex camera that had a crack straight through the lens. Soft and diaphanous, most of her Cornell photos are like a child's dream of Camelot. "Across from Sibley, the towers of Risley rise above the gorge like those of an ancient castle," reads the caption of one of her many campus photographs published during 1926 and 1927 in the *Cornell Alumni News.*

Clearly, even as an amateur she knew what she was seeking, and she had the eye to select and compose her subjects well. The published works, executed in a misty, soft, nineteenth-century tradition, include several frontal views of "Gothic" buildings, carefully framed by trees, and a dynamic high view of ice skaters seen through trees, a composition similar to well-known bird's-eye views by Alvin Landon Coburn and Laszlo Moholy-Nagy. An especially strong composition of the semi-elliptical football stadium, seen at a great distance under a high, cloud-filled sky, has the heroic quality of her later industrial works. But the romance of nature soon gave way in her mind to the romance of technology, with a narrowly focused interest in industrial forms. In 1927 she moved to Cleveland, where her family lived, to start her professional photographic career. Around that time she began hyphenating her last name, a compound of her middle name (her mother's maiden name) and her last name. Within two years she had not only

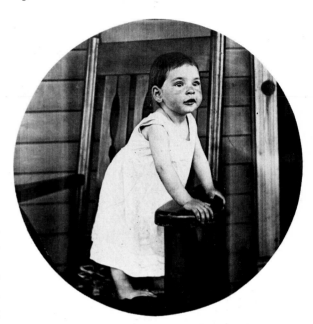

Margaret, a bright-eyed baby at one.

Library Tower showing Law College, Cornell, 1926, from an original rough buff print of the kind that Bourke-White sold for a dollar each to help pay for her year at Cornell.

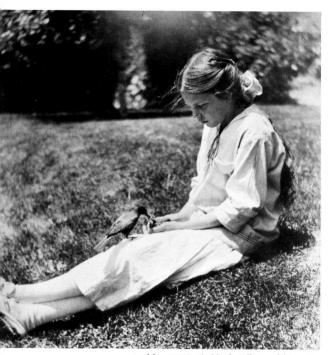

Margaret at 11, feeding robins near her Bound Brook, New Jersey home.

mastered her profession but managed to articulate the basis of her work to a wide audience, when she stated in the magazine *World's Work* (September, 1929) that

> whatever art will come out of this industrial age will come from the subjects of industry themselves, which are sincere and unadorned in their beauty, and close to the heart of the people.

As nineteenth-century artists had found truth, virtue, and beauty in opulent *nature*, Bourke-White and many others in the twenties and thirties were convinced of the universal value of "sincere and unadorned" *industry*.

Toward the end of the twenties, the American avant-garde art world, obsessed with the notion of Modernism, discovered a new beauty inherent in technology. Esthetic principles were applied to the design of such banal objects as washing machines, furnaces, and pots. Painters, architects, industrial photographers and designers began a stimulating interchange of thought and image; the dissemination of their work on an unprecedented scale was aided by the growth of heavily illustrated books and periodicals.

Largely European-based during the twenties, formal belief in the Machine Esthetic and its companion Modernism did not greatly influence American design consciousness until the end of the decade. Yet as Margaret Bourke-White began her career the religion of "the machine" and the "new" began to find expression in the United States.

The year of Lindberg's flight, 1927, saw the establishment of one of the first museums devoted to the understanding and promotion of modern art, Albert E. Gallatin's Gallery of Living Art, at New York University. Two years later the internationally influential Museum of Modern Art was founded in New York "for the purpose of encouraging and developing the study of modern arts and the application of such arts to manufacture and practical life, and furnishing popular instruction."

The new museum's statement of purpose makes clear that in the minds of many Americans modern art was closely linked to its practical application; and in fact American business quickly absorbed the new esthetic into its profit-generating mechanism. Buckminster Fuller's extraordinary career took an important turn in 1927 with the design and publication of his Dymaxion House, a truly Machine Age product. Henry Ford shifted his approach to design in 1927 when he discontinued the Model T ("You can have it in any color, as long as it's black") and introduced the Model A, a product designed for mass consumer appeal. International technological landmarks materialized: the George Washington Bridge, begun in 1927 and completed in 1931, and the Golden Gate Bridge, built between 1933 and 1937. In 1927 radio-telephone service between New York and London and between San Francisco and Manila was established. A national radio network began during that year, and the movies added the dimension of sound. The future was in the air: Buck Rogers appeared at the beginning of 1929, and Flash Gordon began interplanetary exploration in 1934.

As a student at Michigan in 1924 (below) Bourke-White worked for the yearbook, for which she photographed the graduating seniors at left. Along with her first husband, Everett Chapman (above), she exhibited and sold prints like this one called "Fragment of War Bridge with Horse and Rider."

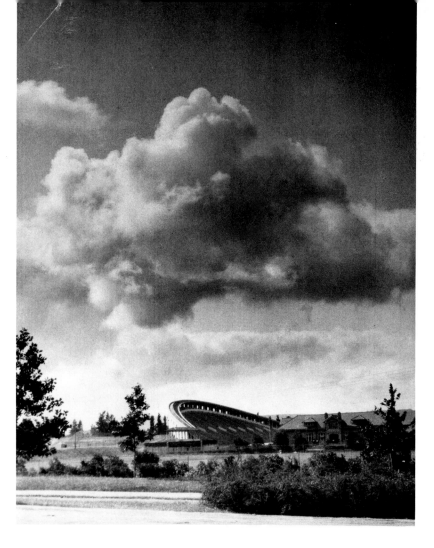

Student Work, Cornell University 1926-7
Baker Dorm (above); Crescent (right); Sage Dorm
(below right).

Margaret B. White, Class of '27

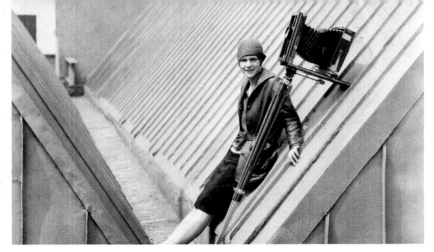

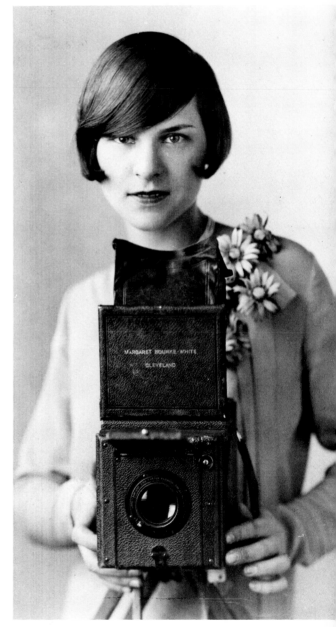

On location, photographed by Ralph Steiner, and a publicity photo below, Cleveland, 1928

It is not surprising, therefore, to read of a "Men and Machine" exhibition (reported in *The New York Times* in 1930) in which Margaret Bourke-White exhibited and where she was quoted as saying that

any important art coming out of the industrial age will draw inspiration from industry, because industry is alive and vital. The beauty of industry lies in its truth and simplicity; every line is essential and therefore beautiful.

A small industrial tradition existed in photography before 1927. During the teens and twenties Paul Strand had isolated precision elements for compositional effects, for example in his "Abstract Pattern Made by Bowls" of 1915, published in Alfred Stieglitz's *Camera Work* in 1916. The painter-photographer Charles Sheeler and Strand published photos in *Vanity Fair* in 1922: spidery patterns created by Brooklyn Bridge cables, cranes viewed against the sky; deep city canyons, a street below seen through a balustrade. A strong urban composition by Sheeler was published in a *Vanity Fair* of 1921, building and street patterns interwoven parallel to the picture surface. These and other American works of the early twenties hardly constitute a "tradition," but the ideas and examples existed nevertheless.

And one cannot forget the series of photographs made by Sheeler in 1927 of the Ford plant at River Rouge, an extensive coverage of a single industrial enterprise which he used as the structural basis of some of his paintings of the early thirties. A comparison of his and Margaret Bourke-White's approach explains some of the innovative qualities of her vision within the tradition then existing.

Indoors, both photographers isolated individual objects such as ladles, conveyers, pulleys, and cranes; outside, they photographed architectural groups, smokestacks, and chutes. Sheeler's objects are treated as separate units, established within clear spaces. On an observable ground plane and distinctly related to each other and to the picture surface, the silent, immobile objects are illuminated to clarify their forms and spatial intervals.

Bourke-White's objects are seen in action: pouring, moving, hoisting, glowing. Dramatic contrasts of light dissolve distinctions of form and obscure the relationships of things to each other and to the picture plane. The observer's position is ambiguous as he seems to hover above, below, and within the hot, noisy, mind-shattering space. Sheeler's compositions have the static, lucid, measurable qualities of a Vermeer; Bourke-White's have more the shifting, dynamic character of a Cubist painting.

Only two years after the start of her career, Bourke-White reached an important landmark. In 1929 Henry R. Luce, already the successful publisher of the six-year-old *Time,* was planning another magazine, to be aimed at a high-level management readership. The first issue stated

Fortune's purpose is to reflect Industrial Life in ink and paper and word and picture as the finest skyscraper reflects it in stone and

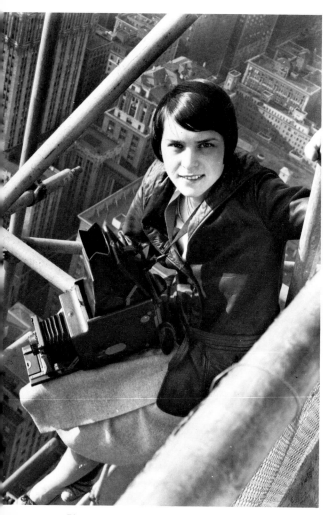

Photographing the construction of the Chrysler
building, 800 feet over Manhattan, 1929

steel and architecture. Business takes *Fortune* to the tip of the
wing of the airplane and through the depths of the ocean along
be-barnacled cables. It forces *Fortune* to peer into dazzling fur-
naces and into the faces of bankers. *Fortune* must . . . jog with
freight cars across Nevada's desert. . . . And above all, *Fortune*
will make its discoveries clear, coherent, vivid.

In the spring of 1929, on the basis of her few published photographs
Bourke-White was asked by Luce to begin working for the unborn
periodical. He had enlisted a photographer peculiarly suited for the
task at hand; she could not have found a better outlet for her work.

With a characteristic explosion of energy, she began immediately
as an associate editor of *Fortune* and started travelling about the
country with writers, working up articles for the first few issues. For
the next several years she worked six months of each year for *Fortune*
and six on commission for advertising agencies. In 1931, she moved
into a fine studio high up in the new Chrysler Building. It was designed
for her by John Vassos, a young member of the new breed of indus-
trial designers.

Fortune's birth was not without anxiety. Luce and his backers had
a few nervous moments after the stock market crashed on Thursday,
October 24, 1929, but against all reason they issued Volume 1, Num-
ber 1 only a few months later, in February 1930.

The first issue contained many Bourke-White photos: a portfolio of
"Trade Routes Across the Great Lakes"; a report on the glass industry
in Corning, New York, with a text by Dwight Macdonald, who had
just graduated from college; an article on orchid production, written
by the managing editor, Parker Lloyd-Smith. Also among the many
Bourke-White pieces published the first year was an extensive cov-
erage of "The Unseen Half of South Bend," an article for which text
was written by Henry Luce.

A piece about the Elgin Watch Company, written by Archibald
MacLeish, contained one of the most beautiful of Bourke-White's
early industrial photographs. Spattered upon the picture surface are
what appear to be either droplets splashing in a viscous fluid or deli-
cate flowers seen from above. In fact, these visual metaphors are sug-
gested by tiny watch hands bristling from the center of a supporting
stand as they were being tipped from luminous paint.

The lead article, entitled "Hogs," was photographed by Bourke-
White and written by Lloyd-Smith. This study of the Swift meat-
packing industry in Chicago was of importance in her career and
possibly in the history of photojournalism as well, because the piece
has the rudimentary characteristics of the as yet unformulated photo-
graphic essay. The story begins with a rear-end view of a group of
pigs, their swelling buttocks crowded into a curvilinear pattern close
to the picture surface. This is followed by several glimpses of the ani-
mals snuffling their way to eternity. The sequence then shows car-
casses hanging in rows, the mechanization of their slaughter empha-
sized by the repetition of hanging bodies moving into deep space.
Humans then appear—trimming, segmenting, packaging the meat.

Seen next are finished hams hanging in their bulging girdles. And finally, the story terminates with a view of the last physical remains of the beasts, a Piranesian interior containing scraps of bone and flesh—pig dust. From the throbbing buttocks to inert dust.

In this early though carefully plotted story, however, the visual element does not dominate as it does in the later, more pictorially eloquent photographic essays which appeared during the next couple of decades. Yet in "Hogs," Bourke-White conceived the photographs in a sequence which leads the viewer through a beginning, middle, and end; the communication is greater than the sum of its individual parts. It is apparent that as early as 1930 she had conceived a new way of handling photographic form—analytically, discursively. Thus the visual statement has some of the elements of a mature photo-essay and is consequently of historical importance not only in Bourke-White's work but in the history of twentieth-century photojournalism as well.

During the early thirties Bourke-White made several trips for *Fortune* to Germany to study industrial subjects: the North German Lloyd shipping docks, the Ruhr Valley, A.E.G., I. G. Farben, and others. Her coverage of I. G. Farben nitrogen plants produced some of her most dramatic industrial compositions, and she did a chilling article on German rearmament. Dummy tanks on maneuver, antitank guns, field command operations, and soldiers training to become officers in World War II were pictured in a *Fortune* issue of 1933. Her main interest during those years was the Soviet Union, however, and in the fall of 1930 she managed to make the first of several tours of Russia.

After months of Kafkaesque frustration, she received the necessary Soviet authorization for a five-thousand-mile excursion. From the trip came about eight hundred photographs, of which forty appeared in *Eyes on Russia,* her first book, published in 1931. The one hundred and thirty-five pages of text are an entertaining, picaresque account of the adventure. Later, twenty-four superb photos were assembled in a portfolio, *U.S.S.R. Photographs* (1934), with an introduction by Bourke-White.

Eyes on Russia is introduced visually by a dramatic grouping of three vertical piers of the Dnieper dam, silhouetted against a cloud-filled sky; tiny people are spotted below to dramatize the immensity of the massive forms, a compositional theme repeated five years later in a photograph she made for the first issue of *Life* magazine. In another of her distinctive pictures from the group, a young man straining on a wrench crouches on a generator shell in an environment defined entirely by bolts patterned over a tilted surface, a tiny detail extracted from a large industrial object. The entire shell was also photographed and published at the time, but the overall view lacks the pungent directness of the austere fragment. Where the macro view is a mere recording, the micro has the memorable quality of a work of art. One of the best embodiments of a romantic approach to the Machine Esthetic, the photograph clings to the memory primarily because of the imaginative juxtaposition of opposed, but allied,

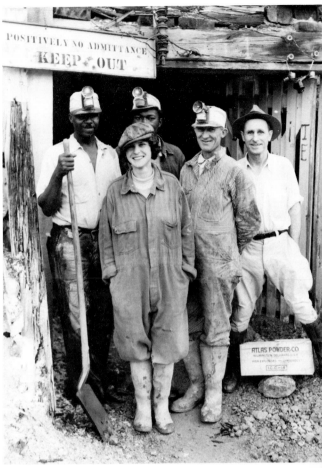

With bauxite miners on a FORTUNE story about the Aluminum Company of America in 1934.

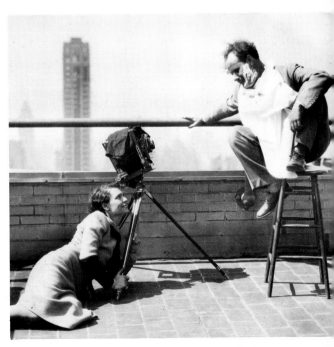

Russian director Sergei Eisenstein is photographed while shaving on the terrace of the Bourke-White studio.

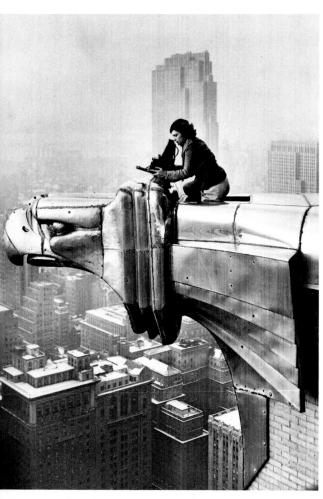

Shooting the New York skyline from one of the gargoyles outside her 61st floor studio in the Chrysler building, 1934, where she was photographed by her darkroom technician Oscar Graubner.

components: the pliant, irregular form of the human and the rigid, repetitive pattern of the efficient-looking bolts.

In another of the memorable Russian photographs two people appear on the curving exterior stairway of a worker's club—a young man ascends while an old man begins to descend. The horizontal stair treads sweep back around the cylindrical drum toward a bridgelike diagonal which intersects two rectilinear blocks. Dressed in tunics, the men seem to have stepped out of a Tolstoy novel into H. G. Wells's play, "Things to Come" (1936).

By 1930 Bourke-White had mastered the composition of mutually reinforcing opposites, and there is indication that she was fully conscious of this artistic device when she wrote a few years later that

> contrast . . . is an essential quality in the making of a great photograph—or any work of art, for that matter. . . . Contrast lends itself to description graphically more easily than it does with words. Even in its most complex combinations, anyone can understand most photographs.

Again in the U.S.S.R. about a year later, Bourke-White concentrated this time on people in a series of six articles for *The New York Times Magazine.* She wrote such human-interest articles as "Silk Stockings in the Five-Year Plan," "Where the Worker Can Drop the Boss," "A Day's Work for the Five-Year Plan," and "A Day in a Remote Village of Russia," pieces which used far more photos of people than were found in her book. Nowhere in her studies, however, is there evidence of the labor camps, the suffering, and the terror that was also an integral part of Stalinist Russia.

Bourke-White did not independently define the Machine Esthetic, nor did she invent its photographic interpretation. As with so many events in her life, she entered the scene at precisely the right moment to pursue her particular interests. It was a time in the United States when concept and practice in the visual world reinforced each other as the Machine Esthetic became associated with industrial design and both were assimilated under the aegis of Big Business. Concurrently, the rise in popularity of visually oriented magazines and books provided rapid and wide dissemination of photographic images.

Thought and intent are impotent, however, without concrete examples, and this is where Bourke-White's educated exuberance was seminal. With the energy of a spirited child and the eye of an artist, she entered the game, produced excellent industrial photography, and won the prizes, which she thoroughly deserved. Unlike many other photographers, who clung to a traditional view of their work, Bourke-White ignored the artistic prescriptions of "fine art" and began producing visually rich material on a large scale for an increasingly wide and influential audience.

As early as 1929, with her "Hogs" story, she was beginning to visualize subjects beyond conventional limits of the single view, to struc-

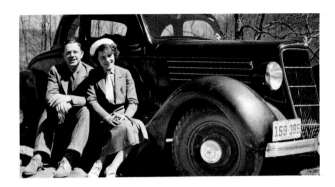

ture a communication greater than the sum of its parts. Indeed, she was beginning to move toward a new visual convention, the photographic essay, a form which dominated photography during the next three decades.

If, however, she had continued dancing only the syncopated rhythm of the machine, today she would be but another footnote in the history of art, one of the best practitioners of the Machine Esthetic, a photographic innovator and the author of an early and visually powerful book on the Soviet experiment. But her aims changed. Bourke-White's outlook broadened and deepened in the mid-thirties to encompass the plight of the twentieth-century life.

During the early 1930s *Fortune* was by no means solely a promoter of the business ethic; the magazine published studies that manifested social concern in areas such as unemployment and housing. "The Drought," a Bourke-White coverage of the Dust Bowl in 1934, was one such study. For decades, mismanagement of plowed fields and grazing cattle had resulted in the erosion of topsoil in large sections of the Midwest. At the beginning of the thirties a drought began, as summer sun dessicated the soil and winds eroded the earth. Drought conditions eventually created an environment of incessantly blowing dirt, and by the spring of 1934 there was a strangling combination of sun, wind, and dust ranging from the Texas Panhandle to the Dakotas. Bourke-White was sent to cover a territory ranging almost from the Canadian to the Mexican borders and she had seven days in which to do it.

She moved about in an ancient airplane, attempting to grasp the bewildering dimensions of the situation. A year later she described what she had seen in an article in *The Nation,* one of her best pieces of journalistic writing:

> . . . this same dust that coats the lungs and threatens death to cattle and men alike, that ruins the stock of the storekeeper lying unsold on his shelves, that creeps into the gear shifts of automobiles, that sifts through the refrigerator into the butter, that makes housekeeping, and gradually life itself, unbearable, this swirling drifting dust is changing the agricultural map of the United States. It piles ever higher on the floors and beds of a steadily increasing number of deserted farmhouses. A half-buried plowshare, a wheat binder ruffled over with sand, the skeleton of a horse near a dirt-filled water hole are stark evidence of the meager life, the wasted savings, the years of toil that the farmer 's leaving behind him.

In 1963, reflecting on the events and thoughts that shaped her life, she said of the drought experience that "this was the beginning of my awareness of people in a human, sympathetic sense as subjects for the camera and photographed against a wider canvas than I had perceived before."

In 1936 she spoke of her earlier preoccupation with industrial objects and of the happy coincidence in the late twenties of artists' and patrons' values and objectives. But as the anxieties and grim realities

Traveling Tobacco Road with Erskine Caldwell in 1936 (below) and in a publicity photo made a year later for *You Have Seen Their Faces* (above).

of life in the early thirties impinged on the world of well-fed and well-clothed subjects usually portrayed in American advertising, Bourke-White began to shift her thoughts to the lives of individuals. She noted sardonically that

> it is possible for hydraulic presses to rear their giant forms majestically in automobile factories, and for the workers who place and replace the metal sheets beneath the stamping block to be underpaid. . . . This car was not an automobile in the ordinary sense; it was a winged chariot which floated smoothly off into space; only happy individuals, only well-dressed people rode in it; no one went to work, wept, worried, or suffered in its tasteful, though inexpensive, insides.

Bourke-White's drought article is not only important in her life, it is historically significant as well. It was the first of its kind to be published in the United States. Dorothea Lange and Paul Taylor had been working on social documentation during the early thirties, but the Bourke-White essay was the first social documentary of the decade to appear conspicuously in print.

Soon after Bourke-White's essay appeared, a major effort was made to photographically document the conditions of farm life in the United States. Beginning in 1935 the Farm Security Administration assigned a group of otherwise unemployed photographers to travel and make pictures around the country. Under the brilliant direction of Roy E. Stryker, the FSA photographers created an archive of over 200,000 photographs which were eventually deposited in the Library of Congress. Among the fine artists working on the seven-year survey were Dorothea Lange, Walker Evans and John Vachon. At about the same time, other photographers found employment under the Works Progress Administration Federal Arts Project. Berenice Abbott and the painter Ben Shahn were two who turned their cameras on the Depression to document its depredations.

By virtue of her job with *Fortune* and her free-lance advertising commissions, Bourke-White had no need of the subsidy offered by government employment during the worst years of the Depression. But her instincts to document the awful upheavals in the social and economic life of the U.S.—manifest early in her drought essay—were to continue to inform her work and her thinking.

In 1935 Bourke-White met Erskine Caldwell, who was planning to write a documentary account of sharecropper life in the South, a subject he knew very well. Caldwell was then internationally known for his earthy novels: *God's Little Acre* and *Tobacco Road;* the latter was adapted for the stage, opened in 1933 and played through the decade—one of the longest runs in the American theater. Bourke-White agreed to collaborate with Caldwell on the study.

Writer and photographer began travelling in June of 1936 on a tour that took them through eight states, from South Carolina and Florida to Louisiana. Eighteen months later, their privately sponsored project appeared as a book, *You Have Seen Their Faces,* in November 1937.

On a LIFE assignment, 1939

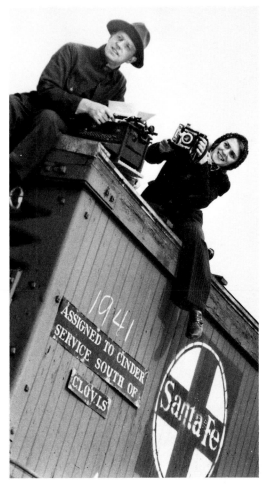

The Caldwells' Christmas card, 1940

The book consisted essentially of word and picture interviews for which they worked out a successful team approach exploiting the special capabilities of each other. Caldwell's innate sensitivity for the feelings, language, and attitudes of his suspicious subjects was aided by his ability to attune his speech to their particular dialects; he patiently talked and listened for hours on end. Bourke-White, more obviously an outsider, remained silent in the background, quietly setting and adjusting her camera equipment for remote-control exposures. As the subjects lost self-consciousness and forgot their fear that they might be ridiculed by the strangers, she made exposures at the most revealing moments. Once, the team adopted a less subtle approach and invaded a revival meeting at the moment of its emotional climax by leaping through windows and quickly shooting pictures within the frenzied group.

Among Bourke-White's pictures for the book are an assortment of devastating images of environmental, social, and personal decay. Many of the people shown are grotesquely malformed in body and mind; rusted auto hulks lie beside crumbling shacks; desperate faces communicate a lifetime of futility. Where earlier Bourke-White assembled machine parts into impeccable compositions, in 1936 she organized the casual bits and pieces of human existence into pictures that speak volumes about poverty, ignorance, and injustice.

You Have Seen Their Faces was not the first book of its kind. The photographic documentary text had antecedents in the late nineteenth century. John Thomson and Adolphe Smith had published a photo-text study of London in 1877; Jacob Riis produced his famous *How the Other Half Lives* in 1890; and from the turn of the century onward Lewis Hine published reformist photographs of immigrant life, sweatshops, and child labor. When Bourke-White and Caldwell began their study, two similar works were in print: Charles Morrow Wilson's *Backwoods America* (1935) and *Roots of America* (1936), both illustrated by photographs. But the increase in communicative effectiveness of *Faces* over such other books is dramatic.

In the layouts of Wilson's books, for example, photos are scattered throughout in no particular order of grouping. Visual material shifts unpredictably from vertical to horizontal, thus discouraging perusal of the book for the sake of the photographs alone. By contrast, through a coherent grouping of photos and by maintaining a consistent alignment, Bourke-White's book invites a visual reading independent of the text. Today, when the written material seems dated and only of marginal interest, the visual may still be read with fascination.

Shortly after its publication, Ralph Thompson wrote in *The New York Times* that "in Margaret Bourke-White's full-page photographs . . . is as arresting a statement of the plight of the Southern tenant farmer as we have ever had. . . . The pictures produce such an effect . . . that the text serves principally to illustrate them."

In agreement, *The New Republic* opined that "the photographs themselves are almost beyond praise. They belong to a new art, one

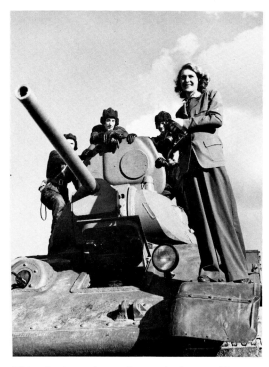

With a Soviet tank squadron at the front and later back in Moscow with Caldwell where they reported the Nazi bombing raids live over CBS radio.

that has to be judged by different standards from those applying to painting or sculpture. . . . Here the important qualities are those which used to be conveyed in words rather than pictures. . . . The roles of text and illustration are completely reversed (since) the pictures state the theme of the book, whereas the prose serves as illustrative material." Writing for *The New York Times Book Review*, Robert van Gelder said that "I don't know that I've even seen better photography. . . . Mr. Caldwell has done some of his finest writing for this book, but he has turned the book into a sledgehammer to pound home an idea that the pictures somehow go beyond."

An interesting sidelight of the success of *You Have Seen Their Faces* is that it seems to have contributed to the delay of the publication of another fine photo document of the period, *Let Us Now Praise Famous Men,* by James Agee and Walker Evans. In 1936, Agee and Evans were commissioned by *Fortune* to do a series of articles on poverty. The magazine decided against publication, so the authors tried to interest publishers in issuing their work as a book. But the successful Bourke-White-Caldwell publication caused one publisher to reject the Agee and Evans work because "Viking (Press) have made such a handsome job of the Bourke-White and Caldwell opus that competition would be ruinous." This great work did not appear in print until five years after it was begun, at a time when Americans were becoming engrossed in World War II. Consequently, the book remained in relative obscurity and it was rediscovered only recently by a new, socially-aware generation.

Bourke-White's career reached a new peak and a much wider audience with the publication of *Life,* the most successful pictorial magazine in the history of journalism. Once again Henry Luce contributed to a new confluence of journalism and photography. By the middle of the thirties, *Fortune* was well established and *Time* magazine had been operating for about thirteen years. Luce intended *Life* as a pictorial complement to *Time*. Where *Time* condensed the week's news into a compact, easily digested verbal form, *Life* was to cover the same area through visual means, primarily photographic, the "mind-guided camera," as he expressed it. With apostolic zeal, he wrote in the prospectus for the new magazine that it was intended.

> to see life; to see the world; to eyewitness great events; . . . to see strange things; . . . to see things thousands of miles away, . . . to see and to take pleasure in seeing; to see and be amazed; to see and be instructed. . . . To see, and to show, is the mission now undertaken by a new kind of publication.

In itself, the picture magazine was not a new idea. Nineteenth-century readers had known the French *L'Illustration* and the British *London Illustrated News*. In the United States, *Leslie's Weekly* and *Harper's Weekly* illustrated, as well as described, the news. During the early thirties, there were some illustrated German and English

Returning home from the Russian
war via the Arctic Circle, 1941.

news journals, the *Münchner Illustrierte Presse,* the *Berliner Illustrierte,* and the *Weekly Illustrated.* Two American picture magazines had begun and failed: *Panorama* started in 1928 and *Roto* in 1934. *The New York Times Mid-Week Pictorial* had been functioning since 1914. But within months of *Life's* appearance a rash of new picture magazines came out: *Focus, Photo-History, Peek, Now and Then, Foto, Picture, Pic, Look,* and others made a bid for the market. Only *Look,* which began publishing two months later than *Life,* survived until it stopped publication in 1971.

The mid-thirties were ripe for a photographic-journalistic medium; people seemed hungry for the concrete, realistic look at the world that photography provides. The Luce establishment had both stimulated and fed this hunger with the visually rich *Fortune,* begun in 1930, and *The March of Time* newsreels, started in 1935. By 1938 a contemporary observer (Simon M. Bessie in *Jazz Journalism*) commented that "the average citizen acquired most of his news through the medium of pictures."

Margaret Bourke-White joined the original *Life* photographic staff, along with Alfred Eisenstaedt, Thomas D. McAvoy, and Peter Stackpole. As a first assignment, she was sent to photograph a huge dam under construction at New Deal, Montana, a WPA project begun in 1933. She not only photographed a variety of structural details and engineering activities, but under her own initiative, she also covered the everyday life of the nearby rough-and-tumble frontier towns.

The dramatic combination of things and people that she produced hit a responsive chord in the editors, who decided to use her material not only for the first cover of the magazine, but for the lead article, thus betting on Bourke-White's photographs for the survival of the risky new enterprise. As the editors wrote in the "Introduction to the First Issue of *Life,*"

> Photographer Margaret Bourke-White had been dispatched to the Northwest to photograph the multi-million-dollar projects of the Columbia River Basin. What the Editors expected—for use in some later issue—were construction pictures as only Bourke-White can take them. What the Editors got was a human document of American frontier life which, to them at least, was a revelation.

The cover of Volume 1, Number 1, hits the eye with a full-page view of gigantic, battered, concrete piers, receding diagonally beneath a cloud-dabbed sky. Rising far above tiny people at their base, the massive forms are topped by swelling supports, making the forms seem like weird pagodas. It is an image of immense visual energy.

The lead article, "Franklin Roosevelt's Wild West," picks up the story with a half-page photo of off-duty workers clinching with taxi dancers who worked through the night for five cents a dance, and leads into an essay on the workers and their families living in the boomtowns surrounding the dam project.

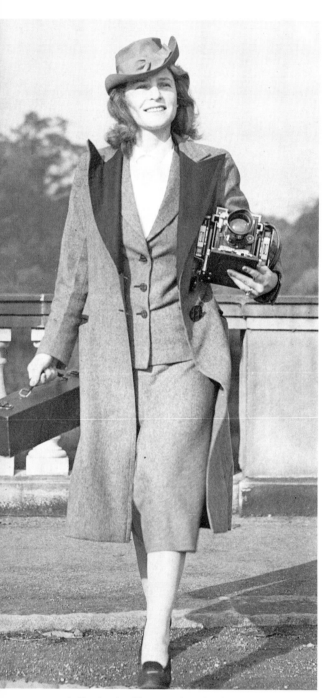

In England writing a series of articles for the
Illustrated London News, 1941.

With the publication of Bourke-White's first picture essay for *Life,* it may be well to digress briefly on the form itself, a journalistic technique not invented by *Life,* but developed, modified and exploited by the magazine in unique and successful ways for over three decades.

The history of the photo-essay is yet to be articulated, and there is little agreement on its nature among the few authors who have written on the subject. Indeed, even the name varies: "picture story," "picture essay," "photographic story," "photo-essay," etc. Yet, at least three general types of picture essay can be identified. The simplest is a purely sequential organization of pictorial components relating to a specific event. Historically, photographic sequences are found in the late nineteenth century with Nadar's interview with the chemist Chevreul, and Eakins' and Muybridge's studies of humans and animals in action, made in the 1880s. In this elementary form, no distinction is made as to the beginning, middle, and end of a story.

Second, the visual essay may be a more complex, less simply sequential study using a recognizable form, perhaps chronological, as, for example, "a day in the life of." A distinct beginning, middle, and end are generally used as structuring elements. Felix H. Man's "Day with Mussolini," published in 1931 by Stefan Lorant, established a precedent for this type of essay.

The third and most sophisticated type essay articulates a complex of events that is *interpreted* by the photographer, whose point of view guides the selection and organization of picture material. Among the acknowledged classics of the interpretive essay are W. Eugene Smith's "Country Doctor" (1948), "Spanish Village" (1950), "The Nurse-Midwife" (1951), and "Dr. Albert Schweitzer" (1954), all published originally as *Life* articles.

No doubt the key figure in the formulation of a successful photo-essay is the photographer; and the photographs themselves are the principal limiting factor in achieving quality. Yet, this art form, like the theater and films, is inherently collaborative. The published photographic essay requires the coordinated skills and imagination of editors, darkroom technicians, designers, pressmen, and writers, in addition to the photographer.

German journalists of around 1930 are generally credited with pioneering the picture story. Stefan Lorant, Berlin editor of the *Münchner Illustrierte Presse,* was instrumental in guiding photographs into an essay form. As early as 1929, Felix H. Man began photographing sequential sketches of conductors and musicians. Later, in England, the same editor and photographer began publishing the *Weekly Illustrated* in 1934, and *Picture Post* in 1938. The latter, which appeared about two years after *Life* began, was more visually refined in layout than *Life* of the same time; but *Picture Post* was obviously cast in a *Life* mode—even the *Post's* logo was almost identical to *Life's.* Although it was not the first to use the form, *Life* was surely an important agent in establishing the visual essay as a universally understood language.

Less than a year after Bourke-White's Fort Peck essay, what is probably her most famous individual photograph emerged from her coverage of the Ohio River flood of 1937, among the greatest natural disasters in American history. The photo shows a relief line of flood refugees in Louisville, Kentucky, standing before a billboard celebrating the "World's Highest Standard of Living: There's no way like the American way." The billboard was sponsored by the National Association of Manufacturers. The people shown in the photo were low-income blacks, who were particularly hard hit in their section of the city, waiting in line for food supplied by a temporary relief agency. It is thus not a scene of unemployment, or welfare, or the kind of chronic poverty documented by FSA and by Bourke-White in the cotton South. Yet, the photograph has been used repeatedly to comment on inequality, poverty, and deprivation. Its meaning was even stretched to include the purposes of the German Propaganda Minister Goebbels, who published the photo in 1937 with the caption "Thank God, we have a better way."

As American concern shifted from home to abroad in the late thirties and early forties, Bourke-White photographed Winston Churchill in the spring of 1940; he was then First Lord of the Admiralty under Prime Minister Neville Chamberlain. "Britain's Warlord," as *Life* captioned him on the cover, "the disillusioned cherub," as he was described within, Churchill appeared full-face on the cover of the April 29th issue. The head emerges from a uniform grey background to stare eye-to-eye at the observer. A comparison with the famous Yousuf Karsh portrait of about one year later emphasizes the disarming candor of Bourke-White's direct vision compared with the more traditional compositional subtleties of the portraitist Karsh.

In Karsh's composition, the subject, placed back in space within a panelled room, is a dark mountain topped by the famous bull-dog head. Within the black mound of his body, highlighted hands and vest chain form a base to the triangle whose apex is the head. It is a forceful and expressive composition, as traditional in Western art as a Renaissance portrait. By contrast, Bourke-White's Churchill is a disembodied head, occupying most of the picture surface, emerging from the cover to meet the observer, like a nose-to-nose greeting of a child or a dog. The determined face is read so closely that we become conscious of its topography, the warped line of the mouth, the assymetry of the incandescent eyes, the sprig of grey hair sprouting from the left eyebrow.

Churchill's impressive head was recorded with the same compelling directness that Bourke-White used in photographing industrial forms and eroded earth. She spoke with few visual words, but these powerful few were chosen with great care. And they say much.

Bourke-White and Erskine Caldwell were married in 1939 (divorced in 1942) and collaborated during those years on two timely but unimportant books: *North of the Danube* (1939), a sketch of life in Czecho-

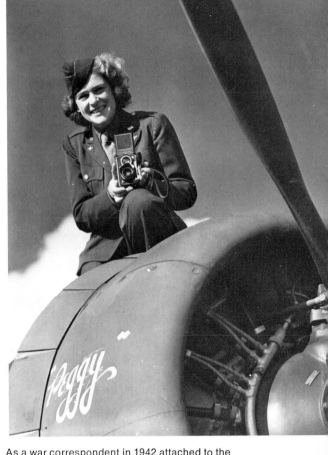

As a war correspondent in 1942 attached to the Air Forces she was honored by a B-17 crew that painted her name on one of its engines. Tradition was that they were reserved for wives and fiancées.

slovakia just before the Nazi takeover, and *Say, Is This the U.S.A.?* (1941), a panoramic survey of the United States. In addition, both were in Moscow in the spring and summer of 1941, when the Germans attacked the city, and they covered the events in words and pictures for *Life.* Bourke-White was the only foreign photographer in the U.S.S.R. at the time.

It was no accident; the couple had been travelling on a world tour and Bourke-White's editor at *Life,* Wilson Hicks, following his hunch that big news was about to break in the East, dispatched her to the scene about a month before the beginning of one of the bloodiest episodes of World War II. Days before the outbreak of hostilities she photographed peaceful Moscow. The city was bombed the night of July 22, and regular attacks followed. Her cameras were not idle. And in her photographs a weird combination of the terror and the satanic beauty of an air raid is superbly delineated by the black, jagged Moscow architecture silhouetted against the menacing traceries of explosions, flares, and antiaircraft fire. It was while living and working under such conditions that Bourke-White managed to gain access to Joseph Stalin for a rare photographic interview.

Just after the United States entered the war, at the beginning of 1942, Bourke-White received accreditation as an official Air Force photographer. Her work was to be used jointly by the Air Force and by *Life.* She was in England as U.S. B-17 squadrons were assembling for attacks on the Continent, and when Air Force action shifted to North Africa, she decided to move with it, but was denied permission to fly with the men on the grounds that it was too dangerous. Ironically, she sailed instead on a slow convoy and her ship was torpedoed near North Africa. Along with the other survivors, she was rescued by a destroyer that landed her in Algiers. General Doolittle, Eighth Air Force commander, then gave her permission to fly a mission with the 97th Bomb Group; and on January 22, 1943, she participated in a militarily important raid on the German airfield at El Aouina, north of Tunis. Later, in Italy, she photographed the extraordinary violence in Cassino Valley while flying in an artillery spotting plane. She also photographed heavy artillery action on the ground. And twice her hard-earned negatives were lost in transit, once after covering a bloody night in a field hospital near Cassino, another time after photographing infantry patrols near Bologna.

During the closing days of the war she moved along the Rhine with General Patton's Third Army, recording the Götterdämmerung of the Third Reich. She entered Buchenwald with the armies to photograph the dead and dying, and also documented the remains of a labor camp at Leipzig-Mochau, a small barbed wire enclosure strewn with charred corpses amid the rubble of recently burned buildings. Shortly before she had arrived at the camp, the SS had lured the remaining prisoners into a mess hall, locked them in, covered the windows, and thrown hand grenades and flaming acetate into the trap. Some human torches escaped, only to die near the barbed wire fence. Others managed to

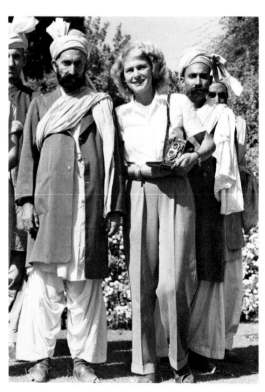

With tribesmen in Kashmir, 1947

flee beyond, but were shot to death by roving Hitler Jugend, according to Bourke-White's account. Of three hundred prisoners, eighteen survived.

The famous photograph of Buchenwald prisoners is surely the best of the thousands of Goyaesque images made of death camps. Stitched across the picture surface, the menacing barbed wire establishes a distinct separation of viewer and prisoners. Figures in a macabre frieze, the emaciated men beyond hope, despair, or even life itself; indeed, they seem unaware of the camera's presence and of the fact that they are free. The picture remains a lasting testimony to the kind of hell-on-earth that only humans can create.

During the nightmare ending of the war in Germany, Bourke-White flew over the devastated countryside, photographing remains of urban centers. At the same time, she managed to photograph some of the many family suicides of Nazi officials during those dreadful days.

Bourke-White's popularity peaked when she returned to the United States. Her war photography had reinforced her international fame; even the comic-book set was reading of her exploits. *Calling All Girls* sang of her adventures; *Real Fact Comics* published one that was headlined "The World's Most Famous Photographer was a Girl."

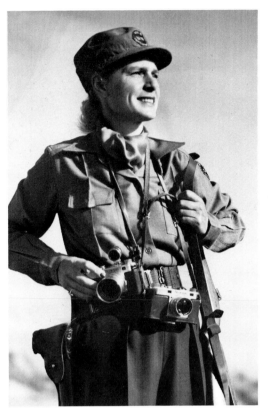
As a correspondent covering the Korean War.

Immediately after World War II, Bourke-White was assigned to India, where she worked intermittently through 1948. She approached the gigantic task of photographing aspects of India by first concentrating on Mohandas Gandhi, the tough exponent of action through passive resistance. But the large retinue surrounding him established barriers between her and the man, among them the requirement that she learn to use the spinning wheel, Gandhi's symbol of resistance to modern technology and of his Thoreauvian emphasis on self-reliance. After overcoming such obstacles, she still had to face unsympathetic lighting conditions in Gandhi's study, generally low luminosity and a glaring backlight. Even Margaret Bourke-White could not adjust Gandhi to her photographic requirements, so her photography had to adjust to Gandhi's situation. She made countless studies—the most successful juxtaposes the introspective, relaxed man with the taut geometry of the wheel.

After it became apparent that Gandhi's dream of peaceful unification was to be frustrated by the partition of the country into largely Hindu India and Moslem Pakistan, ancient religious hatreds boiled into contagious riots. And in the late summer of 1946, Bourke-White found Calcutta streets strewn with putrifying corpses decaying in the heat and being consumed by bloated vultures. Even the toughest journalists found it impossible to enter the death zone, but the single-minded Bourke-White moved within the nightmare to produce works that continue to wrench the stomach as they mock our humanist notions of human dignity.

Accompanied by disease and death, she followed millions of displaced Moslems, Sikhs, and Hindus who suffered heat, pestilence, and

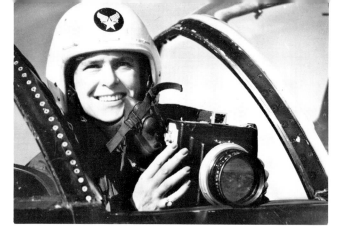

In the cockpit of a B-47 jet bomber photographing a LIFE story on the Strategic Air Command, 1951.

violence to escape the terror unleashed at the time of partition. Today, Bourke-White's epic images are tragic reminders of India's prolonged agony.

Acquainted with Gandhi for several years, she had a long candid conversation with him around noon, January 30, 1948; he spoke of the darkness and madness engulfing the world and of his waning hope for a better world. A few hours later he was murdered by a Hindu fanatic; Bourke-White was again at the scene of an important world event.

Working in South Africa in 1950 on a long article, she decided to do a day-in-the-life sketch of some gold miners. Two were selected as subjects, and she asked the foreman for their names and for permission to follow their day's work. She discovered that from an employer's point of view, workers had numbers, not names, since they are defined as working units, interchangeable parts of a human machine. She learned also that these particular men worked miles underground in the most dangerous section of the mining system. She followed and photographed them in their brutal environment, producing one of the most haunting images of her career and one of her own favorites.

In her autobiography she wrote that "I left the mine realizing that I had spent only four hours underground, and I would not have to return if my pictures were all right. But these men . . . were destined to spend the better part of their waking hours underground with no hope of escaping the endless routine."

During the Korean war Bourke-White concentrated on human aspects of guerrilla warfare, on families split by conflicting political allegiances. En route to Korea she was stoned by rioters in a Tokyo street demonstration. She did a photo-essay on Strategic Air Command operations, and made an air study of the United States in the early fifties from a cruising helicopter.

By the mid-fifties, the effects of Parkinson's disease were beginning to curb her photographic activities, though she fought the disease until the end in August 1971. Of the many works that came out of these last, productive years, the Indian and South African are among the most valuable of her career.

Margaret Bourke-White's work is a fascinating record of objects, people, and events that have shaped our lives during the past forty years: pristine industrial forms of the twenties; pinched faces of the thirties; the insanity and heroism of World War II; postwar images of degradation, along with images of hope for redemption.

But her lifetime production is much more than a mere record, since it helps enlarge our consciousness. The Buchenwald photo of prisoners is one of the consummate warnings, along with Goya's and Picasso's, about the human capacity for inhumanity. Her photographs of bridges and factories continue to express the hope that construction will overtake destruction. The shackled feet of chain gang prisoners reveal more about the nature of human societies than most of

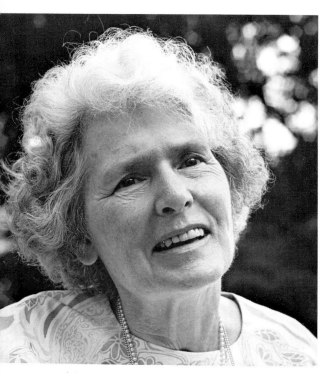

In retirement at her Darien, Connecticut home, 1970. Photograph by Stuart Abbey.

us care to hear. Poverty-scarred facial landscapes speak of an aspect of life on earth largely unknown to the affluent third of the world's population. The gentle Gandhi and the sweat-drenched faces of South African miners are haunting reminders of the collision of promise and reality for millions today.

Throughout her life, Margaret Bourke-White spoke of "fact" and "beauty" as the basis of good pictures; and perhaps this simple affirmation is a key to her personal ethic and to her view of reality. With a belief in the sacred value of fact, no matter how distressing, she operated on the assumption that fact and beauty are supportive partners, and she joins a long line of artists—Constable, Thoreau, Van Gogh, Whitman, Eakins, Mathew Brady, Paul Strand, Alfred Stieglitz—who also wove the two into the fabric of their art.

Her approach was deceptively simple. She immersed herself in situations, extracted the maximum from the experience, and communicated the essence of the event through extremely succinct means —isolation of cogent details, juxtaposition of mutually reinforcing elements, and straightforward views of subject.

For those who continue to be intrigued by the Bourke-White legend, there remains the question of whether she succeeded in a "man's world" *despite* the fact that she was a woman or *because* of this fact. A few people may remain upset because she "engineered" some stories. Some will tut-tut because she worked at such a mad pace, suspecting that she shot without discrimination hoping to achieve good results through the law of averages. But after all the gossipy questions have been forgotten, her work will remain as silent testimony to the richness, turmoil, and quality of life on earth during the second quarter of the twentieth century.

With a child's sense of wonder, an adult's understanding of tragedy, and a strong impulse to share experience, Margaret Bourke-White had excellent credentials for photojournalism. Beyond this, her empathy, discerning eye, and agile mind created a body of work which establishes her as one of the great visual artists of our time.

After two operations to stem the tremor of Parkinsonism, Bourke-White spent most of her time at home with a nurse and housekeeper and their children. She wrote her autobiography in 1963 (*Portrait of Myself,* Simon & Schuster) and compiled notes for an anecdotal reminiscence about some of her experiences but stopped working on it in 1968. Along the country road leading to her house she took solitary walks with short, halting steps, trying to stave off the encroaching rigidity of the disease. Photograph by Alfred Eisenstaedt.

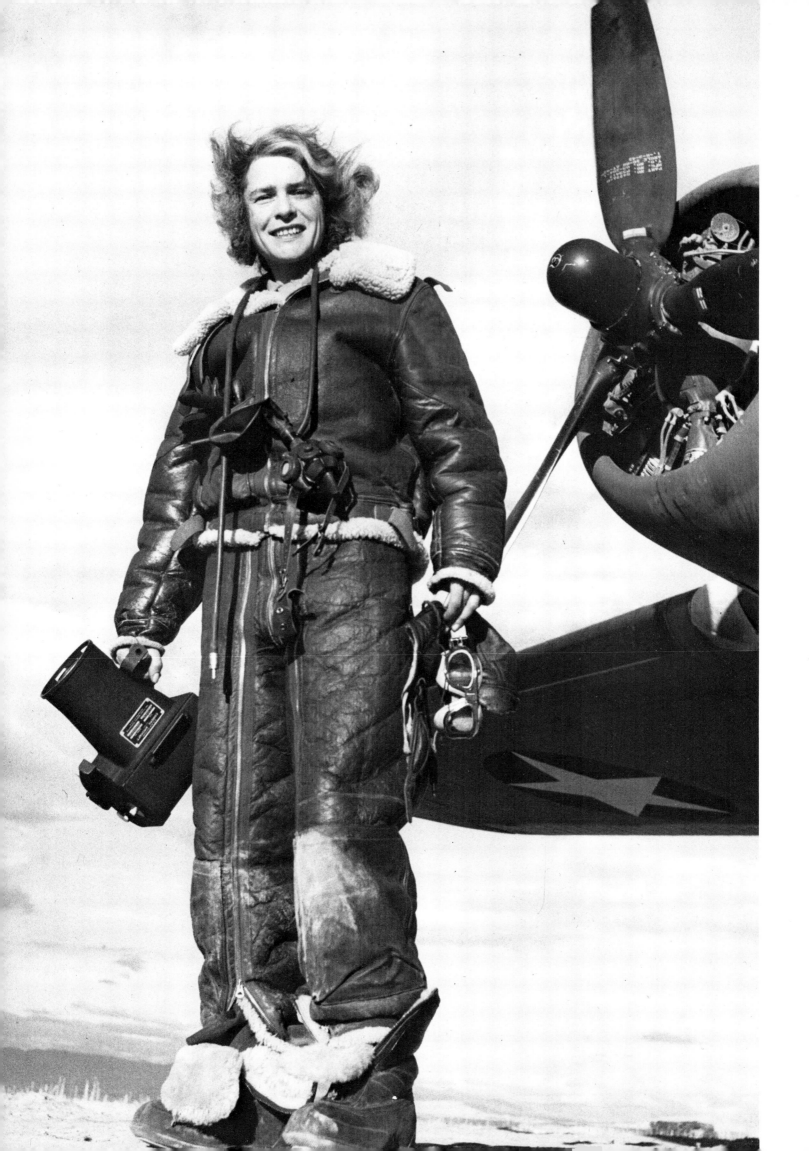

A Tireless Perfectionist

From the moment she first fell under the spell of a camera while an undergraduate at Michigan, Margaret Bourke-White was obsessed by the excitement of what she and the camera could do together. "We all find something that is just right for us," she once reflected, "and after I found the camera I never really felt a whole person again unless I was planning pictures or taking them."

And looking back on those early years she told me once how she felt when she was asked at a social gathering what she did. "I'm a photographer," she said. "And they never knew what a thrill it was for me to say that."

Margaret Bourke-White rose to pre-eminence in that remarkable decade—1925-1935—when camera development, editorial imagination and a breakthrough in printing processes combined to bring about a revolution in communications through the still picture. As the first photographer for *Fortune* and later as one of the four original staff photographers for *Life,* her monumental work became known throughout America and the far reaches of the world—beyond that of any other photographer of her time.

The new and exciting form of photojournalism which *Life* created caught the interest and imagination of readers everywhere, and Bourke-White was its star. Her twelve- and fourteen-page essays were the talk of the time and wherever she went she was received like the great innovator and artist that she was. In retrospect it would seem that she was born in anticipation of this new era of picture journalism and that in its early stirrings it awaited her, gathering its energies while she prepared herself to ride the crest into the new age.

Over the years she became a photographer's photographer. Her work was so widely published throughout five decades that there are few photographers who cannot bring instantly to mind a gallery of her pictures. And her influence on them has been incalculable. She was indefatigable and a perfectionist. Little that she ever did really satisfied her.

"When my prints come out of the darkroom," she once told me, "I sit with them alone. Every now and then I find something that gives me a thrill. But for the most part I see something that I failed to do, or that I did that wasn't right. I have never forgotten a picture that I ever made. I would recognize one in a flash anywhere. But I guess what I see in them first—and over and over—is what I *ought* to have done."

This relentless drive towards higher goals often made her seem a difficult person, almost ruthless, when she was at work. And about this she was forthright. "Sometimes," she said, "I could murder someone who gets in my way when I'm taking a picture. I become irrational. There is only one moment when a picture is there, and an instant later it is gone—gone forever. My memory is full of those pictures that were lost."

And it was this dedication, this singleness of purpose and concentrated energy—along with her outstanding success—that made her the target of jealousy among some of her fellow professionals. For

she was one of the first women to compete and excel in this male-dominated field. That she has often been called "the finest woman photographer of our times" is a significant commentary on her life and on our society. For what she long ago achieved was pre-eminence simply as a photographer—one of the very finest *photographers* of our times. The qualifying label "woman" was important only as an indication of the odds against her in a man's world.

Perhaps it was held against her also that she was strikingly handsome and that she cloaked her driving will in a deceptive femininity. Rather tall, she gave the impression of being petite, and her blue eyes were clear and keen. Half a generation ahead of her time in her personal style as well as her photography—she wore pants suits to the office and on assignments and in those years when it was unusual for a woman to color her hair, she tinted hers. She was quick to smile and her voice rang out when she laughed.

And she was highly visible. Never one of the "invisible witness" school of photographers who work unnoticed with 35mm cameras and value most highly the untampered picture, she worked instead with a large camera, multiple flash, and often a battery of assistants to carry her heavy equipment and set up lights. That was her style. And as an active, swiftly moving person, she had little patience with a slow assistant but often darted in and took over his tasks herself. Often she left small eddies of turbulence behind her as she swept through an industrial plant trailed by corporation heads or hurried up a mountain trail to photograph a battle followed by officers eagerly lugging her equipment.

She was dedicated to the story she was creating as well as to the individual picture. And she was faithful in preparing herself, gathering the background facts, feeling for the mood. Speaking of her experience with Mahatma Gandhi, she said: "If you want to photograph a man spinning, give some thought to why he spins. Understanding is as important for a photographer as the equipment he uses. In the case of Gandhi, the spinning wheel is laden with meaning. For millions of Indians it was the symbol of their fight for independence."

In her early years her interests ranged widely—from insects to industry, agriculture to architecture—but as she became more absorbed in the tragedies of human conflicts, in men's struggle to live, her interests in other subjects lessened.

She was a woman of indomitable courage, dedicated to capturing on film the events of our times, and she would not cringe from any scene or action that she thought should be photographed and added to the record of men and the world they live in. She was often asked—and she felt the question implied criticism—how she, as a sensitive person, could photograph the stark and ghastly scenes at Buchenwald at the end of the war. "Sometimes I have to work with a veil over my mind," she answered. "When I photographed the murder camps the veil was so tightly drawn that I hardly knew what I had taken until I saw the prints of my own photographs."

"And sometimes," she once said to me, "I come away from what I have been photographing sick at heart, with the faces of people in pain etched as sharply in my mind as on my negatives. But I go back because I feel it is my place to make such pictures. Utter truth is essential, and that is what stirs me when I look through the camera."

It was nineteen years ago that Margaret Bourke-White felt the first threat of a malady that destroys the nerves and wastes the muscles and encapsulates the body with a creeping rigidity. For years she fought back, tenaciously, furiously. "I'm under attack every minute," she once said. "Every moment of inactivity I lose what I cannot gain back. I fight it, fight it." She made heaps of crushed paper balls, working them with her hands to keep them mobile. She danced—towards the end she said she could dance better than she could walk—and she walked, on and on, often stumbling, but walking on.

It was when she fell two months ago and cracked three ribs and had to be immobilized that the disease at last found its chance. In the end only her clear mind and eyes—still alert and ranging—moved. It was these that made Margaret Bourke-White the great photographer and person that she was. And they were the last to go.

—Carl Mydans
(Written on the day of her
death, August 27, 1971.)

Margaret Bourke-White photographing praying
mantes, 1938. Photograph by Carl Mydans.

The Cleveland Years

1927-1929

At Cornell, Bourke-White studied biology and upon graduation was considering a position with the Curator of Herpetology at the Museum of Natural History in New York. Although she had moderate success selling her campus pictures, Bourke-White never was confident of her ability as a professional photographer until some architects who were Cornell alumni convinced her that she could make a living as an architectural photographer. She returned to Cleveland, where her family lived, and started to build up a portfolio, calling on architects who were Cornellians and their friends.

Her first job was a newly completed school surrounded by the remnants of its construction. Another photographer had previously tried and failed to make an acceptable picture. Bourke-White's solution was to go to a florist shop to buy an armful of asters which she stuck in the muddy ground, and to shoot over the blossoms at such an angle as to obstruct the morass of debris and delicately frame the subject. Impressed by her ingenuity, the firm placed more orders and the Bourke-White studio was founded. At first this was located in her one-room apartment, with the developing done in the pantry, printing in the kitchen, and rinsing in the tub. When the hide-a-bed was up the living room was the reception area. Whatever profits she made by day photographing elegant homes and gardens were spent on materials used nights and weekends photographing steel mills in Cleveland's sprawling industrial area.

She never thought of her industrial pictures being saleable until someone at a bank spotted some in her portfolio and started putting them on the cover of a local trade magazine. This brought her work to the attention of the city's biggest industrial tycoons, among them Elroy Kulas of Otis Steel. Kulas was amused by this young girl in his office rhapsodizing about the beauty of his mills. She wanted permission to photograph inside. He consented, and fortunately for her, left for Europe for five months. Her first efforts were disastrous. The slow films of the day couldn't capture the wide range of light between molten steel and the sooty maw of the mill. Her pictures were meaningless streaks of light. A camera-store owner, Alfred Hall Bemis, who had befriended her when she first arrived in Cleveland, came to her rescue, lending his shop's staff and supplies. When that wasn't enough he prevailed upon the traveling salesmen who sold photo equipment to contribute their sample cases. She had an armful of prints by the time Kulas returned. He was pleased with her pioneering efforts, bought eight at $100 a piece, and ordered eight more. She began specializing in industrial photography and was starting to get jobs from Detroit automakers. The Bourke-White Studio had moved into the prestigious new Terminal Tower skyscraper. A portfolio of her industrial pictures had appeared in the rotogravure sections of several Mid-West papers when in late spring of 1929 she got a telegram: "Have just seen your steel photographs. Can you come to New York within week at our expense?" It was signed "Henry R. Luce," and "Time, the weekly newsmagazine."

Terminal Tower, Cleveland, 1928 (above and left)
An early series made in the city's industrial area and focusing on Cleveland's newest skyscraper.

High Level Bridge, Cleveland, 1929
Other magazines began buying pictures from her
industrial portfolio. *Trade Winds,* published by a
local bank, made a cover out of this silhouetted
bridge detail.

J. P. Burton Estate, 1928
Bourke-White's first commercial accounts were
with architectural firms and the owners of plush
estates around Cleveland.

A Preacher and His Parishioners, Cleveland, 1928
Making her rounds with a portfolio one day, she saw
this black preacher sermonizing to his flock in the
Public Square. Borrowing a camera from a nearby
photo store she made this picture and sold it to the
Chamber of Commerce for their monthly magazine.
They paid $10 and she got her first cover.

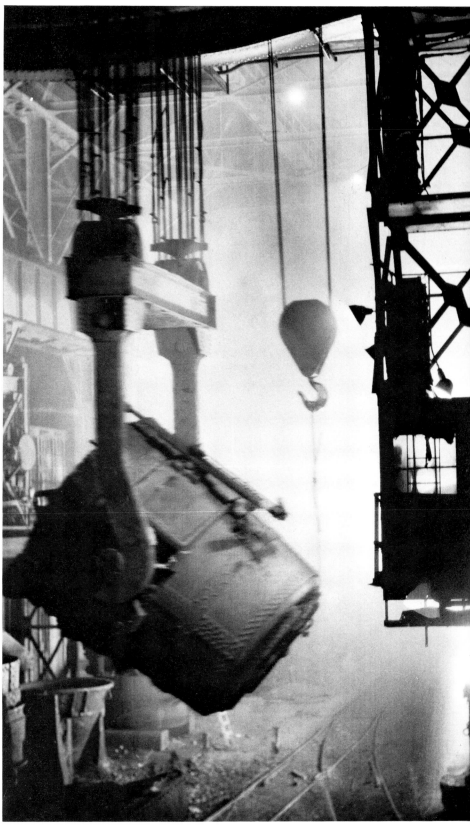

Pouring the Heat, Detroit, 1929

A Ford Motor Company foreman shields his eyes against the fiery light of the open-hearth mill.

Niagara Falls Power Company, 1928

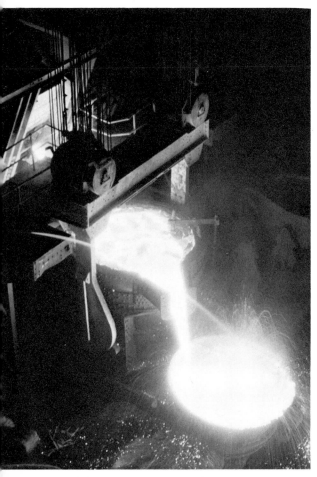

200-ton Ladle, Otis Steel, Cleveland, 1929

For five months, Bourke-White experimented with films, lenses and even magnesium flares to produce a series of dramatic pictures under challenging conditions. Her technical innovations were extraordinary for the day.

Otis Steel, Cleveland, 1928

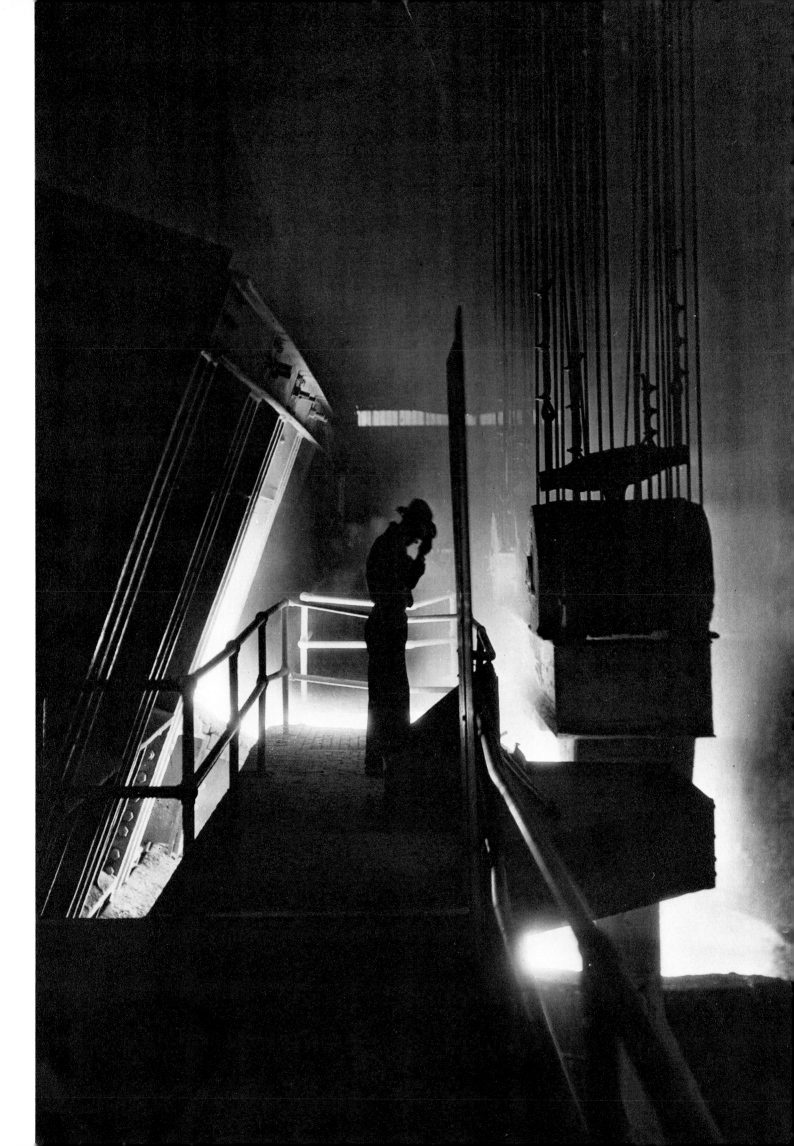

The Fortune Years

1929-1936

Bourke-White accepted Luce's invitation to come to New York, using it as an opportunity to visit some of the big architectural firms there. She was unimpressed by TIME. The only important use it made of pictures was on the cover and like most magazines of the day, would pick them up anywhere. But she lost all apprehensions upon meeting the voluble Henry Luce and his imaginative young editor Parker Lloyd-Smith. They had plans for a new business magazine that would make dramatic use of the best industrial photographs ever taken, that would show, Luce said, "everything from the steam shovel to the board of directors." "This was the very role I believed photography should play," she wrote, "but on a wider stage than I could have imagined. I could see that this whole concept would give photography greater opportunities than it ever had before." She accepted their offer of a staff position on the spot. Contributing her portfolio to the dummy, she returned to Cleveland to await the advertisers' response. In July, 1929, it was decided to publish the magazine, called FOR-TUNE, and she began shooting stories for the first issue eight months away.

She worked with Lloyd-Smith on the story about Swift & Co. that was chosen as the lead article. They followed the disassembling of the hogs in the packing plant until happening upon a storeroom heaped high with pungent offal. Lloyd-Smith retched and made for the car as fast as he could, rolled up the windows and locked himself in. Bourke-White had to take more time to gather her impression because of the dim light. After finishing shooting she left behind for burning her camera cloth, light cords, and everything else she could spare. As she proved throughout her career she could tolerate anything to get pictures except when something stood in the way of her getting pictures. While photographing the America's Cup trials off Newport in 1934 she was swept overboard unnoticed by the crew. She floundered helplessly in the rough water for over ten minutes still clutching her 5x7 Graphlex. Another boat rescued her from near drowning. Back on land she realized that the camera was irreparable, with the big race the next day. Then she broke down and wept.

In the beginning she tried to work out of Cleveland but soon moved to New York. By 1933, she was accepting fewer editorial assignments from FORTUNE to concentrate on her lucrative advertising business, and the studio staff was expanded to eight, headed by Oscar Graubner, a master technician, and Peggy Smith Sargent, her secretary. But a FORTUNE story, the Great Drought of 1934, exposed her to human suffering for the first time and it changed her life. Sometime later she had a nightmare about being chased by a herd of Buick automobiles that she had been photographing. The driverless cars had her surrounded, flapping their hoods maniacally as if to devour her. She awoke on the floor with a strained back and a resolve to get out of the advertising business fast. She began searching for a way to get involved with people again and a book seemed to be the only medium capable of containing her ambitions.

Glass Blower, Corning, N.Y., 1929

Ore Loading Docks, Superior, Wis., 1929 (opposite)
From two of the stories that Bourke-White
photographed for FORTUNE's first issue.

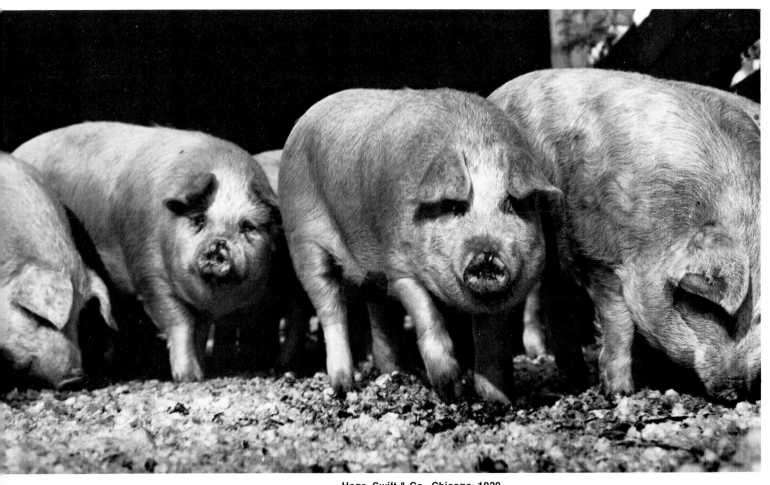

Hogs, Swift & Co., Chicago, 1929
Bourke-White's documentation of the meat packing process for
FORTUNE's lead article, from which these three pictures are taken,
was a move in the development of the photographic essay.

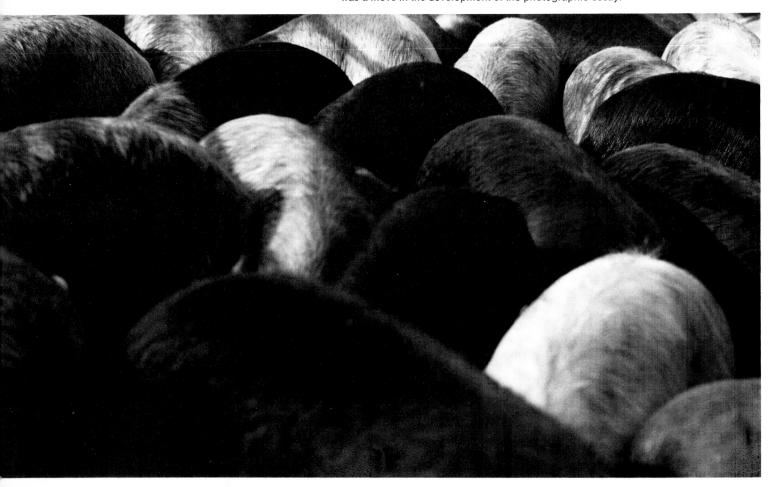

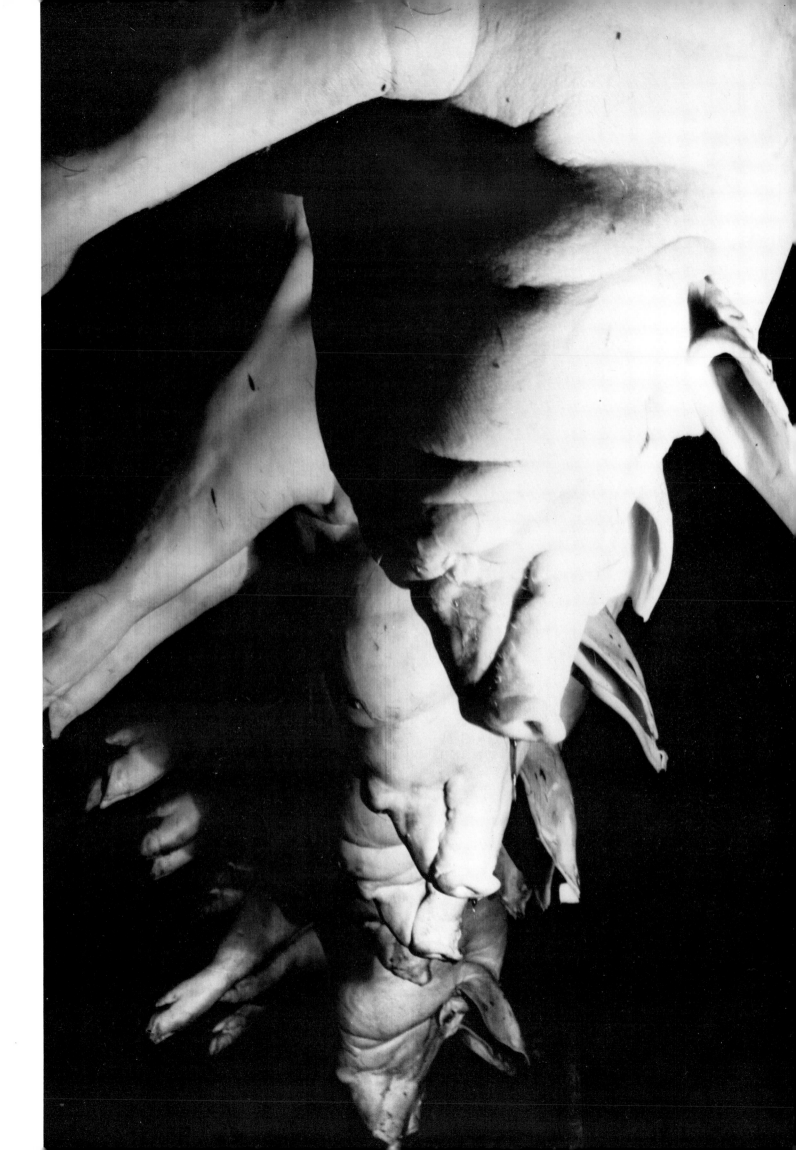

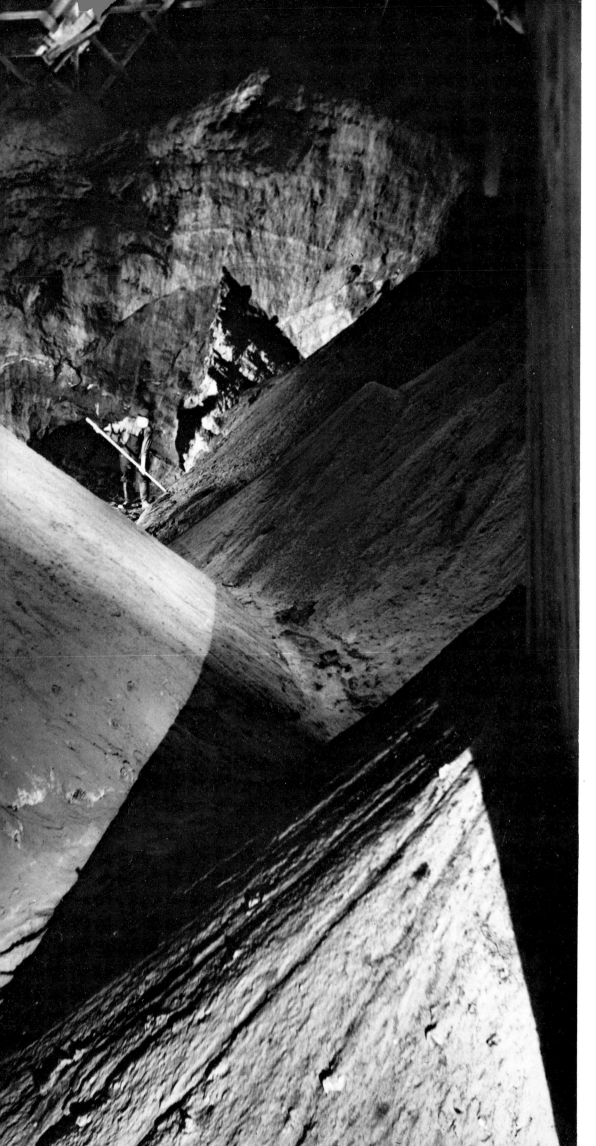

Pig Dust, 1929

The final remains of the pigs
are ground to an acrid powder
that is later mixed with meal
and sold as fodder. This was
the closing picture in
FORTUNE's first essay on
Swift and Company.

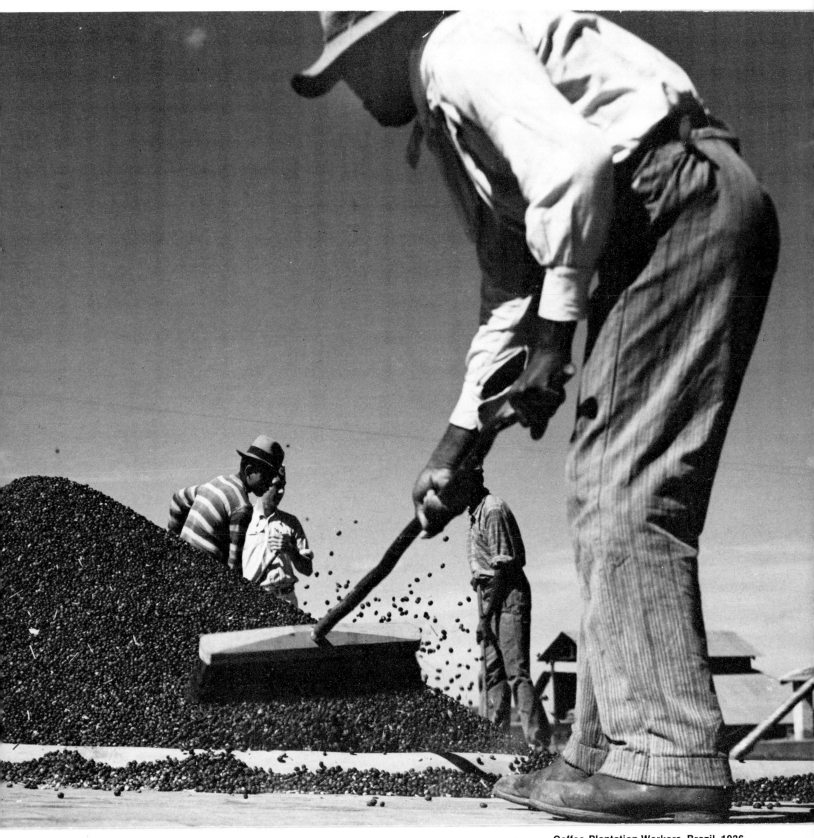

Coffee-Plantation Workers, Brazil, 1936

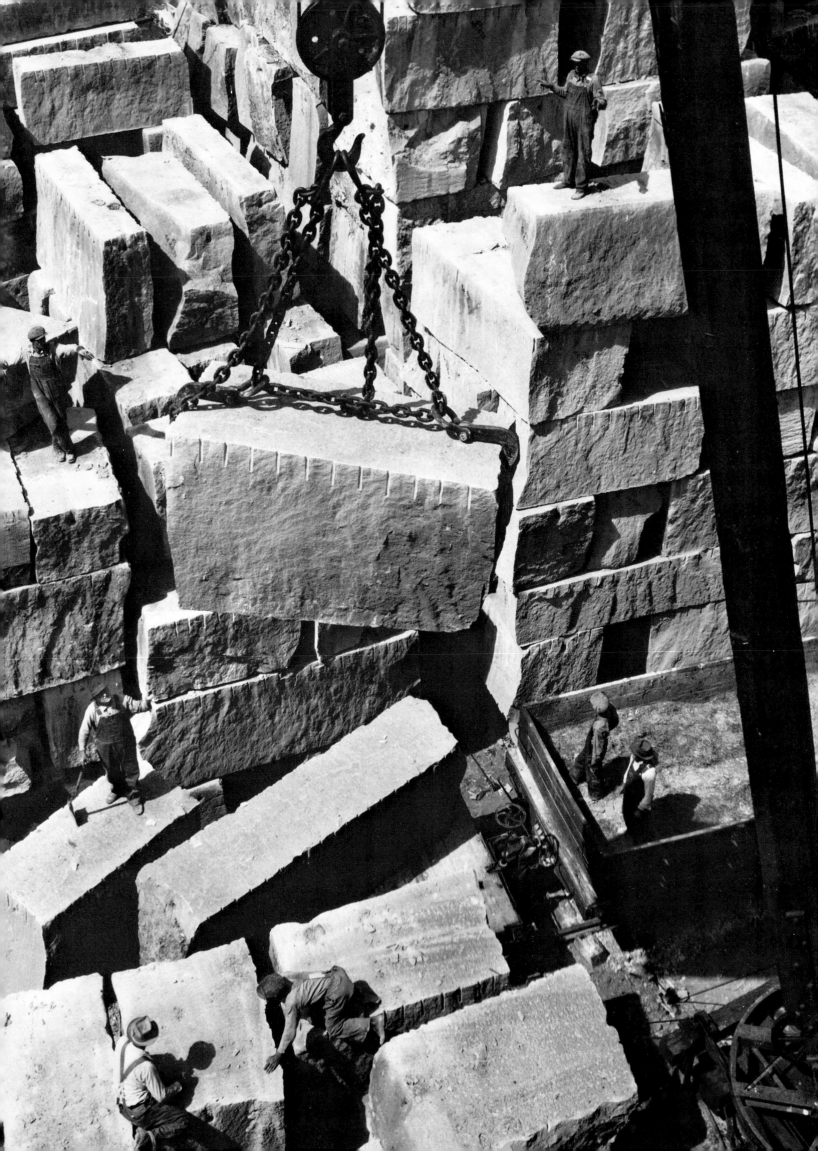

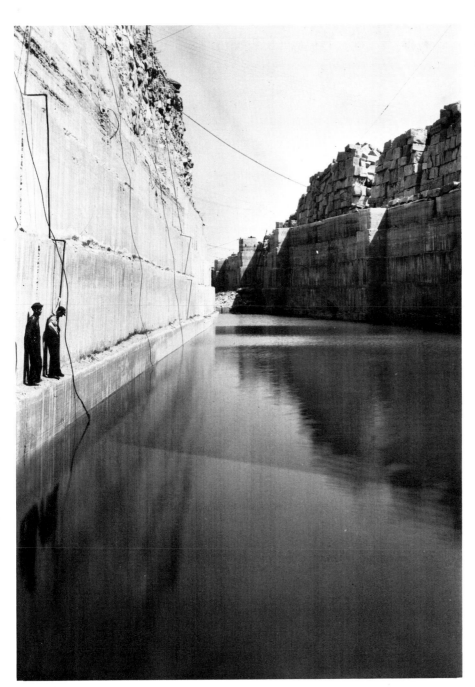

Indiana Limestone, 1931

Quarrymen (opposite) stack the massive stone blocks as easily as cordwood.

Indiana Limestone, 1931

Of this quarry the FORTUNE caption read: "Here Lay the Empire State Building in Prehistoric Majesty,"—before 207,000 cubic feet of limestone were extracted and sent to Manhattan.

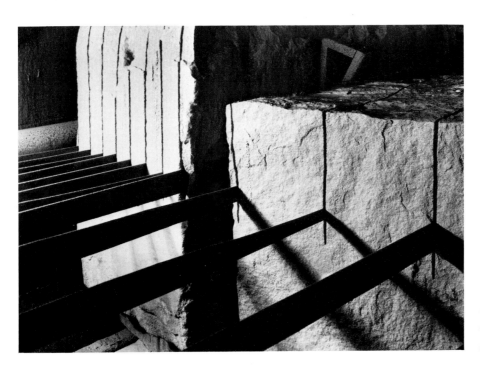

Indiana Limestone, 1931

Gangsaws pare the giant slabs down to the architect's precise measurements.

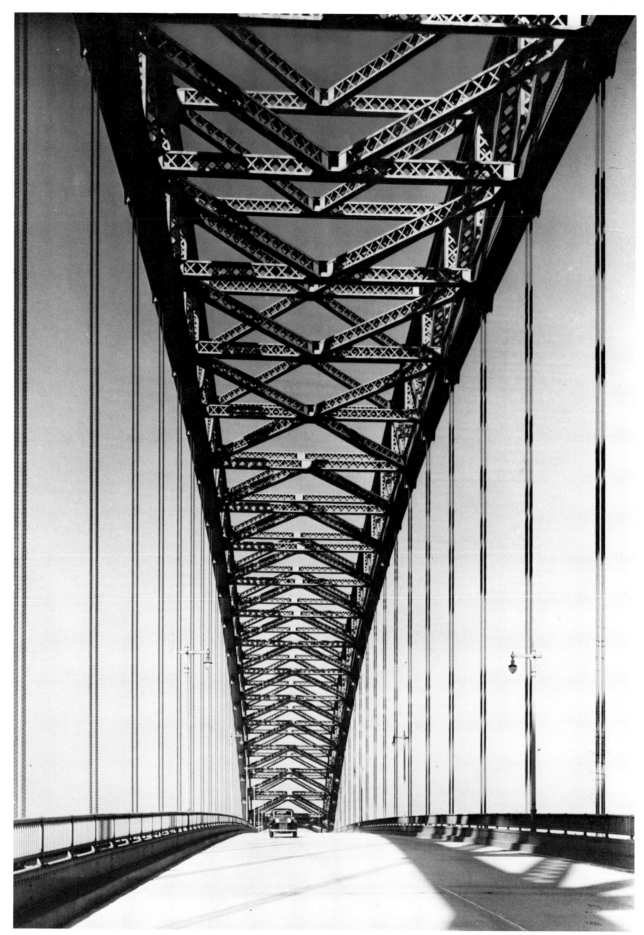

The Bayonne Bridge, 1933

The George Washington Bridge, 1933
At the time of this FORTUNE story on the Port of
New York Authority these bridges were respectively
the longest single arc and the longest single span
bridges in the world.

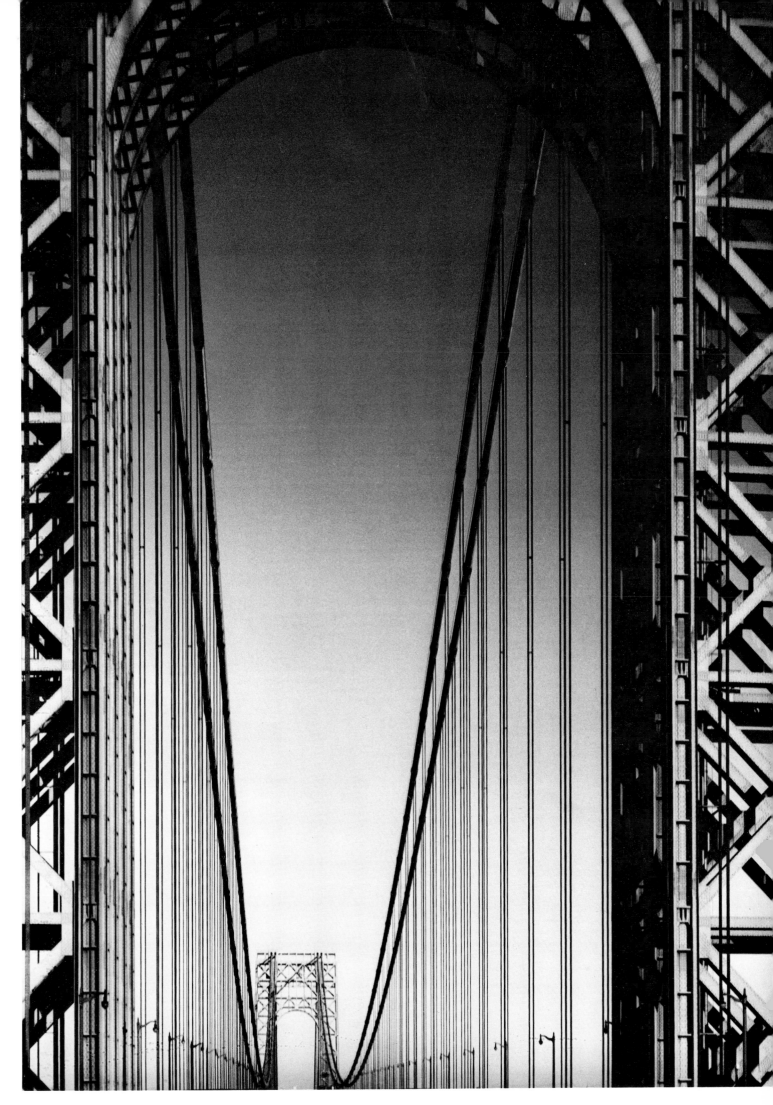

Pierce-Arrow, 1931

Ore being poured into pigs, Alcoa, 1934

Union Fork & Hoe, 1934

Bauxite, mother of aluminum, Alcoa, 1934

WOR, radio transmitting tower, 1935

Goodyear Tire, 1934

One of Bourke-White's most profitable advertising accounts was Goodyear, which ran a campaign boasting an extra-deep tread that made its tires stop more quickly. Bourke-White shot hundreds of set-ups showing the distance between screeching halt and sure disaster. In the ads, the distance between car and victim was sometimes illustrated with dotted lines, showing "the Goodyear margin of safety."

Bar at "21," 1933

For a FORTUNE story on speakeasies.

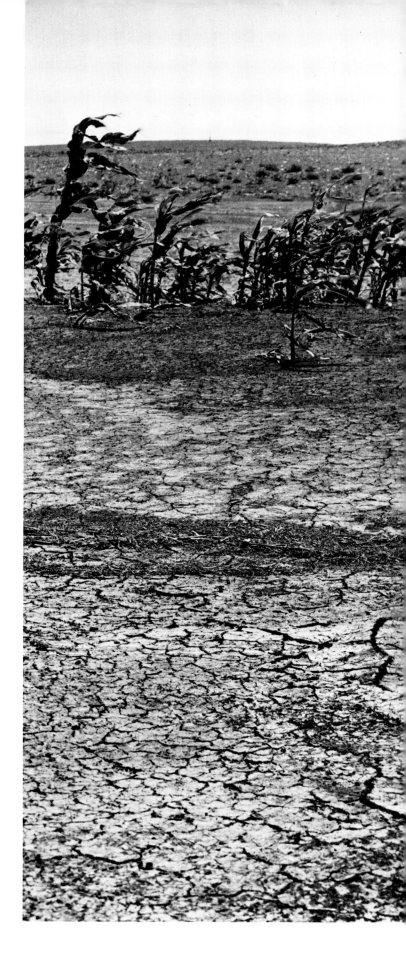

Dust, Just Dust, South Dakota, 1934
To cover the Great Drought for FORTUNE,
Bourke-White barnstormed through the plains states
in a decrepit two seater airplane for five days.
Although she produced no notable pictures of the
suffering farmers, the experience aroused a social
consciousness that changed her career.

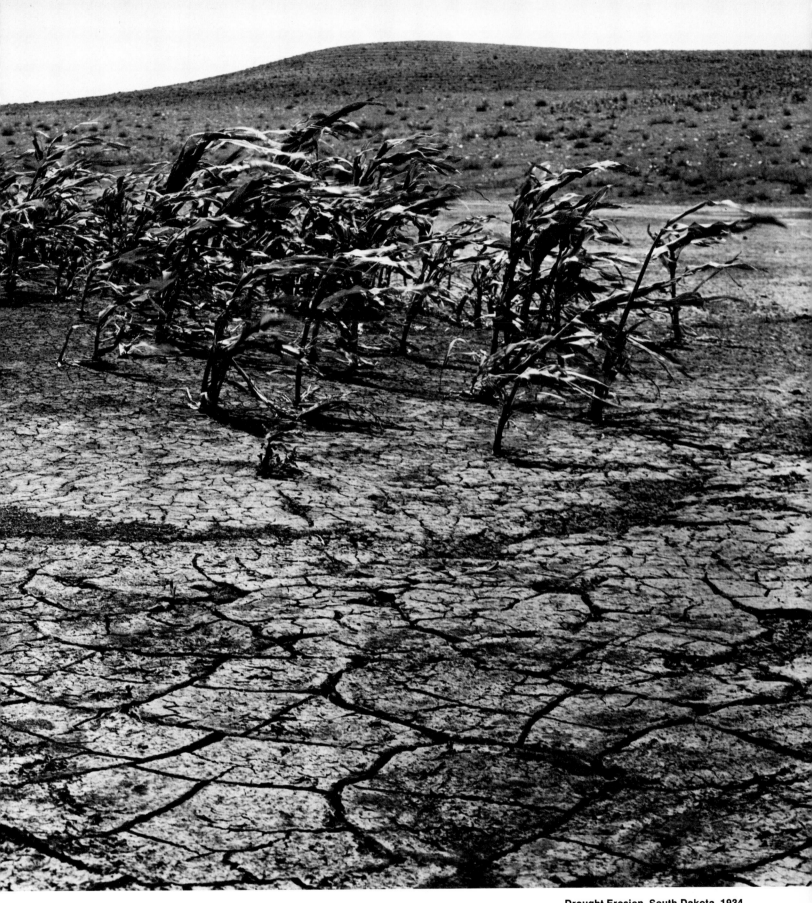

Drought Erosion, South Dakota, 1934

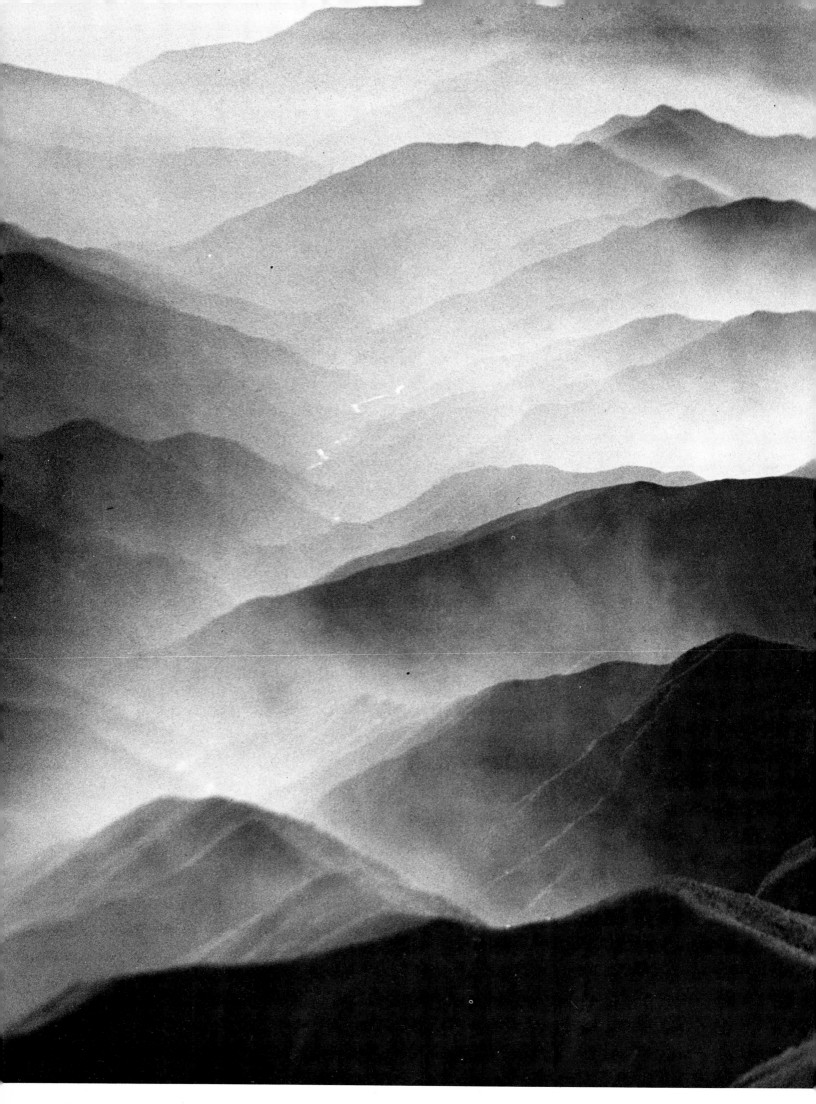

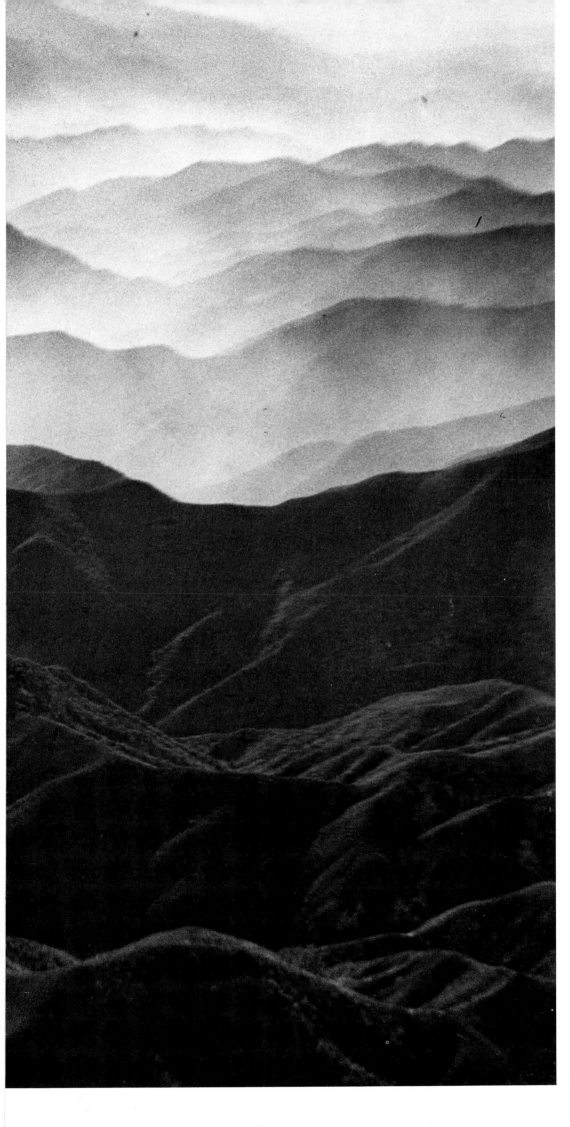

Sierra Madre, 1935
From a portfolio of aerial
scenic pictures produced for
Trans-World Airlines.

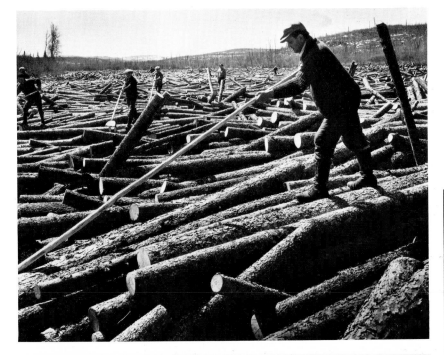

Lumberjack, International Paper Co., 1937
Log Jam, International Paper Co., 1937 (top left)
Still Life, International Paper Co., 1937 (left)

Log Rafts, International Paper, 1937 (opposite)
Logs, gathered together like giant lily pads, lie on
the surface of a lake in Canada, waiting to be milled.

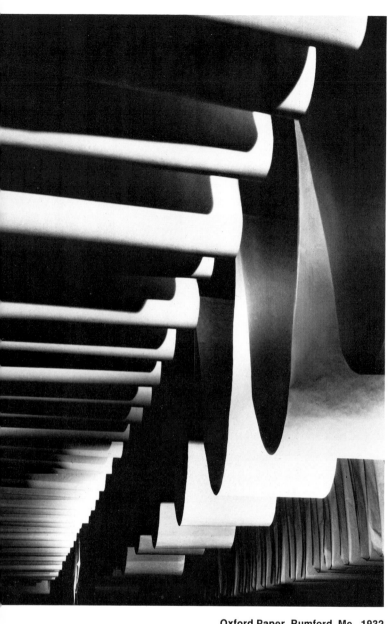

Oxford Paper, Rumford, Me., 1932

Miles of coated paper hang to dry.

Oxford Paper, Rumford, Me., 1932

An inspector fans sheets of finished stock checking for flaws.

Capitol Steps, Washington, 1935

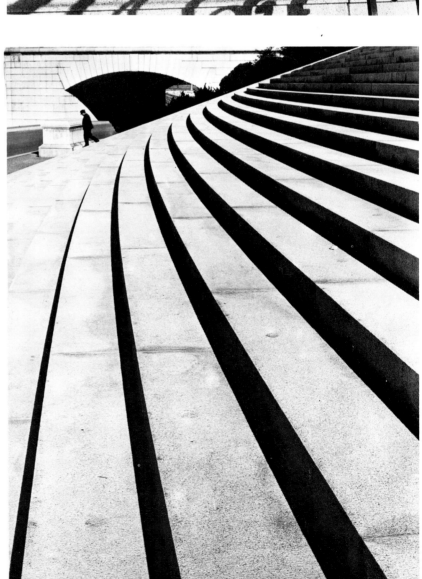

Supreme Court Building, Washington, 1935

Steps, Washington, 1935

President Franklin D. Roosevelt, Washington, 1935
(opposite) As part of an NEA assignment to document the Capital she made this stiffly formal portrait of the President in his office.

58

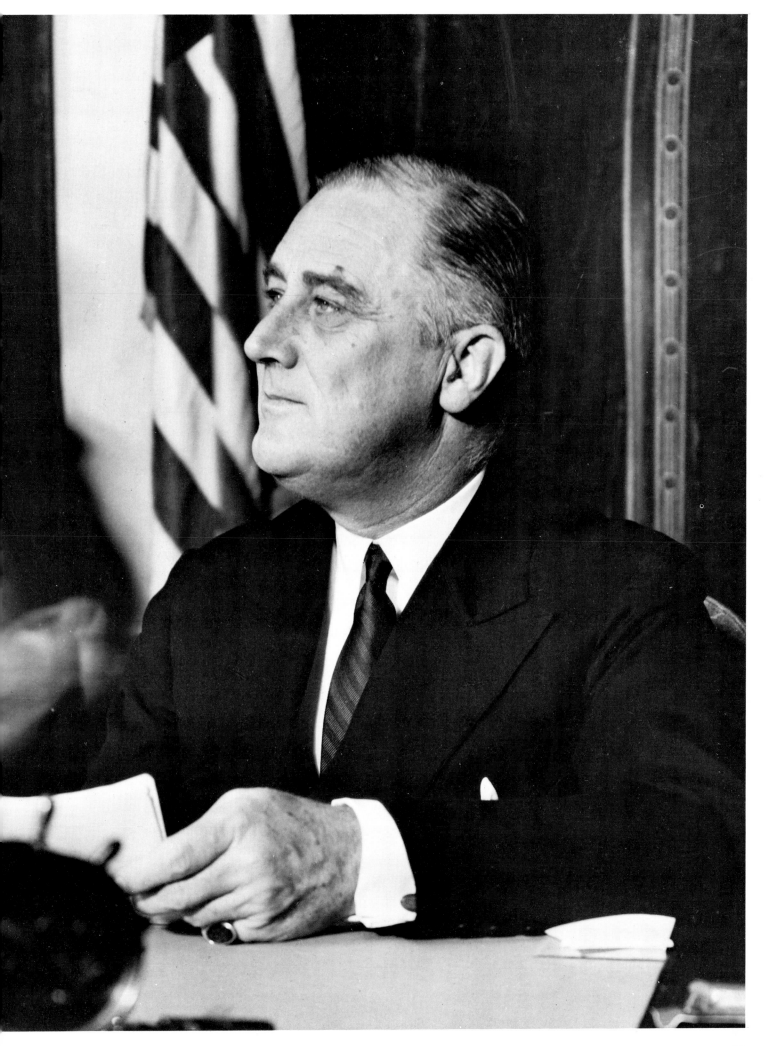

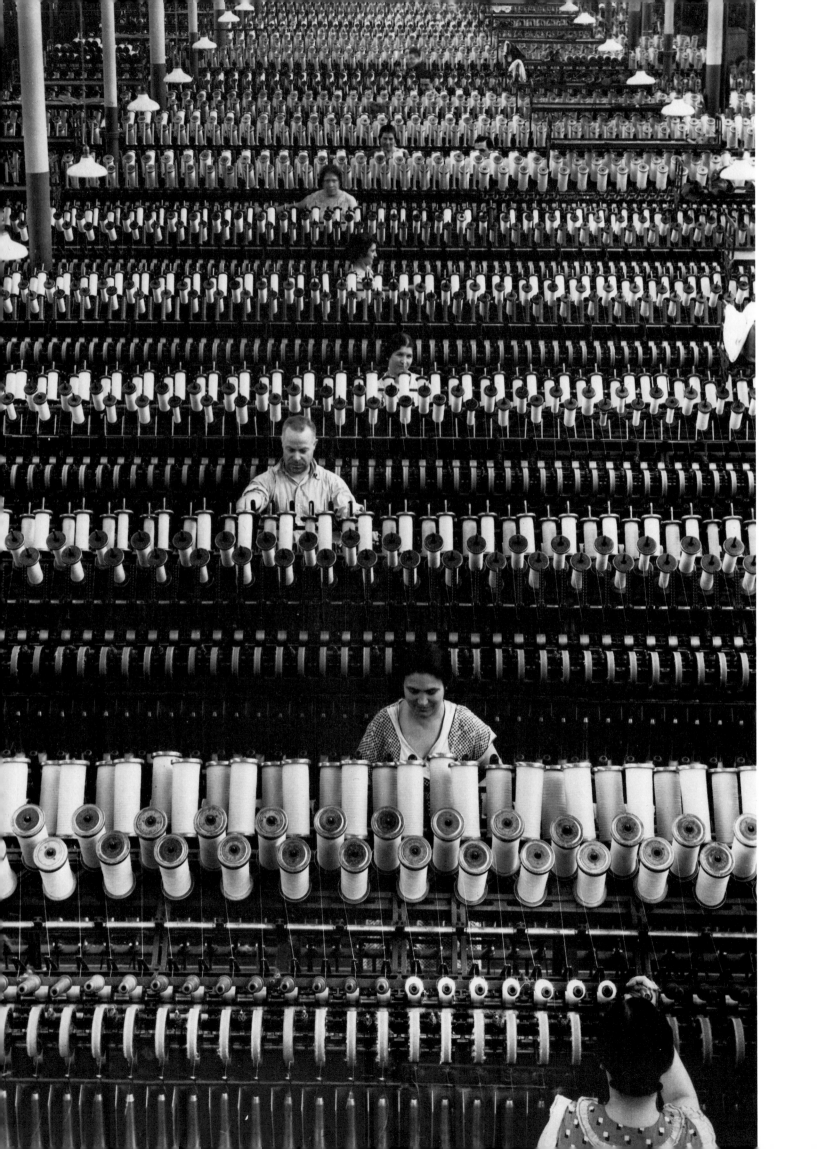

American Woolen Co.,
Lawrence, Mass. 1935

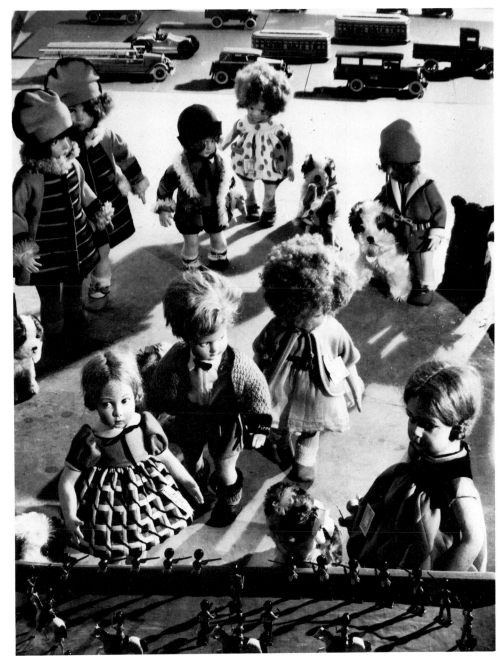

Dolls in a Store Window, 1929
Bourke-White's first advertising
assignment was for a Cleveland
department store.

Royal Typewriter, 1934

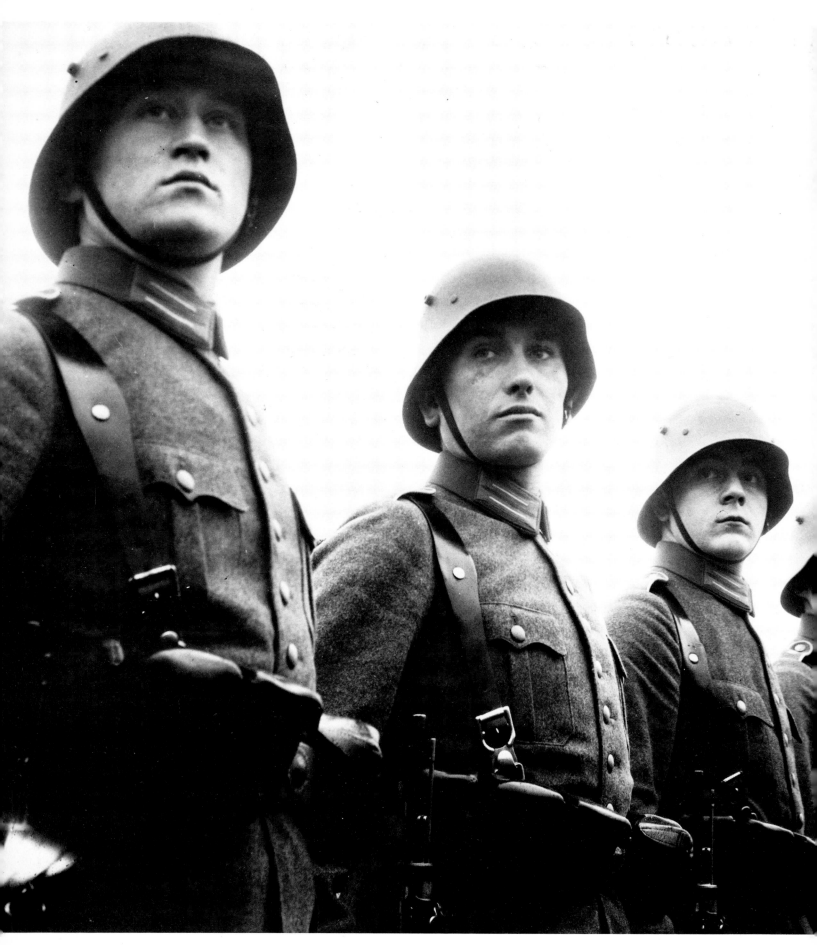

Today's Troops, Tomorrow's Officers, Germany, 1932

Gen. Hans Von Seeckt, Germany, 1932
Founder of the Reichswehr, he built up an efficient new German
army despite the restrictions of the Versailles Treaty.

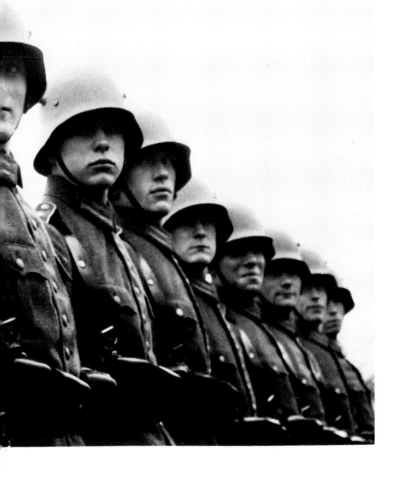

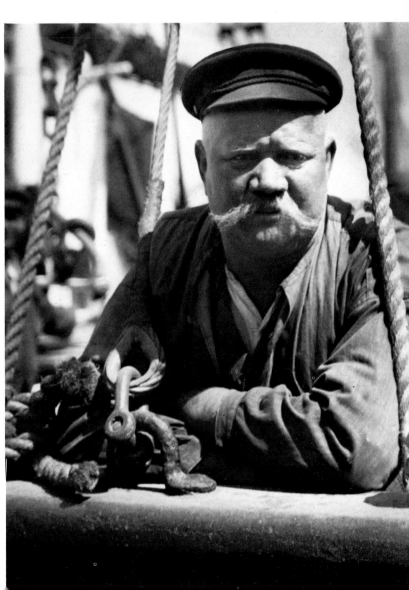

Portrait of a Sailor, Germany, 1930

Ammonia Storage Tanks, I. G. Farben, 1930
A nitrogen fixation plant in Leuna, operated by
Germany's largest chemical company.

Generator Stator, AEG, 1930
Detail showing the turbine blades for a FORTUNE
story on the new industrialized Germany.

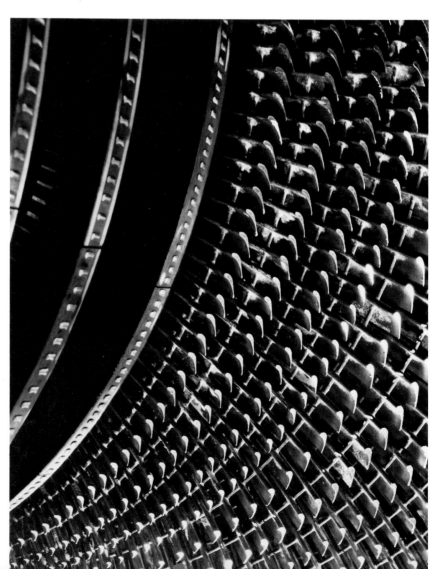

The *Bremen* at Bremerhaven, 1930
The North German Lloyd Line's cruise ship in for
refitting at her home port.

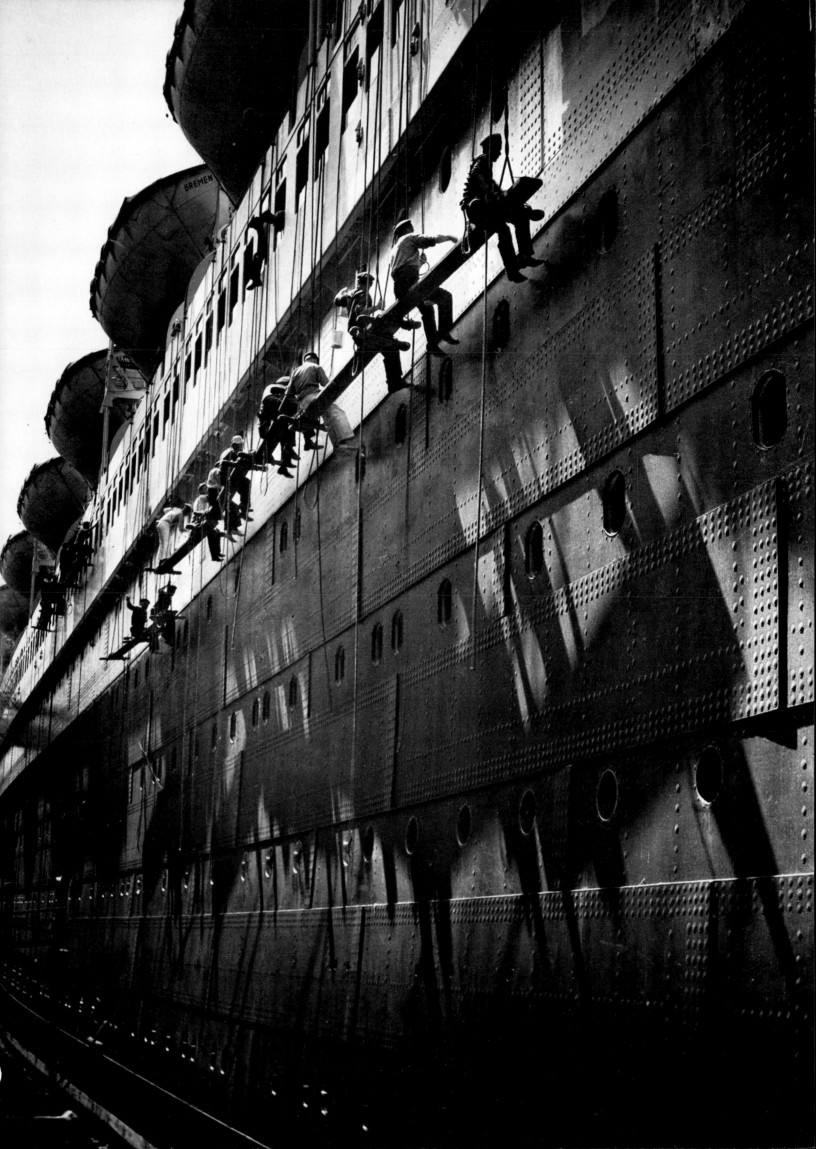

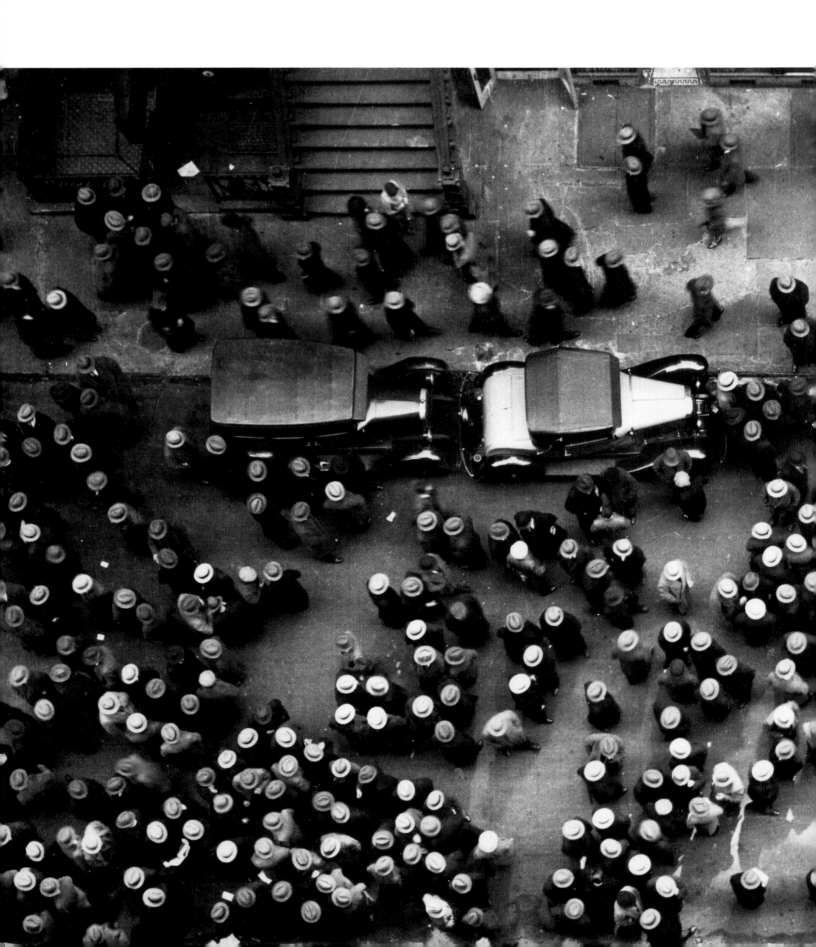

Garment District, New York, 1930
Fortune called this stretch of West 36th Street the
"Play Street" where jabbering, gesticulating men
haggled over prices and swapped rumors.

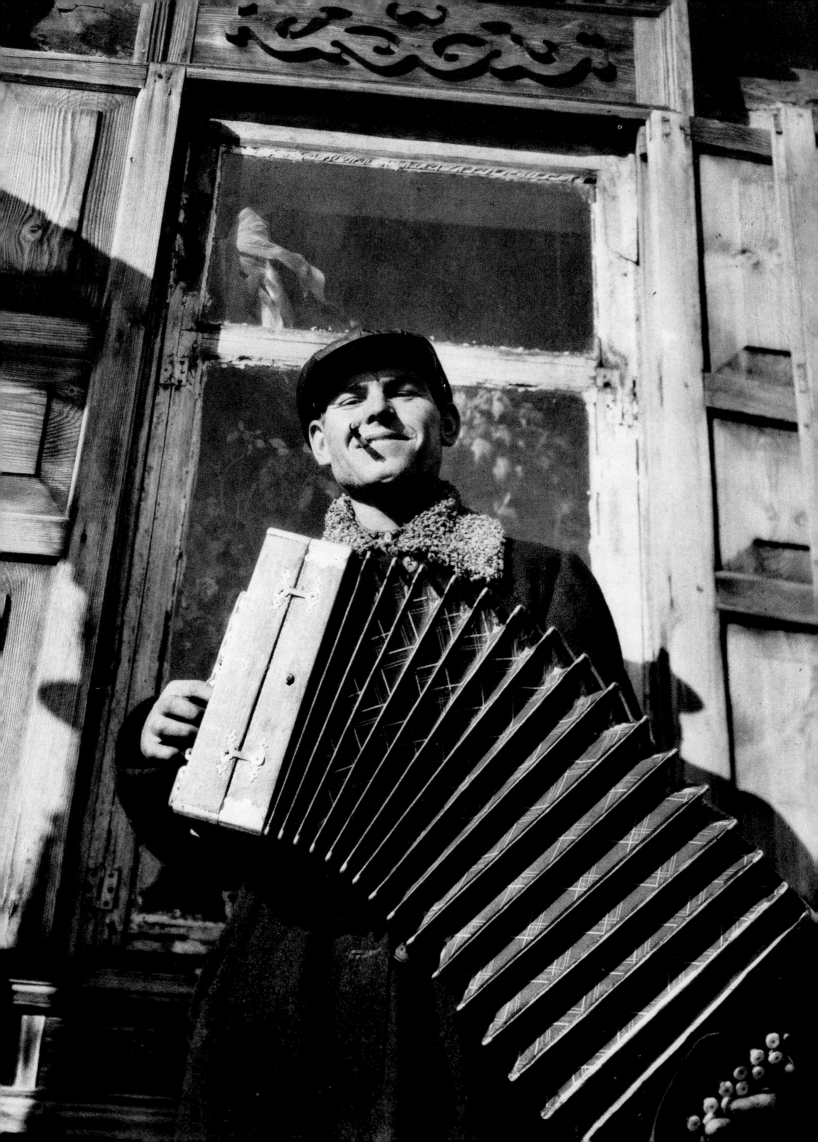

Soviet Russia
1930,1931,1932

After the Revolution the Soviet Union was all but closed to the West as Russia roiled in sweeping reforms. Russia in 1930 was a tantalizing mystery, particularly to those who revered the machine esthetic, for here was a nation of 150 million marshalled by its government into the celebration of Modernism.

"Nothing attracts me so much as a closed door," Bourke-White wrote in 1963. "I cannot let my camera rest until I have pried it open, and I wanted to be first. With my enthusiasm for the machine as an object of beauty, I felt the story of a nation trying to industrialize almost overnight was just cut out for me." FORTUNE's editors were skeptical of her chances of getting into Russia but were sending her to photograph the new German industries. She decided to go there on her own and Germany would be a good jumping-off point. Six frustrating weeks were spent in Berlin waiting for her visa to clear through the stifling Soviet bureaucracy. When it finally arrived she quickly packed her bulky view cameras in a trunk, loaded another with sausages and canned goods because of the reported near-famine conditions outside the cities, and hopped the Trans-Siberian Railway. Moscow was a quagmire of red tape. Commissars, bureaucrats, army generals, all had to grant her permission. Fortunately her portfolio of American industrial pictures impressed someone enough to write a permit that required the entire Soviet citizenry to help her with her work. Over the next five weeks she made a 5,000-mile whirlwind tour of Russian dams, factories, farms and workers, and was accorded celebrity status wherever she went. One night in Moscow she and her interpreter slipped off to a party at a student's apartment. Word spread fast that there was an American girl present. Soon a stag line formed outside in the hall, everyone waiting to dance with the Americanka. Later, sitting on the floor drinking thimblefuls of vodka, she held court to an admiring circle of men and nodded politely to their animated conversations in Russian. The next morning she learned that five men had proposed and she had accepted each one. One suitor had already gone out and divorced his wife.

She addressed a group of Soviet editors and photographers about her ideas on photography. Although emphasizing the power and beauty of industrial subjects, she advocated a hard-edged realism that mirrored the philosophy of Edward Weston and the f.64 group. Afterwards, she was bombarded with questions for hours, and even her interpreter was grilled on how Bourke-White operated in the factories. "When she works," said the interpreter, "she is the lightning."

"What does she do evenings? Does she have any admirers?"

"Miss Bourke-White loves nothing but her camera." But she loved Russia enough to return the next year to do six feature articles for the *New York Times* and the following year to make an educational film for Kodak. Nearly 3,000 negatives came out of the Russian trips, the first complete documentary of the newly emerging Soviet Russia—which still stands as one of the best.

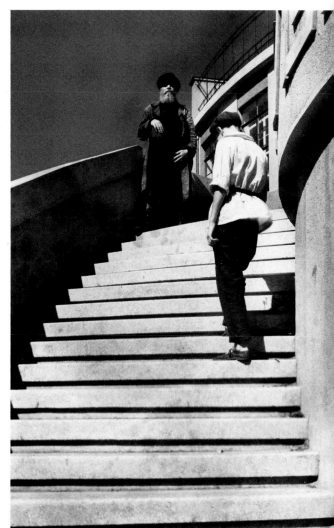

A Workers' Club in Moscow, 1930

Soviet Serenade, 1931

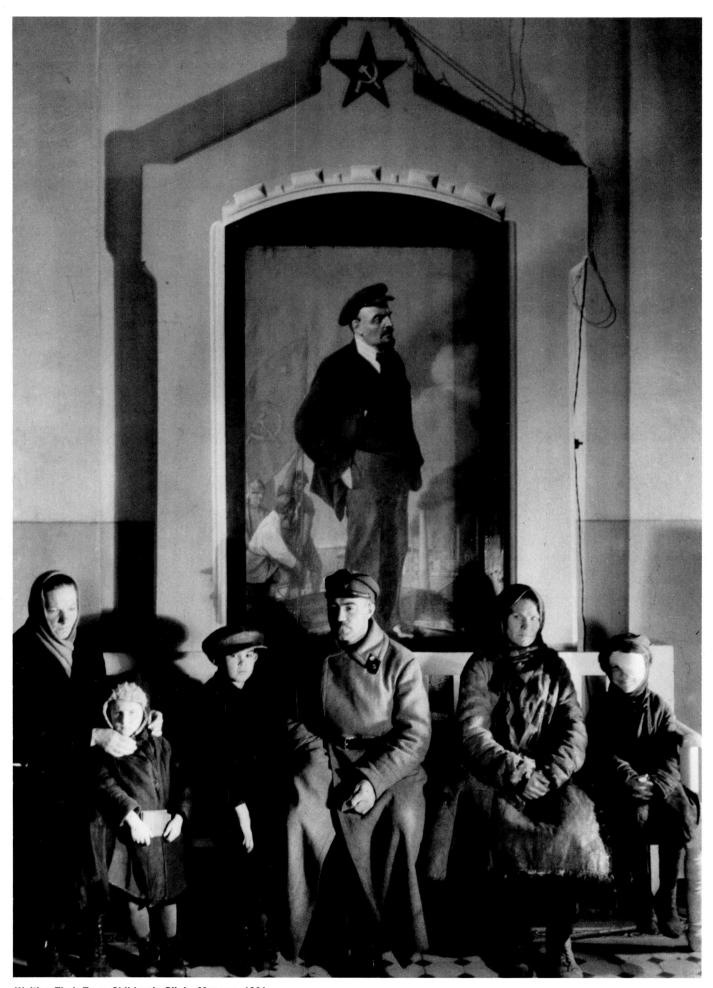

Waiting Their Turn; Children's Clinic, Moscow, 1931

The Steppe, Ukraine, 1930

The Kremlin, Moscow, 1931

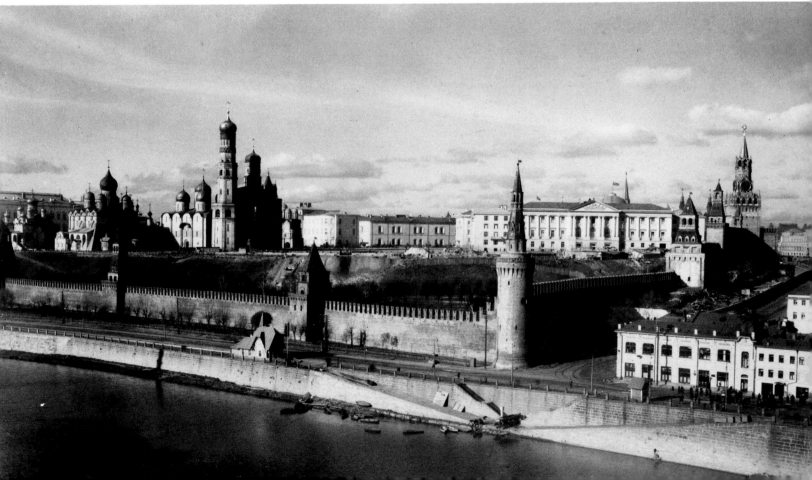

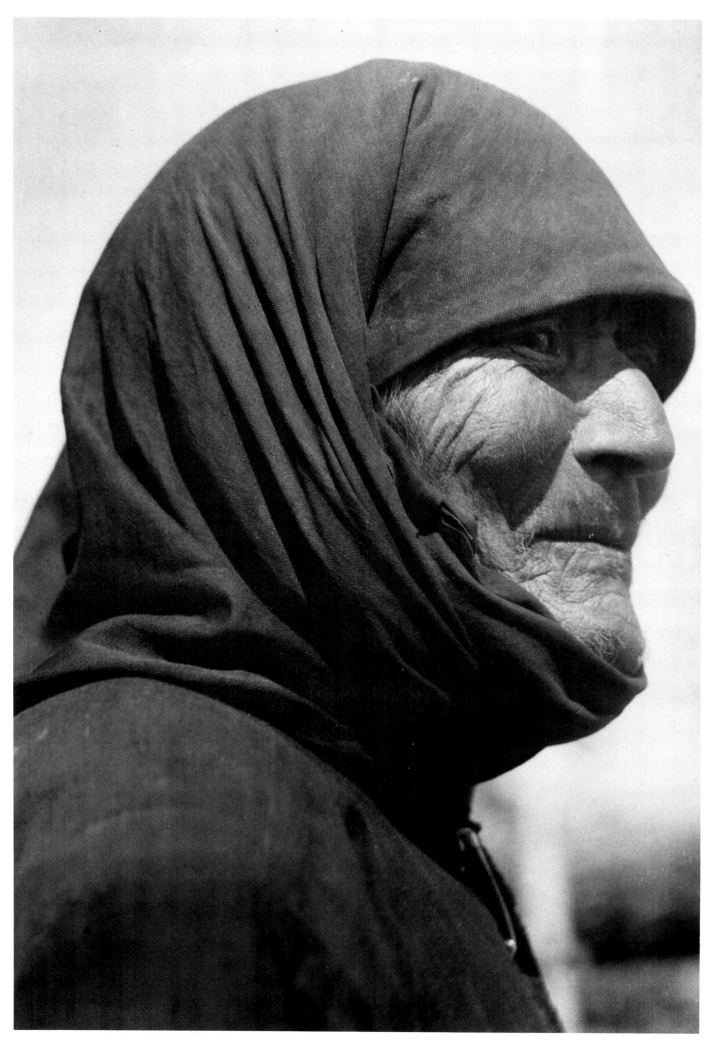

Stalin's Great-Aunt, Didi-Lilo, 1932

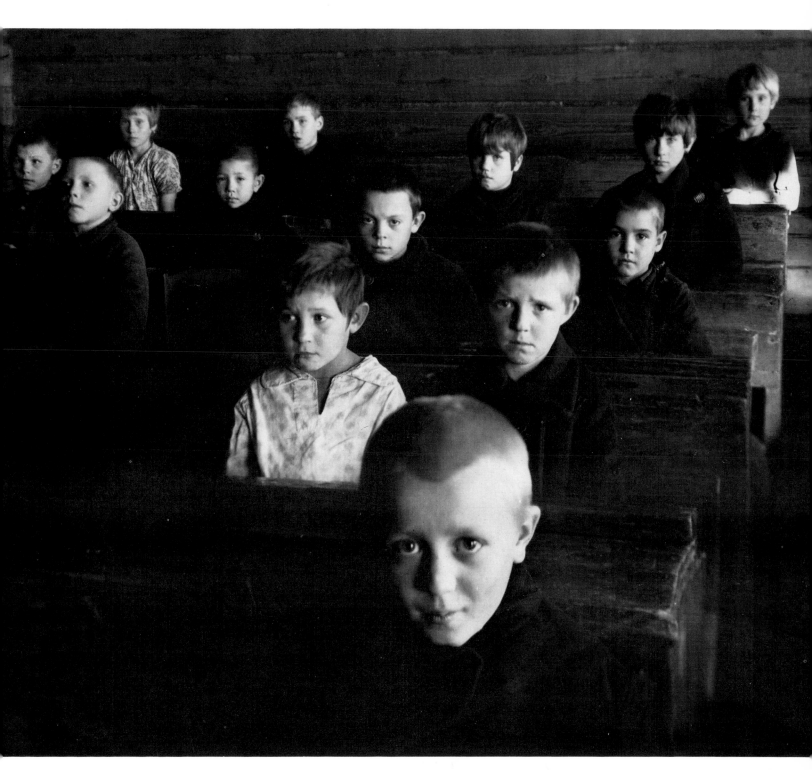

Village School, Kolomna, Volga Region, 1932

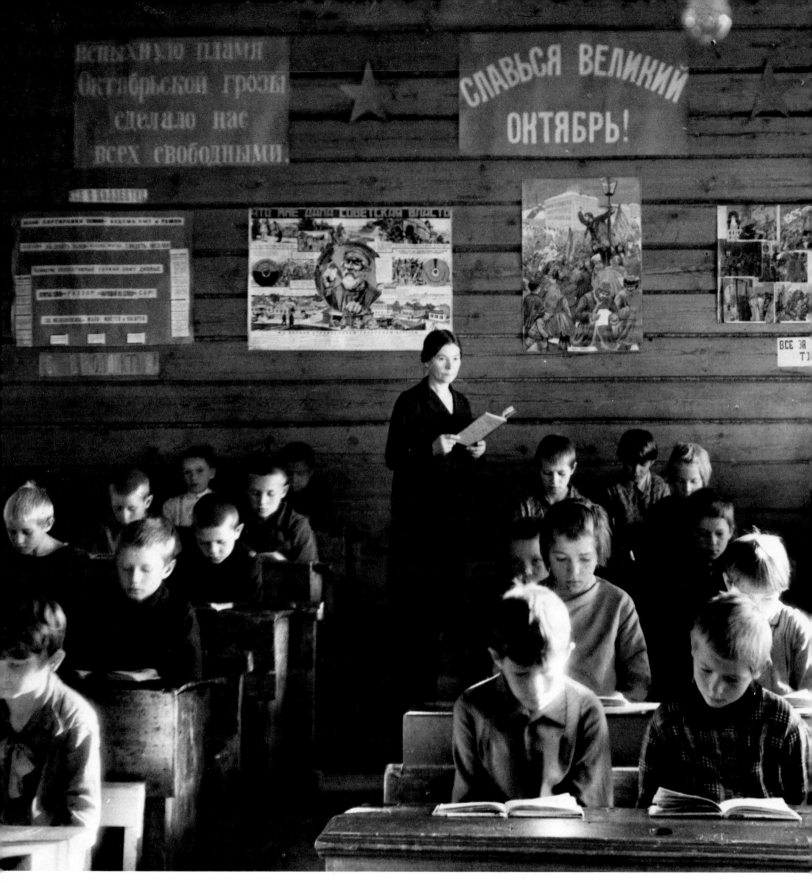

Soviet Schoolroom, 1931

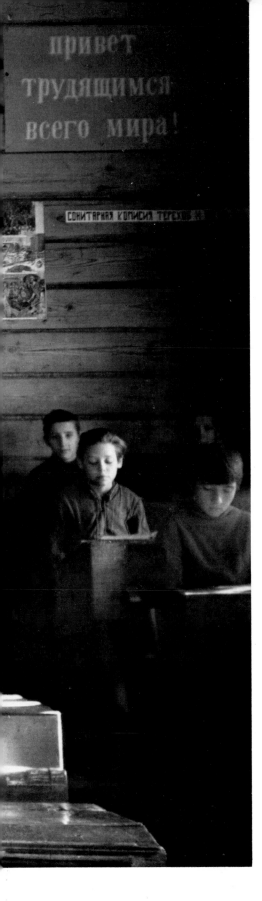

Nursery in Auto Plant, Moscow, 1931

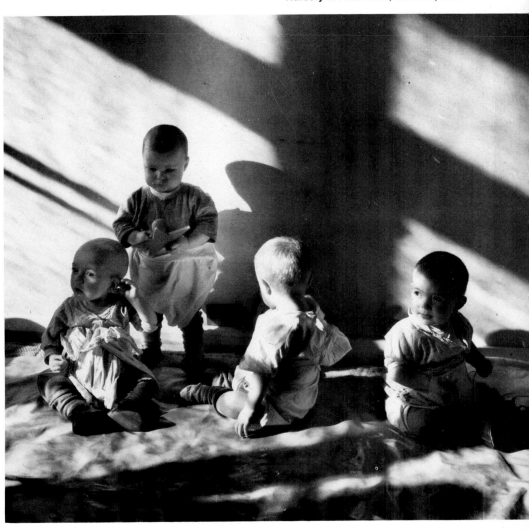

A Foreman, Tractorstroi, 1930

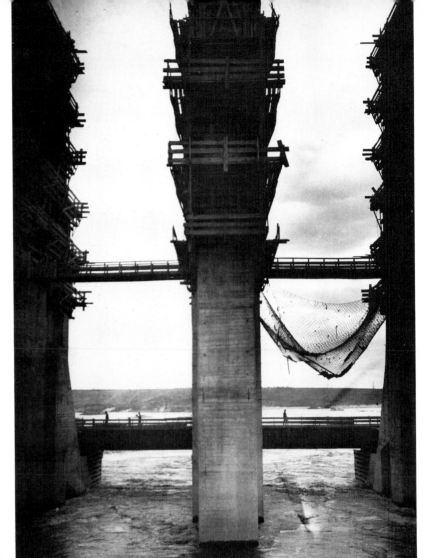

World's Largest Dam, Dnieperstroi, 1930

World's Largest Blast Furnace, Magnitogorsk, 1931

A Priest, 1931 (opposite).

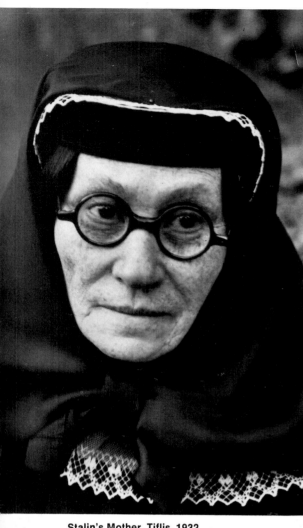

Stalin's Mother, Tiflis, 1932

Tovarisch Mikhail, A Bricklayer, 1931

Semionova, Premiere Ballerina

Great Theater, Moscow, 1931

Chain Belt Movement

Machine Dance, Moscow Ballet School, 1931

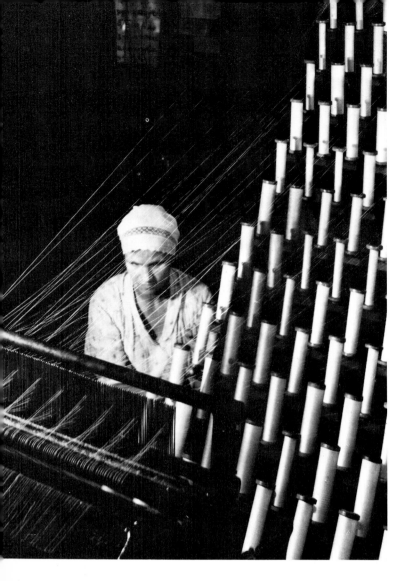

Textile Mill, Moscow, 1930

In the Quarry, Novorossisk, 1930

Women Loading Crushed Rock, Novorossisk, 1930

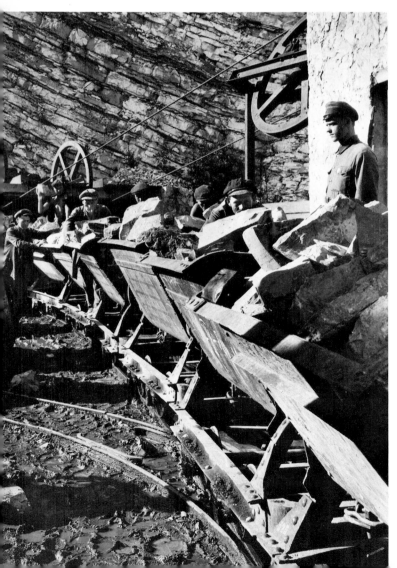

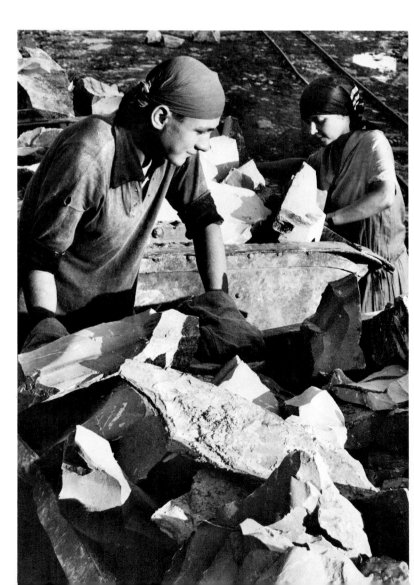

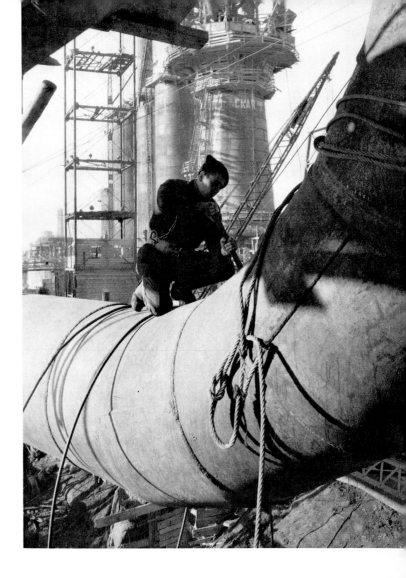

Steel Worker, Magnitogorsk, 1931
A Generator Shell, Dnieperstroi, 1930
Inspecting the Lace, Moscow, 1930

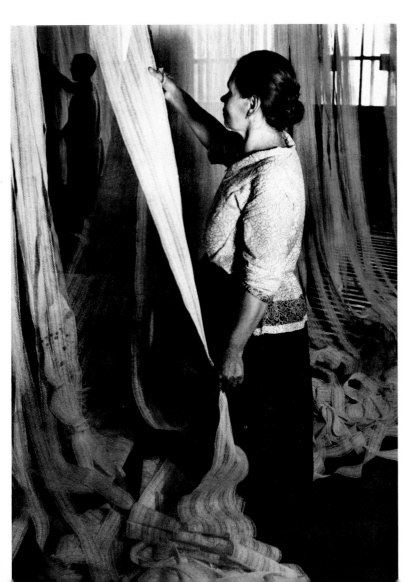

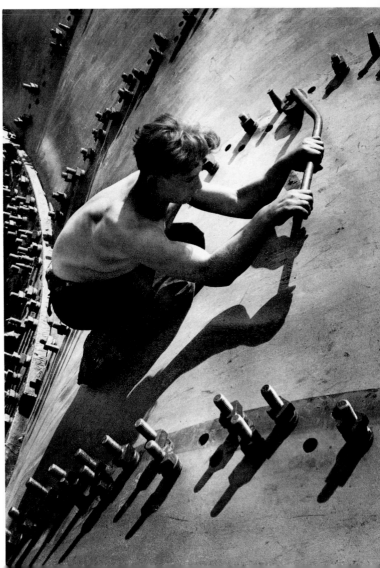

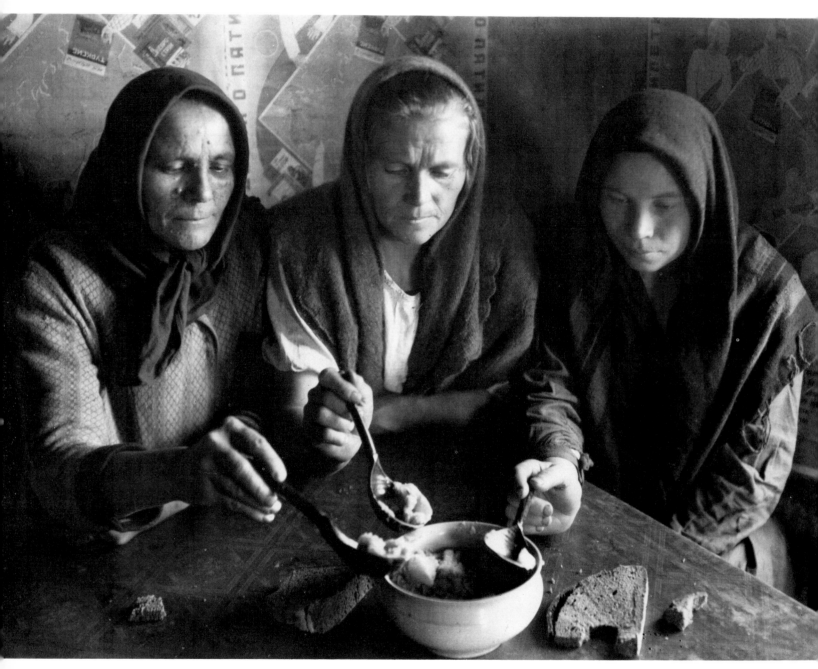

Borscht, Georgia, 1932

Iron Puddler, Stalingrad, 1930

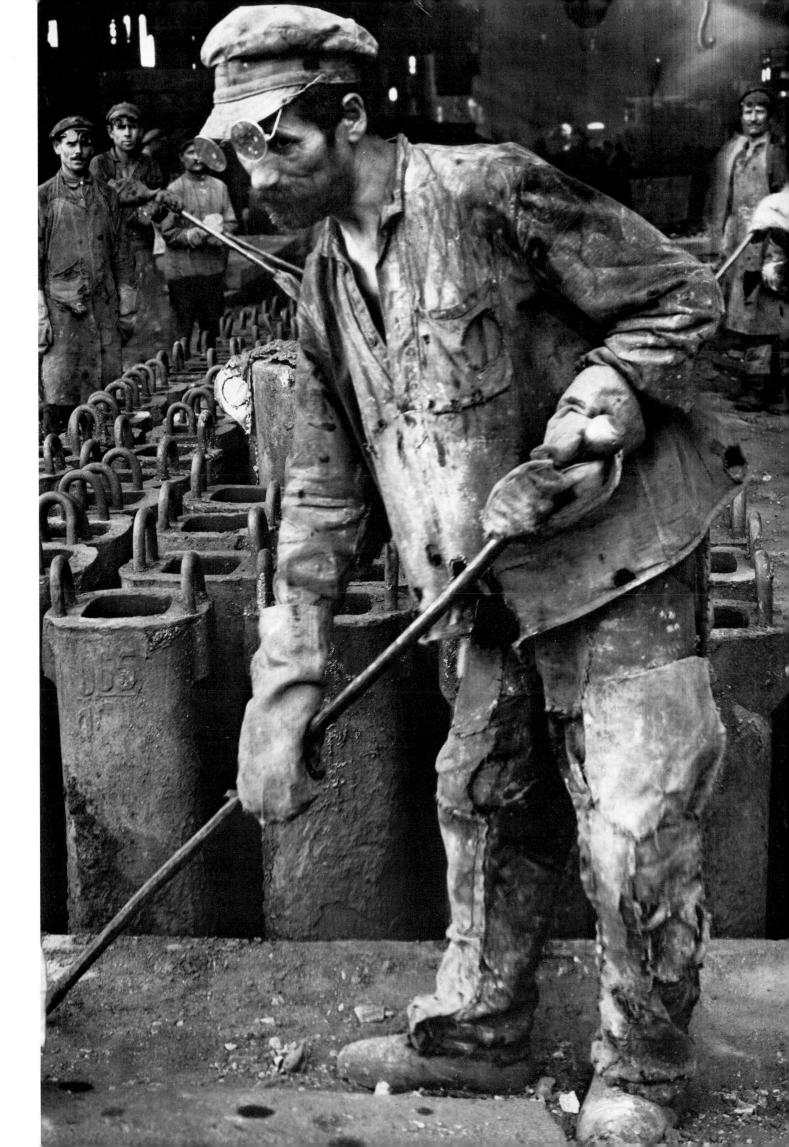

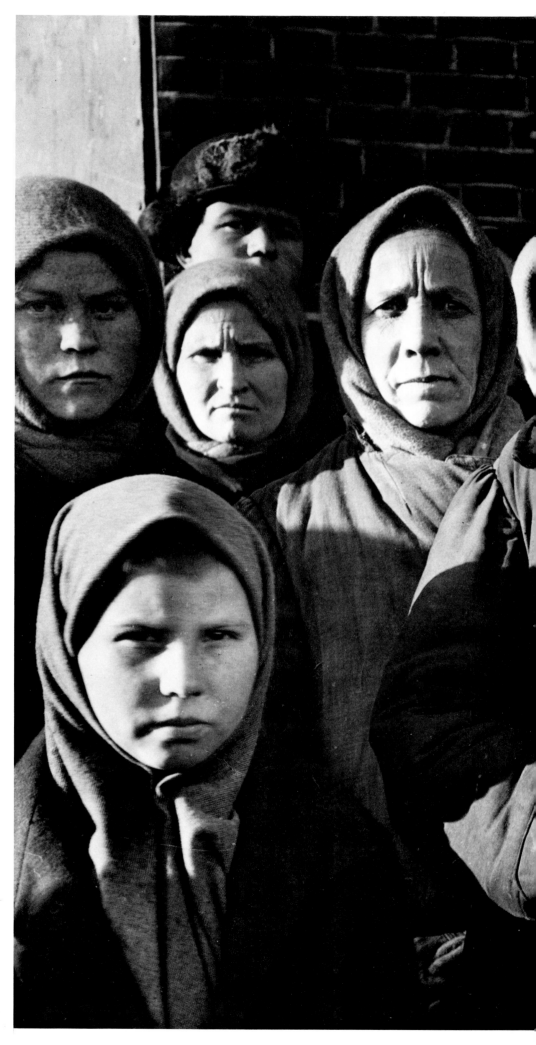

Woman with Meat, Magnetnaya, 1931

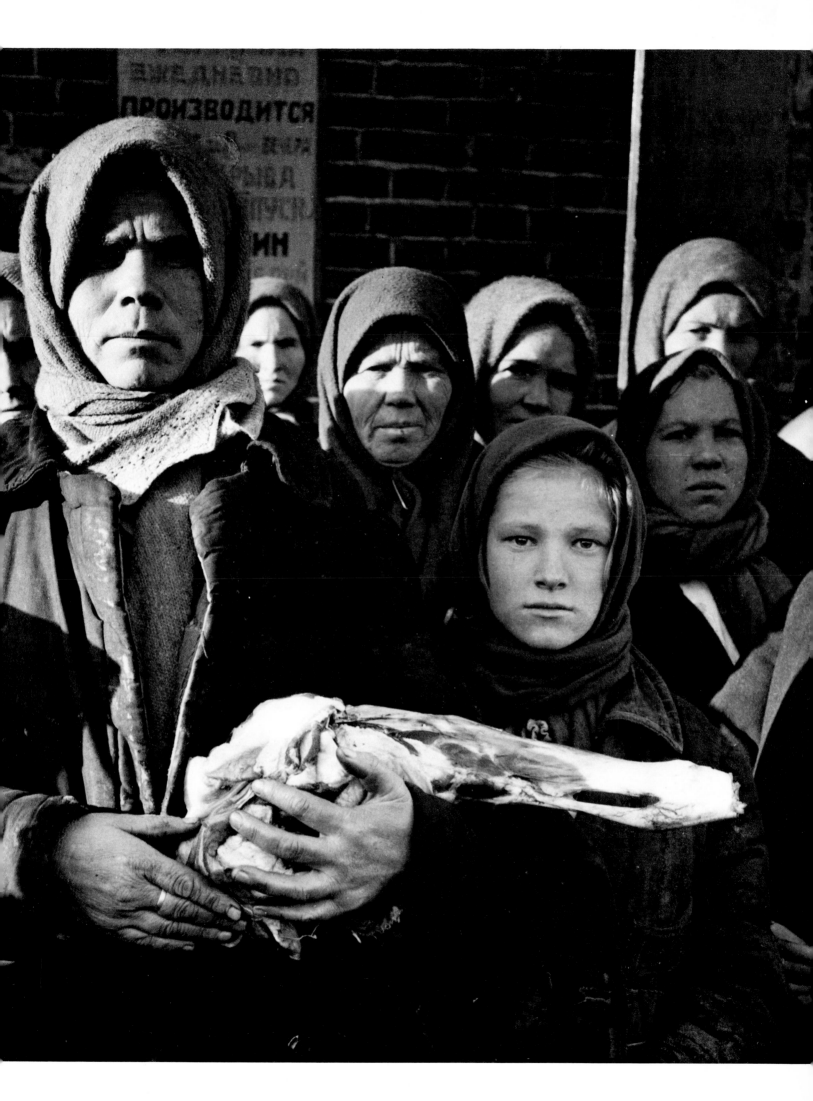

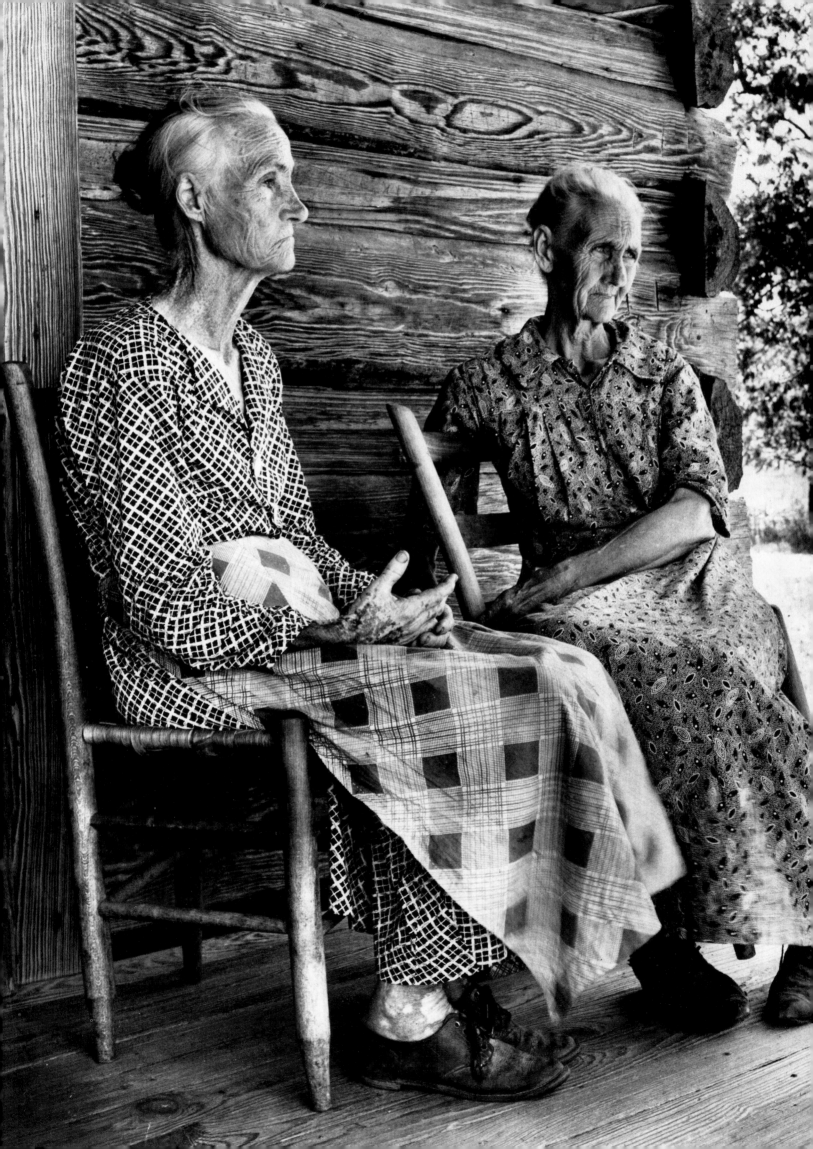

"You Have Seen Their Faces"

1936

You Have Seen Their Faces laid bare the insidious strangle-hold that the sharecropping system had on the lives of ten million Southern farmers. Sharecropping evolved when the plantations closed down as the thin soil gave out. Owners chopped up the estates into small one-family farms that were rented out against a share, usually one half, of the cotton crop. This proved more lucrative than slavery, as the absentee landlord was not responsible for the welfare of his tenants. They took all the risks—frost, drought, boll weevil and blight—yet still had to make the "rent cotton." Families, sometimes succeeding generations, became hopelessly indebted.

Erskine Caldwell wanted to do a non-fiction book with photographs on the sharecropping system to counter criticism of *Tobacco Road,* his novel and stage play about sharecroppers. Many had felt that the picture of Southern life he presented was overdrawn. At about the same time, Bourke-White was growing increasingly frustrated and bored photographing tires, garden tools, and corporate chief executives. Hearing of Caldwell's plan, she arranged for an introduction.

When they met, she was surprised that Caldwell bore no resemblance to the lusty characters in his stories. He seemed painfully shy as he described, without apparent enthusiasm, the outline of the book. His agent had previously told her that Caldwell did not like the idea of working with a woman and liked her pictures little more. She repeatedly stressed how important the book project was to her, all the while thinking that she was failing to impress him, Then, inexplicably, he suggested that they set a date to begin—June 11, 1936—nearly six months off. As the date approached, Bourke-White found that she needed more time in New York so she phoned Caldwell, who was staying at his father's farm near Atlanta, and requested a week's delay. Her call met with stony silence, suggesting that they might not begin at all. In a panic she finished her business and flew to Atlanta. She checked into a hotel in the early morning and promptly wrote Caldwell a contrite letter explaining her tardiness and promising that they could now work uninterruptedly. She paid a boy five dollars to deliver it and spent the rest of the day in the lobby, eyes riveted to the telephone switchboard. At six that evening a large figure in a loose blue jacket ambled in. "His face was flushed with shyness," she wrote in her autobiography. "We went into the coffee shop and ordered hot coffee. While we waited to be served, Erskine Caldwell looked quietly down at his hands. We drank our coffee in wordless communication. When the last drop was drained, Erskine turned to me and smiled. 'That was a big argument, wasn't it?'

I nodded.

'When do you want to leave?'

'Now.' "

After piling her gear into the back of his Ford coupe, they were off. Along the way they fell in love. They also produced a pioneering photo-documentary about social injustice.

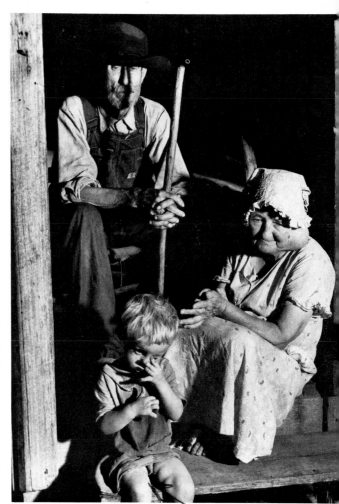

Sweetfern, Arkansas
"Poor people get passed by."

Lansdale, Arkansas (left)
"There comes a time when there's nothing to do except just sit." In a disclaimer at the front of the original edition of *You Have Seen Their Faces,* the authors explained that "the legends under the pictures are intended to express the authors' own conceptions of the sentiments of the individuals portrayed; they do not pretend to reproduce the actual sentiments of these persons."

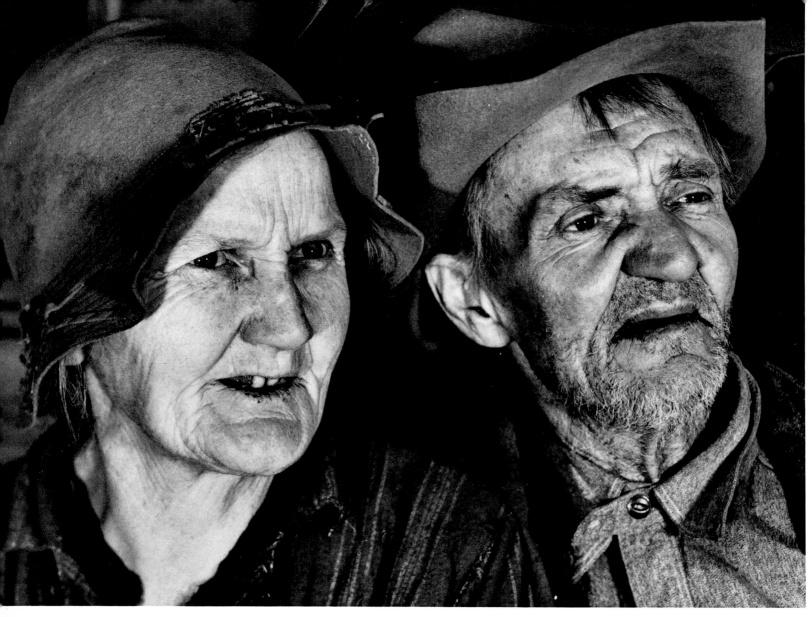

Yazoo City, Mississippi

"I think it's only that the government ought to be
run with people like us in mind."

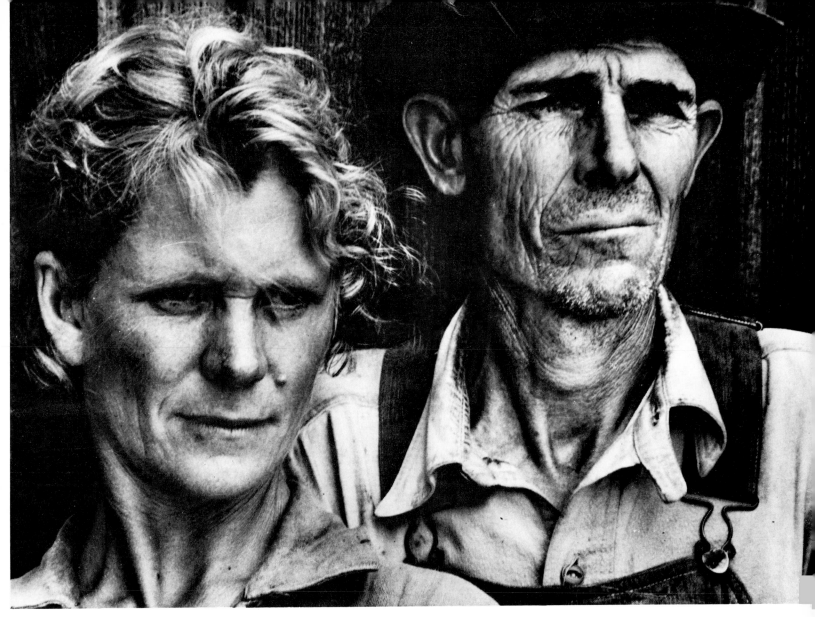

Maiden Lane, Georgia

"A man learns not to expect much after he's farmed cotton most of his life."

Locket, Georgia

"I've done the best I knew how all my life, but it didn't amount to much in the end."

93

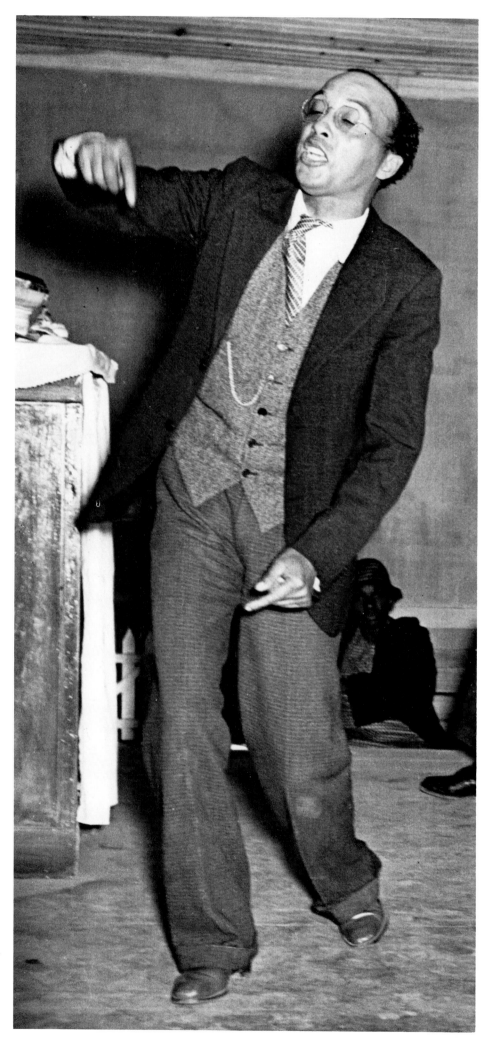

College Grove, Tennessee
"Hurry folks, hurry! Getting religion is like putting money in the bank...."

"...We've got a first class God."

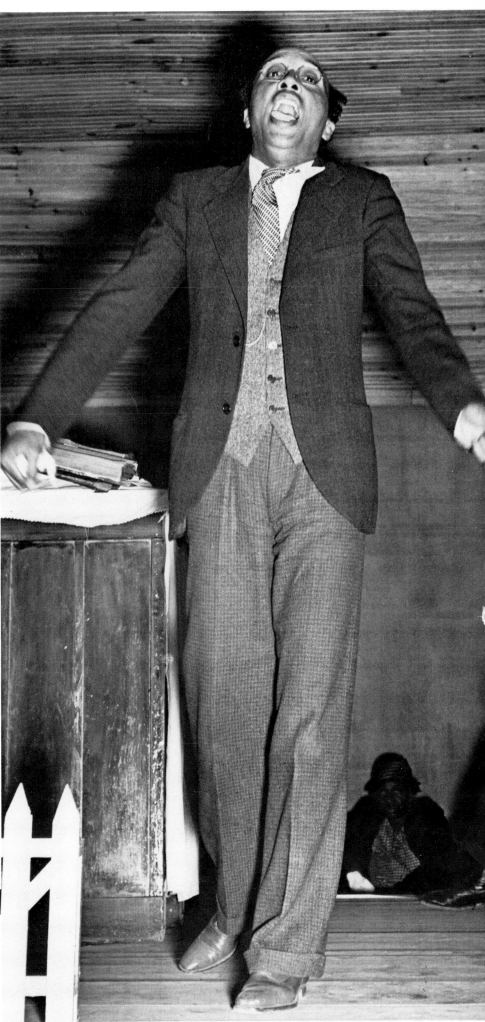

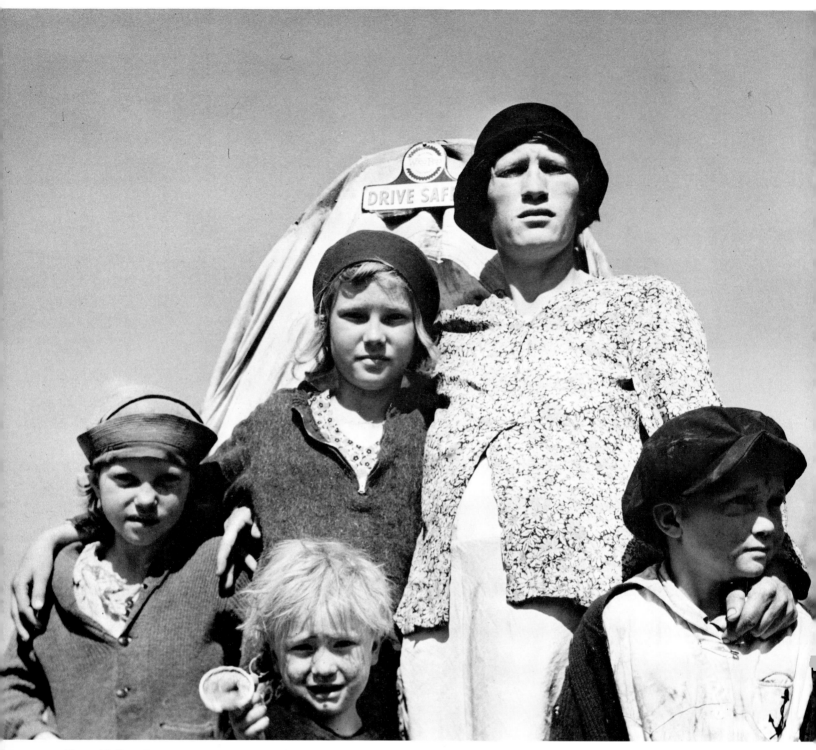

Ringgold, Georgia

"Those poor people walking all the way from Florida looking for a job, and hungry every step. It's a shame they have to walk so far, but they've got to go somewhere—they can't stay here."

Okefenokee Swamp, Georgia

"Every month the relief office gives them four cans of beef, a can of dried peas, and five dollars, and the old lady generally spends a dollar and a half of it for snuff."

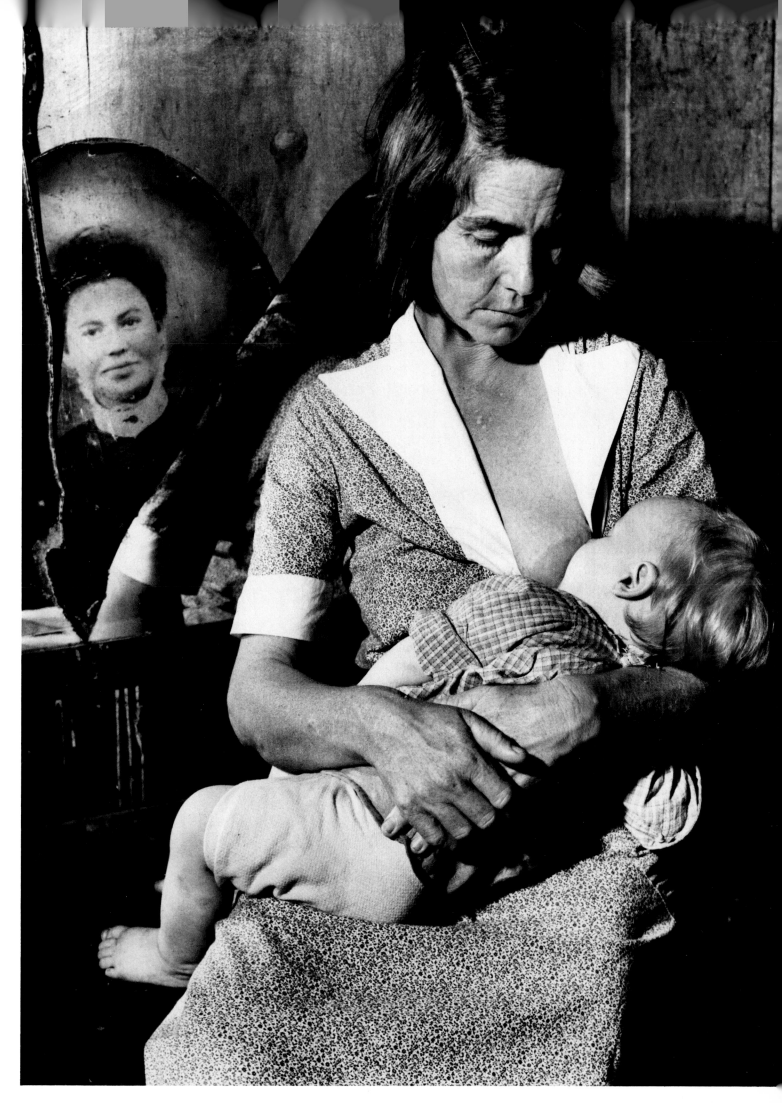

Rose Bud, Arkansas

"I remember when that automobile was a mighty
pretty thing to ride around in."

East Feliciana Parish, Louisiana

"Blackie ain't good for nothing, he's just an old
hound dog."

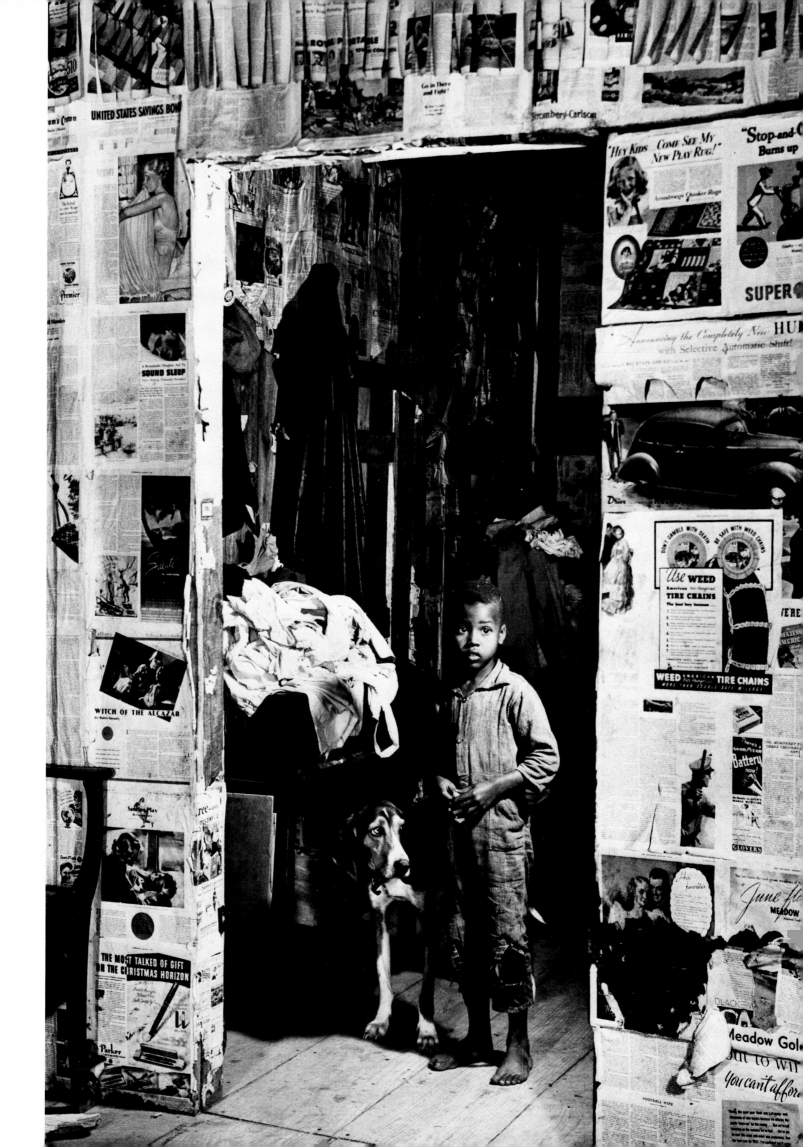

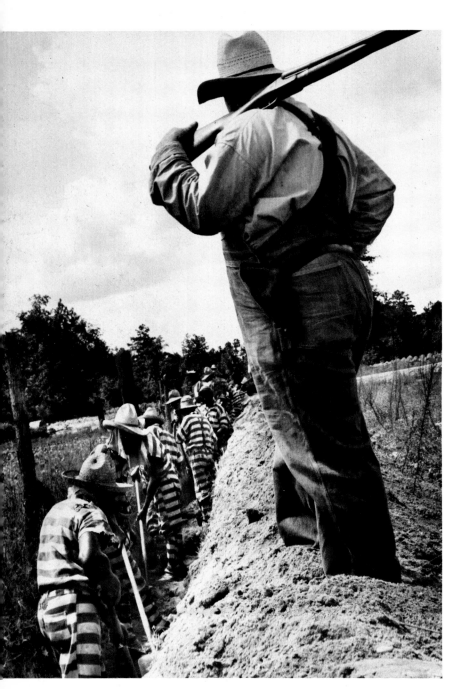

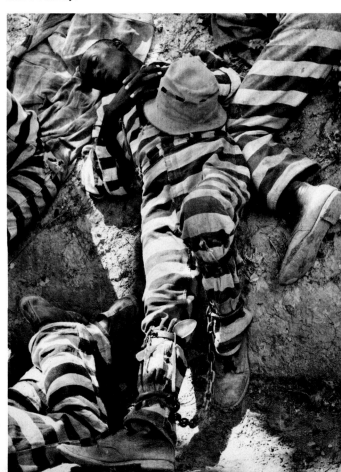

Hood's Chapel, Georgia

"They can whip my hide and shackle my bones, but they can't touch what I think in my head."

Hood's Chapel, Georgia

"I reckon i was naturally born a black boy in a white man's country."

Hood's Chapel, Georgia

"The gang goes out in the morning and the gang comes back at night, and in the meanwhile a lot of sweat is shed."

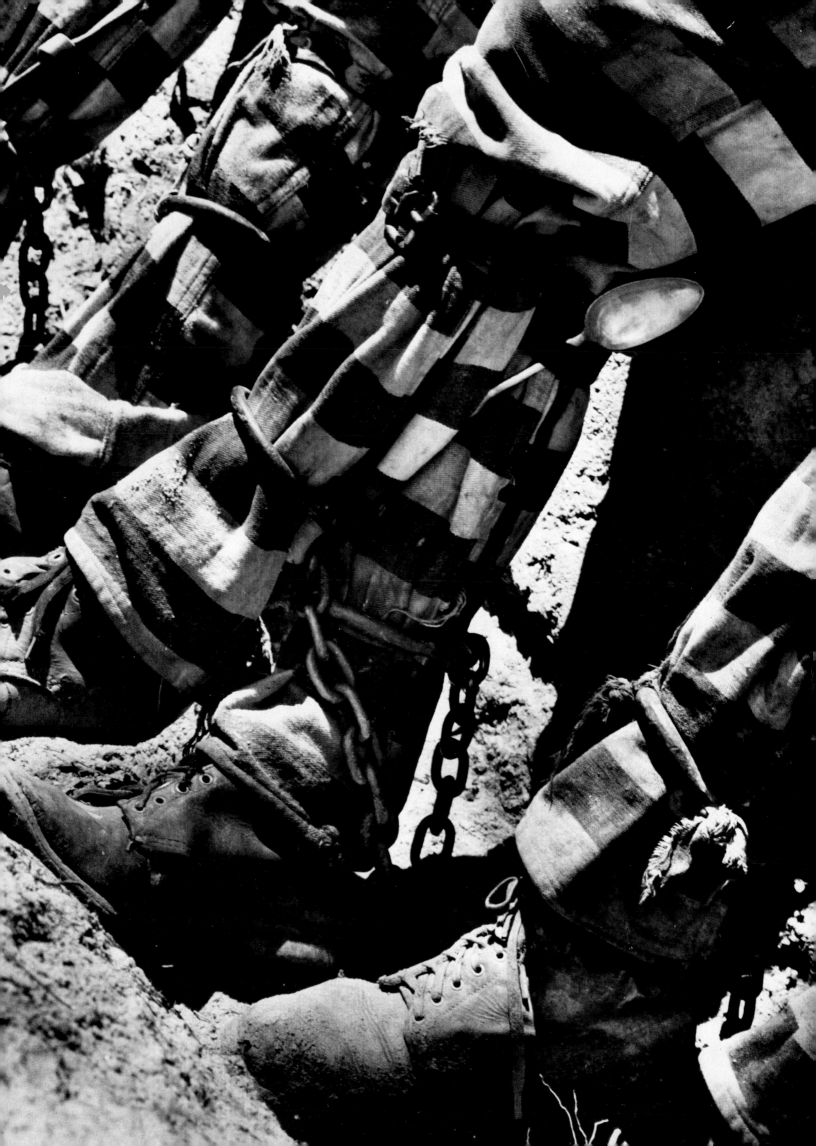

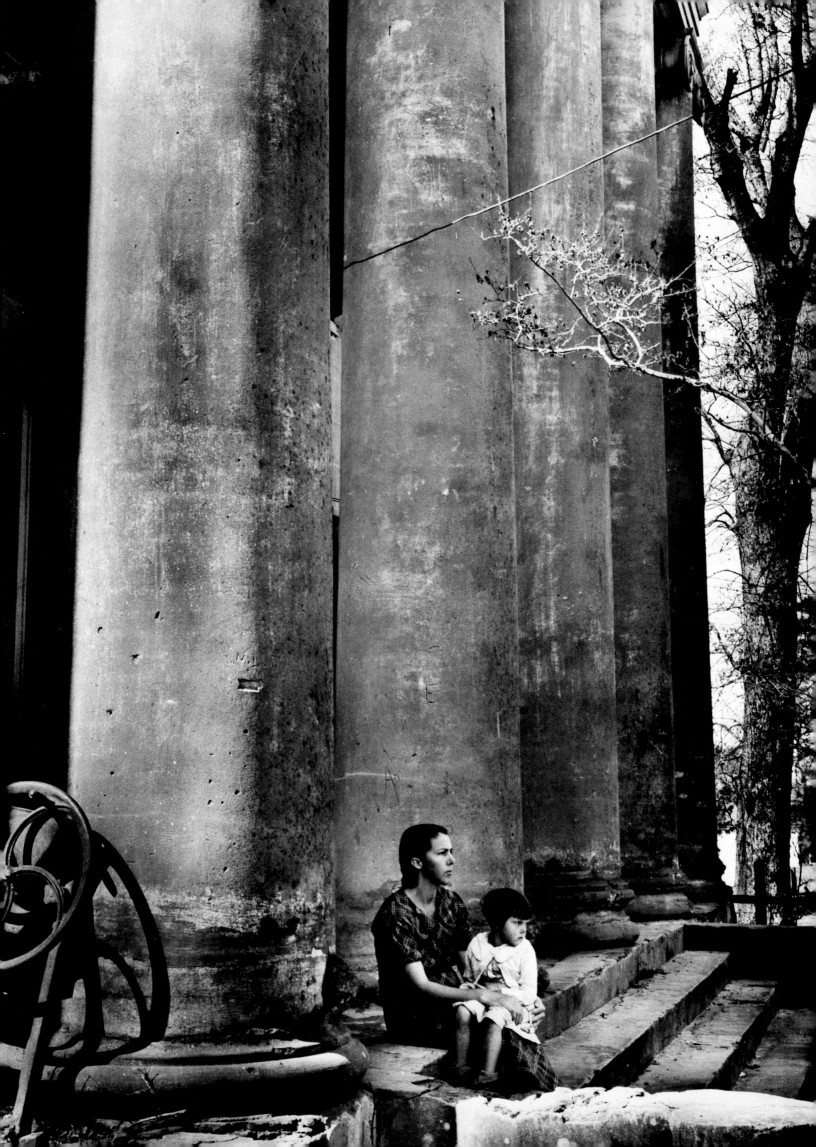

Clinton, Louisiana

"I don't know what ever happened to the family that
built this house before the War. A lot of families
live here now. My husband and me moved in and get
two rooms for five dollars a month."

Statesboro, Georgia

"The auction-boss talks so fast a colored man can't
hardly ever tell how much his tobacco crop sells for."

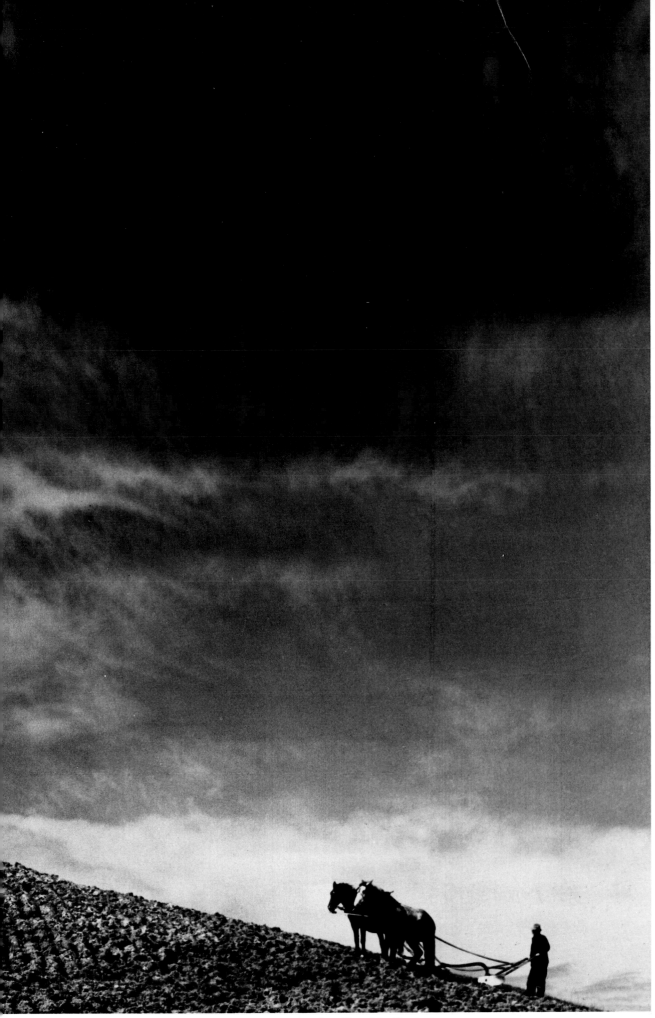

Iron Mountain, Tennessee

"There's lots of things easier to do, and pay more money, but plowing the land and harvesting the crops gives a man something that satisfies him as long as he lives."

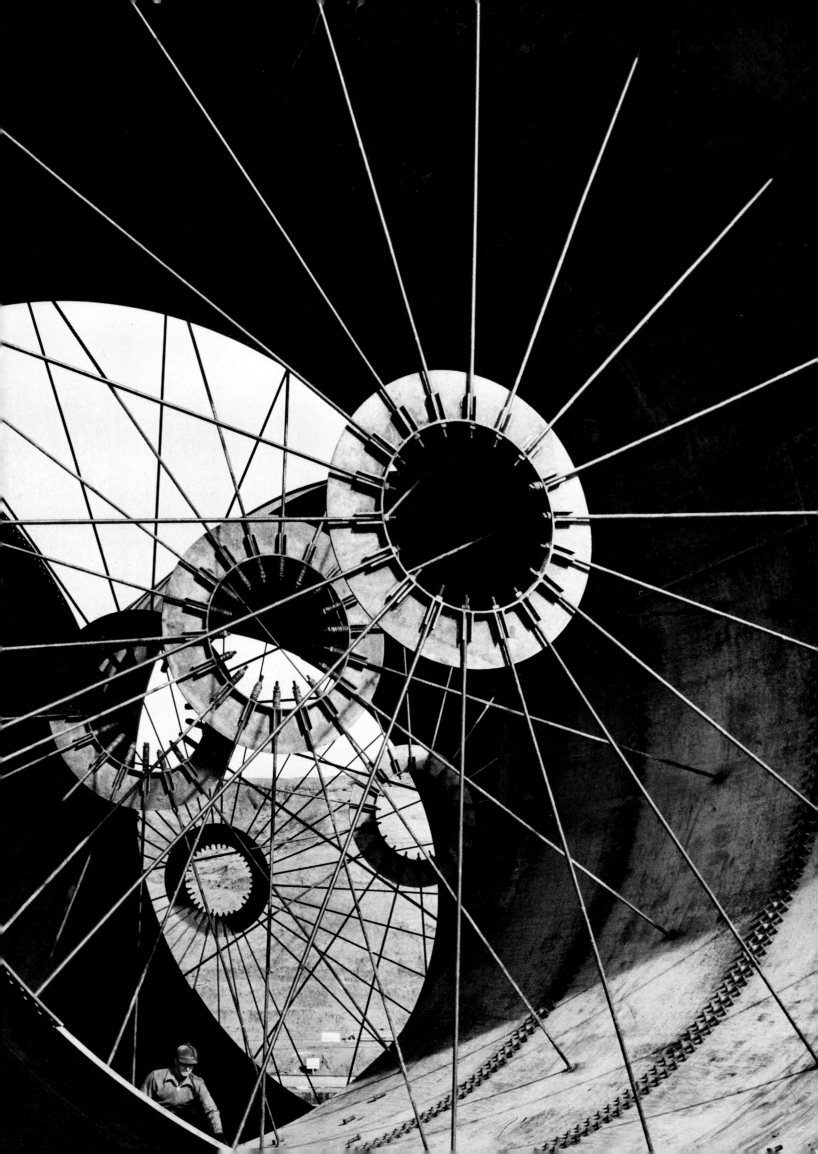

LIFE
Begins
1936-1940

Taking a cue from the successful European photo tabloids, Luce and his editors began working on a picture complement to TIME. In the spring of 1936, when Luce was toying with the idea of naming it "Dime, the Show-Book of the World," Bourke-White was asked to join and again contributed pictures to the dummy. Prior to her FORTUNE years she thought in terms of single pictures, but working for the magazine she had acquired a journalistic sense and once said, "Pictures can be beautiful, but (they) must tell facts too." Within the FORTUNE format, however, photographs, although well displayed, were subservient to text. The new magazine would depend upon the photograph to carry the story line. "I could almost feel the horizon widening and the great rush of wind sweeping in," she wrote, "This was the kind of magazine that could be anything we chose to make it . . . everything we could bring to bear would be swallowed up in every piece of work we did." The new magazine got its name at the last minute, when the venerable humor magazine "Life" was about to fold, and Luce bought it up just for the name.

Bourke-White was one of four original LIFE staff photographers but throughout her career with the magazine she maintained a fluid relationship that allowed her freedom to take time out for personal projects such as her book, *Say, Is This the U.S.A.?* (1940), with a text by Caldwell. The book was a quick collaboration of their talents utilizing Caldwell's special knack for picking up local color and Bourke-White's ability to make the commonplace dramatic. Like *North of the Danube,* a portrait of Czechoslovakia done two years before as part of a LIFE assignment, *U.S.A.* was a travelogue.

When she came to LIFE, she took four of her studio staff with her. Among them were Peggy Smith Sargent, who was the nucleus of the new magazine's picture department, eventually rising to the position of film editor, and Oscar Graubner, who started the photo lab. Bourke-White always asked Graubner to print her pictures to the edge of the negative until it left a black border—evidence that she was getting the same composition in the print that she saw on the ground glass. This dictum Graubner passed on to his technicians and even today all LIFE prints come out with the black border, guaranteeing that nobody has interposed an editorial judgment between photographer and editor. Throughout all of her LIFE assignments, and she received 284 of them up to 1957, there was rarely a time when the pictures ran cropped differently from the way she had composed them. The first cover is a notable exception, the original negative being a horizontal of a row of concrete forms diminishing in size. But at that time cover pictures and photo essays were yet to be defined.

In the fall of 1936 Luce called Bourke-White up to his office to ask if she would shoot some dramatic construction pictures of the dams being built in the Northwest as part of a New Deal relief project. She returned with them, plus a documentary on the life of the workers that demanded a different mode of presentation. It became LIFE's first essay and is reproduced in its entirety on the next ten pages.

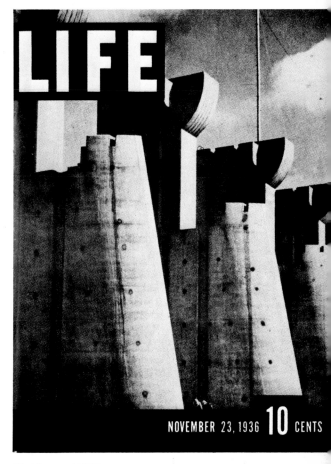

First issue of LIFE
Cover by Margaret Bourke-White

Wind Tunnel Construction (opposite)
Ft. Peck Dam, Montana, 1936

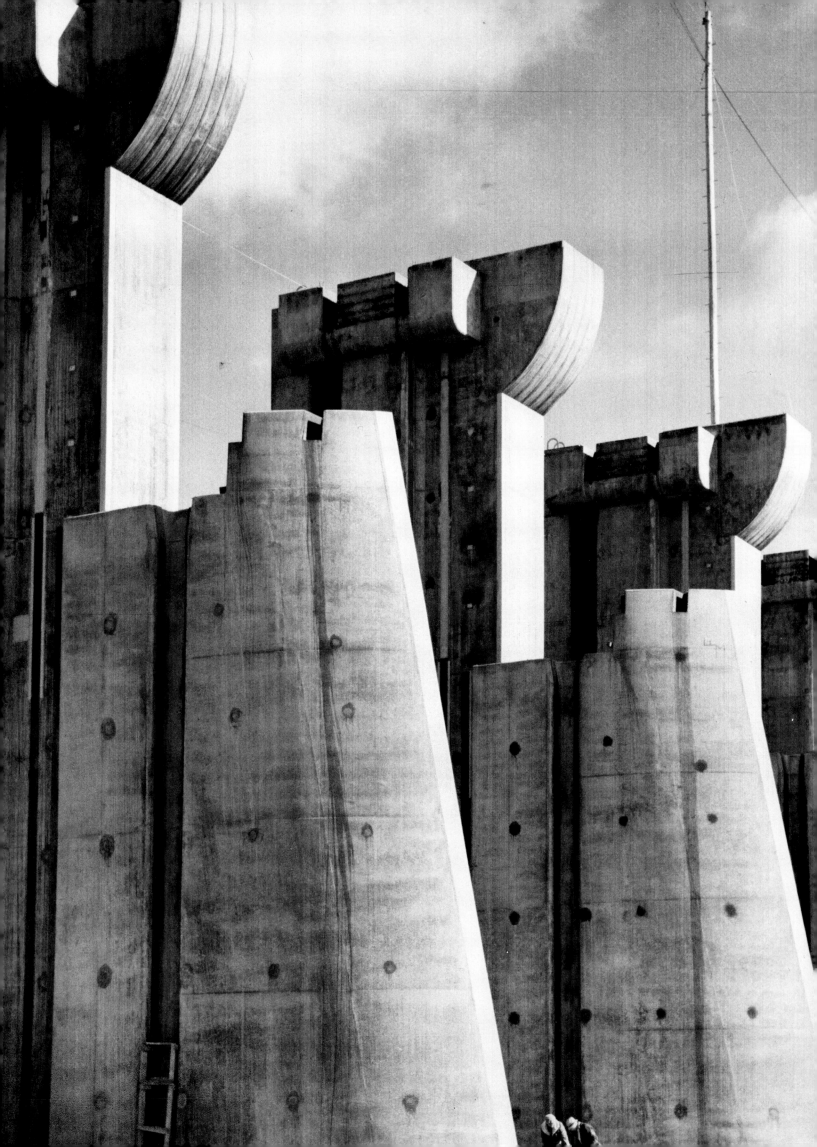

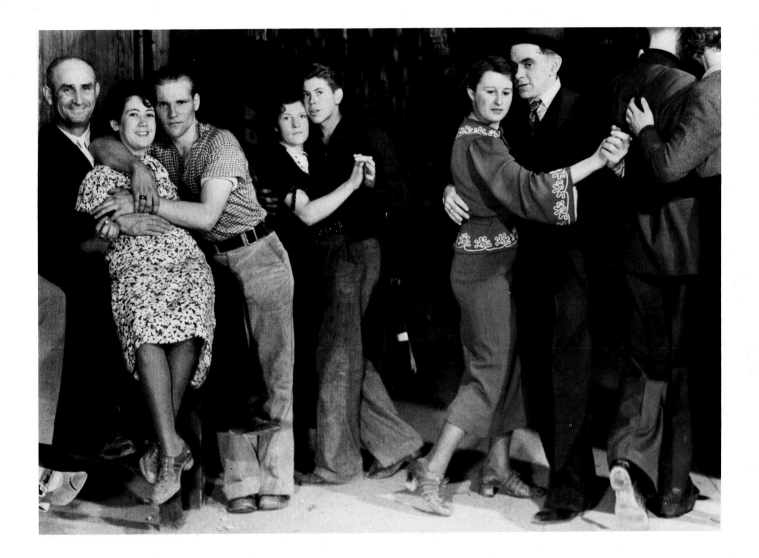

10,000 MONTANA RELIEF WORKERS MAKE WHOOPEE ON SATURDAY NIGHT

THE frontier has returned to the cow country. But not with cows. In the shanty towns which have grown up around the great U. S. work-relief project at Fort Peck, Montana, there are neither long-horns nor lariats. But there is about everything else the West once knew with the exception of the two-gun shootings; the bad men of the shanty towns are the modern gangster type of gun-waver. The saloons are as wide open as the old Bull's Head at Abilene. The drinks are as raw as they ever were at Uncle Ben Dowell's. If the hombres aren't as tough as Billy the Kid they are tough enough—particularly on pay day. Even the dancing has the old Cheyenne flavor. These taxi-dancers with the chuffed and dusty shoes lope around with their fares in something half way between the old barroom stomp and the lackadaisical stroll of the college boys at Roseland. They will lope all night for a nickel a number. Pay is on the rebate system. The fare buys his lady a five cent beer for a dime. She drinks the beer and the management refunds the nickel. If she can hold sixty beers she makes three dollars—and frequently she does.

THE LAW TOTES A GUN

In the Wild West town of Wheeler,* near Fort Peck, Montana, Frank Breznik (*Left*) is the law. He used to be a traveling salesman in Atlantic City. His pals are Realtor Walt Wilson and Publisher Jerry Reinertson.

FRANKLIN ROOSEVELT HAS A WILD WEST

AND you are looking at it in the photographs on these nine pages. It is about as wild and about as far west as the Wild West which Franklin's cousin Theodore saw in the Eighties. Its shack towns, of which you see one opposite, are as wide open and as rickety as git-up-and-git or Hell's Delight. The only real difference is that Theodore's frontier was the natural result of the Great Trek to the Pacific, whereas Franklin's is the natural result of $110,000,000.

The $110,000,000 is being spent on a work-relief project in Northeastern Montana. The project is an earthen dam—the world's largest —2,000 miles up the Missouri from St. Louis. The dam is intended to give work to Montana's unemployed and incidentally to promote the carriage of commerce on the Missouri. Whether or not it will promote the carriage of commerce is a question, but as a work maker it is a spectacular success. It has paid wages to as many as 10,000 veterans, parched farmers and plain unemployed parents at a time.

That it has also provided extracurricular work for a shack-town population of barkeeps, quack doctors, hash dispensers, radio mechanics, filling station operators and light-roving ladies is partly the army's fault. Army engineers, loaded with a project they didn't want and hadn't recommended, resolved to put it through on a strictly business basis. They built a decent town for their workers called Fort Peck City, fully equipped with dormitories, hospital, sanitary equipment, etc., but they provided quarters only for the workers —not for all their families. For those quarters they charged rents which left the married worker without enough margin to support a second home for his family somewhere else. Consequently, to keep his family housed and to dig himself in for the winter freeze, the married worker and his friends moved a few miles off the reservation and built the shanty towns you see here.

There are six of them, short on sanitation, long on bars and only restrained by the kind of law you see at the top of this page. Wheeler, Montana, has 3,500 inhabitants and 65 small businesses of one kind or another—mostly another. A second is hopefully named New Deal. A third is Delano Heights. A few miles away are Square Deal, Park Grove and Wilson. The Red Light suburb is Happy Hollow. Margaret Bourke-White's pictures enable you to observe at close range the labors and diversions of their inhabitants.

*SEE IF YOU CAN FIND THE MOOSE ABOVE IN THE MAIN STREET PICTURE ON THE RIGHT. (ANS: FOURTH BUILDING FROM RIGHT, FACING YOU.)

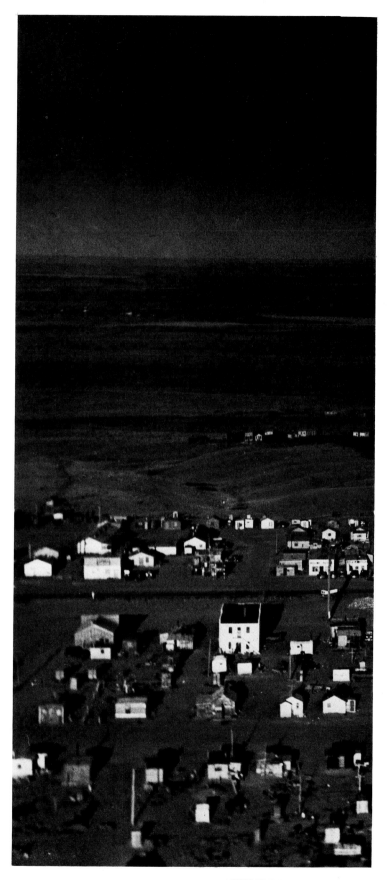

THIS IS WHEELER, MONTANA,

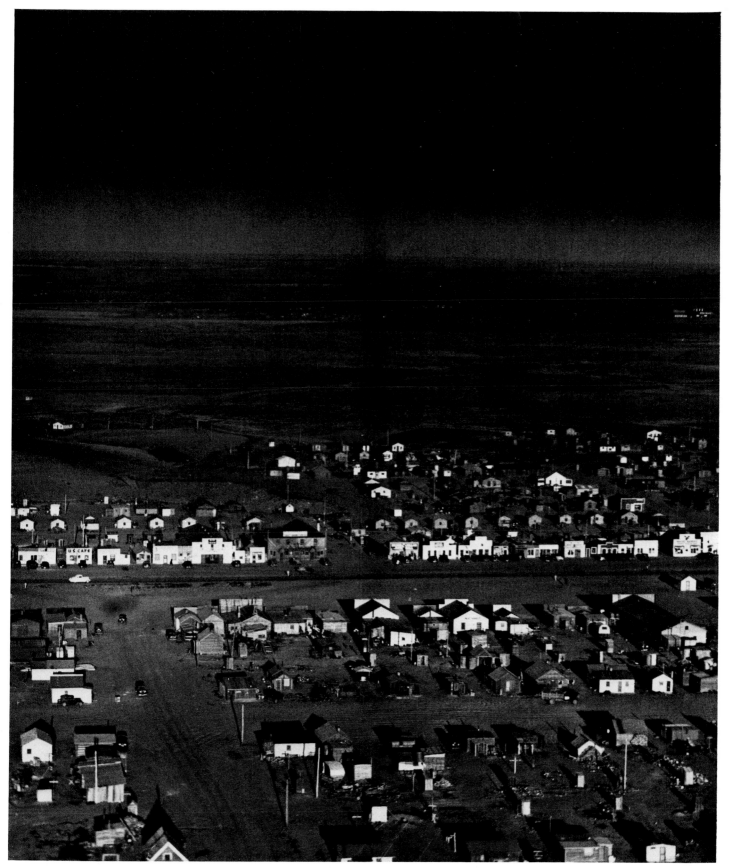

ONE OF THE SIX FRONTIER TOWNS AROUND FORT PECK IN MR. ROOSEVELT'S NEW WILD WEST.

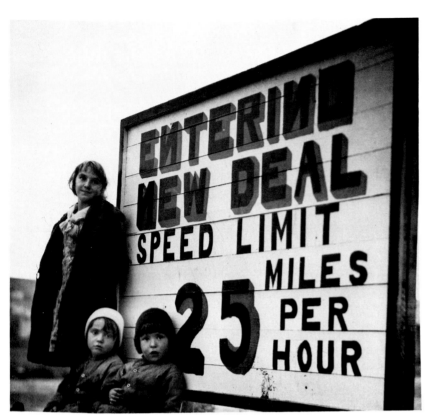

THE NEW WEST'S NEW HOTSPOT IS A TOWN CALLED "NEW DEAL"

A relief project started the new Wild West. But you don't need a government loan to build a house there. For $2 a month you can rent a fifty foot lot in Wheeler from Joe Frazier, the barber over in Glasgow, 20 miles away. Joe had the fool luck to homestead the worthless land on which shanty towns have sprouted. You then haul in a load of grocer's boxes, tin cans, crazy doors and building paper and knock your shack together. That will set you back $40 to $75 more. You then try to live in it in weather which can hit minus 50° one way and plus 110° the other.

THE ONLY IDLE BEDSPRINGS IN "NEW DEAL" ARE THE BROKEN ONES.

. . . . THEIR MILK FROM KEGS

Water in the cities of the new Wild West comes from wells, many of them shallow, some condemned—and at that it may cost you a cent a gallon. Sewage disposal is by the Chic Sale system. Compulsory typhoid inoculation is non-existent. Fires are frequent—Wheeler has had 20 more or less this year. Nevertheless the workers here refuse to move to the Army's sanitary barracks. Life in barracks is too expensive; life in the shanty towns too gay. When the Army tried compulsion they wrote to Montana's Senator Wheeler for whom their metropolis was named. They won.

UNCLE SAM TAKES CARE OF THE INDIANS: THE LITTLE LADY, HERSELF.

LIFE IN THE COWLESS COW TOWNS IS LUSH BUT NOT CHEAP.

THE TIN CITY RODEOS . . .

COMPETITION between hot spots in the shanty towns of the 1936 Wild West is as keen as it is in New York. Ruby Smith's place (*below*) is an old favorite which has held up. Ed's Place (*opposite*) is slipping. Some say the customers are turning against Ed's murals. But Ed is faithful to them. He boasts that the painter, one Joe Breckinridge, averaged only twenty minutes a panel. Bar X (*below*) is almost as popular as Ruby's. Bar X is more dance hall than bar but that doesn't prevent the customers from drinking, or the taxi-dancers either.

ONE-FOURTH OF THE MISSOURI RIVER

This apparatus goes into one of the four diversion tunnels which will carry the river around Fort Peck dam during construction, will later control release of water. With sections in place, the steel spider web will be removed. Theoretically

BAR X

RUBY'S PLACE

This is the beer bar. The only drink you can legally sell by the glass in Montana is beer and you mustn't sell that to Indians. For the heavy liquor the customers go to another bar behind. It's merely a formality. The back bar is just as open.

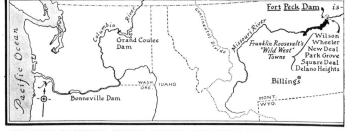

THE NEW FRONTIER TOWNS AROUND THE FORT PECK DAM PROJECT

14

. . . RUN ALL NIGHT

LIFE in Montana's No. 1 relief project is one long jamboree slightly joggled by pay day. One of its shanty towns has 16 all night whooperies. The workers are on night shift as well as day with the result that there is always someone yelling for a whiskey or calling on the little ladies of Happy Hollow. College boys mingle with bums in the crowds. Bill Stender, at the bottom of the page, is a Texas U. footballer who bounces for Ruby Smith. He hopes to get to be a football coach when he graduates but he is studying history and engineering just in case.

MAJOR CLARK KITTRELL IS No. 2

ED'S PLACE

WILL RUN THROUGH THIS STEEL "LINER"

the relief workers at Fort Peck are building things like diversion tunnels. Actually they are building Wheeler and New Deal and the rest of the relief-boomed towns.

ARE 275 MILES BY ROAD FROM BILLINGS, MONTANA

RUBY HERSELF

Ruby, second from the left is the founder of the town of Wheeler—and its rich woman. What she learned in the Klondike she has turned to good account. Bill Stender of Texas U. (the big fellow above) is keeping in condition as her bouncer.

MONTANA SATURDAY

THE pioneer mother can trek in broken-down Fords as well as in covered wagons. And she can crack her hands in the alkali water of 1936 as quickly as in the alkali water of 1849. When the Fort Peck project opened in 1933 the roads of Montana began to rattle with second-hand cars full of children, chairs, mattresses and tired women. Most of them kept right on rattling toward some other hopeless hope. Some of them parked in the shanty towns around Fort Peck. There, their women passengers got jobs like Mrs. Nelson (*right*) who washes New Deal without running water, or tried their feet at taxi-dancing like the girls on the preceding pages, or made money like Ruby Smith on page 15, or gave birth to children in zero weather in a crowded 8 by 16-foot shack like many an unnamed woman of New Deal and Wheeler. The girl at the bar (*above*) who works as a waitress ("hasher") takes her child to work with her because she can't leave her at home. She sits on the bar while her mother kids with the customers. The group on the right, it will be noticed, resembles a statue recently erected to the Pioneer Mother of the old frontier. No statues are expected at New Deal.

NIGHTS: FINIS

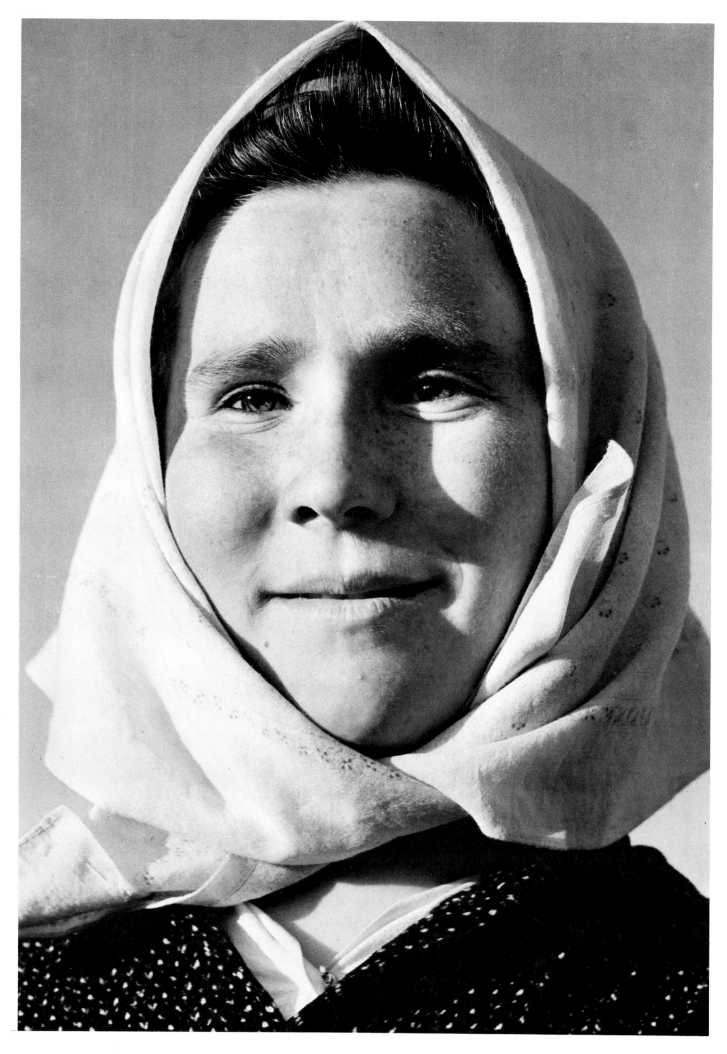

Paprika Sower, Slovakia, 1938

Nazi Storm Troopers' Training Class, Moravia, 1938

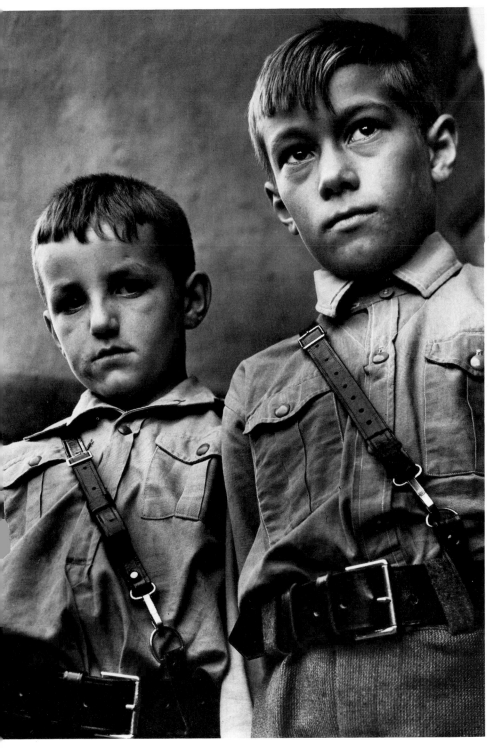

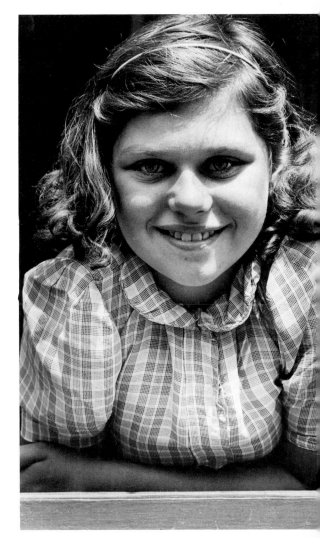

Czech Schoolgirl, Bohemia, 1938
Bourke-White had a LIFE assignment to cover
the conflicts brewing in eastern Europe and
took the opportunity to collaborate with Caldwell
on another book which they called *North of
the Danube*. It was a slim word-and-picture
portrait of Czechoslovakia during the tense
months before the crisis.

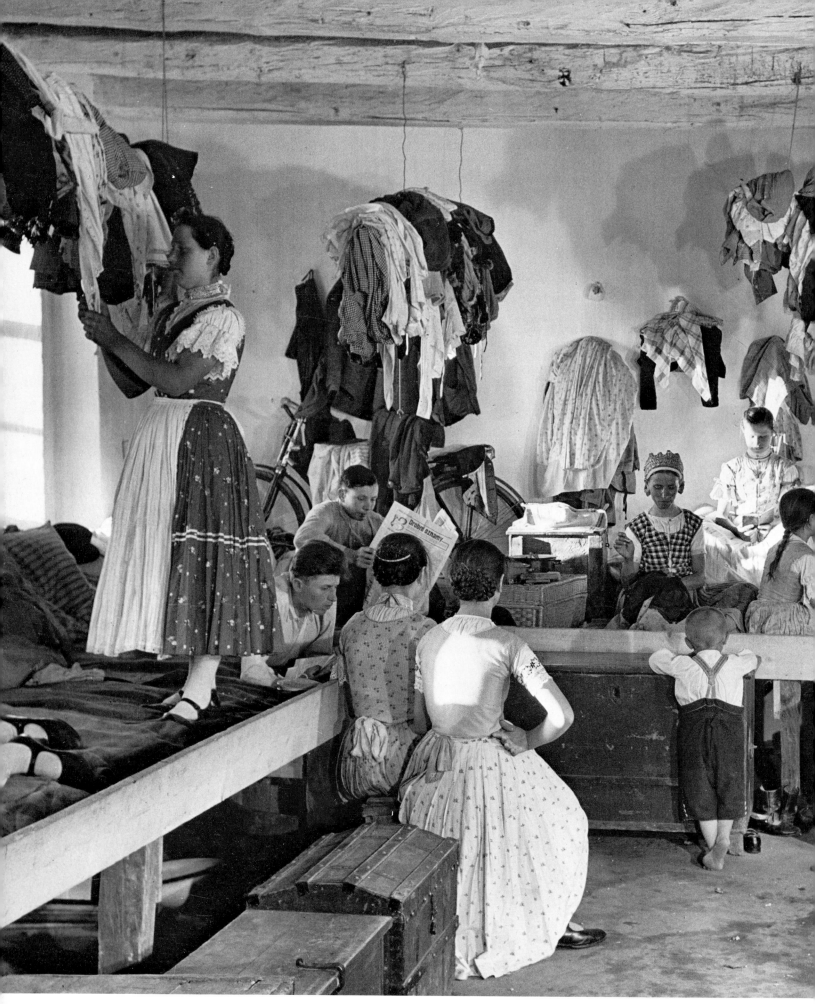

Fieldworkers' Dormitory, Slovakia, 1938

120

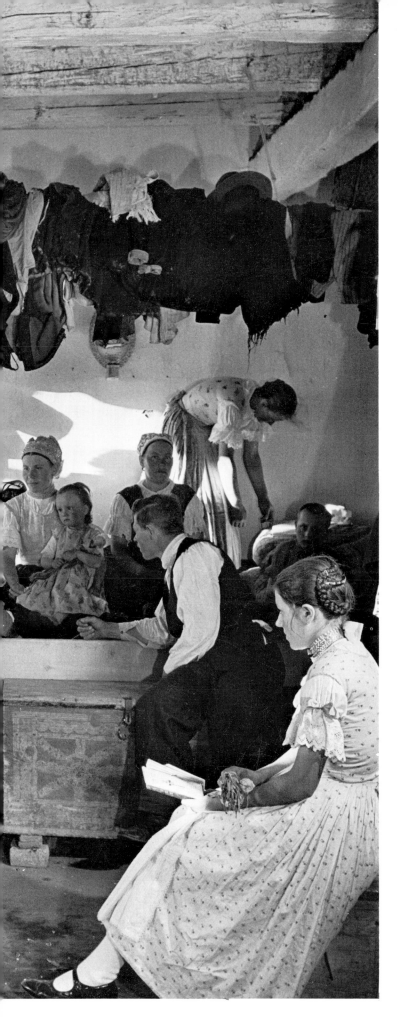

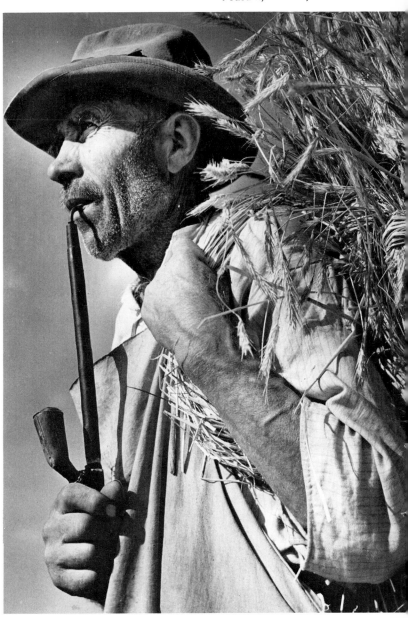

Peasant, Moravia, 1938

121

Henlein Family, Czechoslovakia, 1938
The parents of Konrad Henlein,
Nazi leader of the Sudeten German
minority in Czechoslovakia,
photographed in their Reichenau
home. Heinlein, who advocated
alliance with Germany for
economic reasons, paved the
way for Hitler's usurpation of the
entire country. The senior Henlein
was a third-generation Bohemian
who, said the LIFE caption, was
"a little confused by his son's politics."

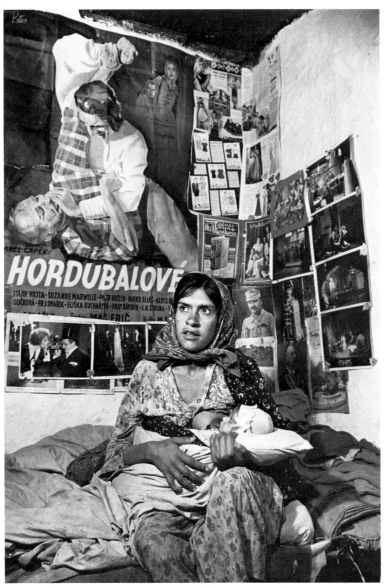

Gypsy Mother, Carpathian Ruthenia, 1938

Apple Seller, Bohemia, 1938

Prince Festetic's Library,
Hungary, 1938
Surrounded by the 52,000 volumes
of his private library, the largest in
Hungary, Prince George-Tassilon-
Joseph Festetics studies his
autograph album.

**Conversation Club,
"Middletown, USA," 1937**

Middletown was a revealing book
written by sociologists Robert and
Helen Lynd about the average
American small town and based on
studies made in the 1920's of
Muncie, Indiana. When a follow-up
survey was made ten years later,
LIFE took the opportunity to send
Bourke-White to do a photographic
essay on the community. Muncie's
Conversation Club had been getting
together for 40 years and on this
particular morning at 9:30, its
members were listening to an expert
paper on astronomy.

Pocahontas Lodge, Muncie, Indiana, 1937

Order of Odd Fellows, Pretty Prairie, Kansas, 1940

In the fall of 1940 Caldwell and Bourke-White hopscotched around the country producing a word and picture portrait on the state of the union called *Say, is This the U.S.A.?* They traveled 10,000 miles, from a rustic Vermont village to a San Diego naval base and in between stopped to observe once again the peculiar dedication some Mid-Westerners showed for their fraternal organizations.

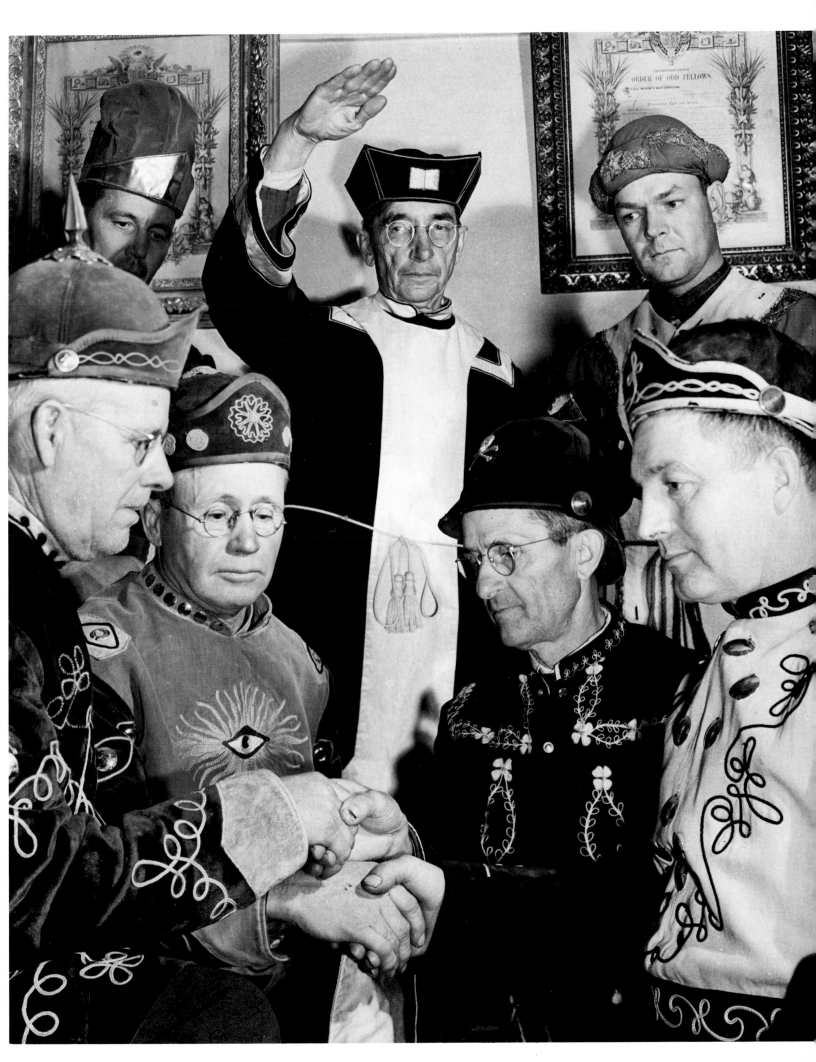

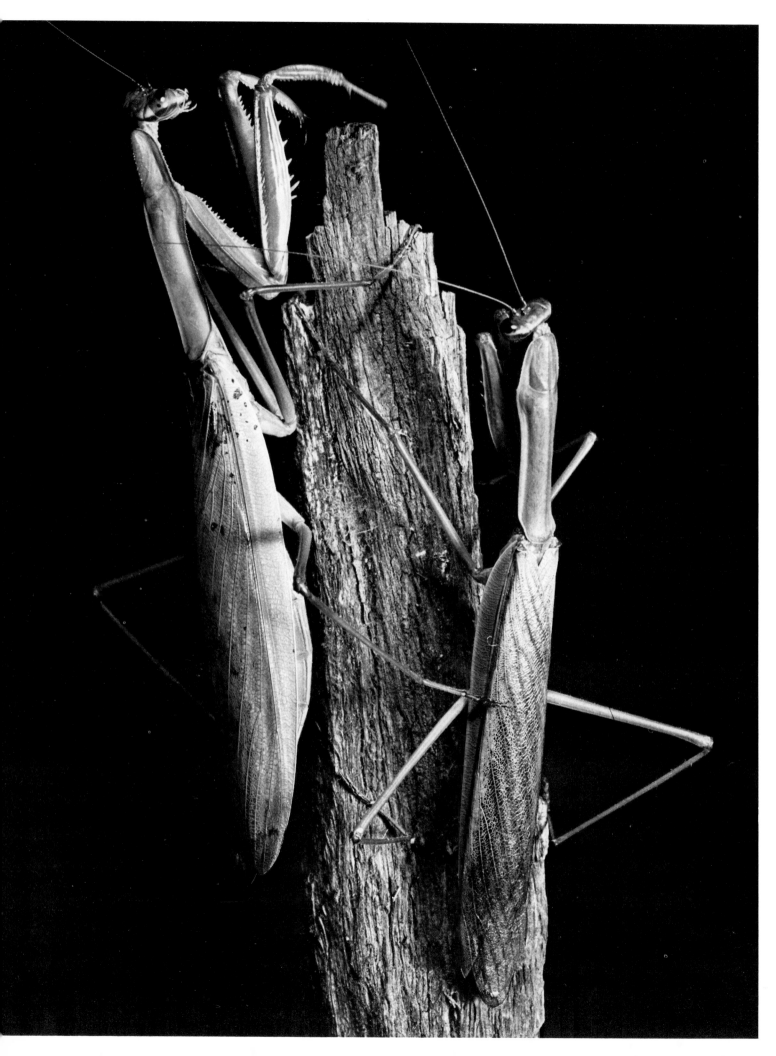

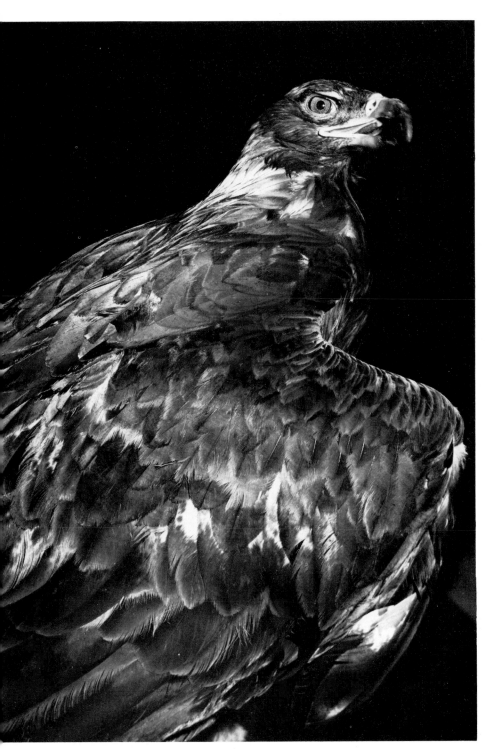

At the time of the Louisville Flood, 1937 (overleaf)
That winter, flooding throughout the Ohio River
valley claimed four hundred lives and left
thousands homeless. This photograph, probably
the most famous of Bourke-White's career, is
of refugees lining up for supplies at an emergency
relief station in the black quarter of Louisville.

Horned Owl, 1940

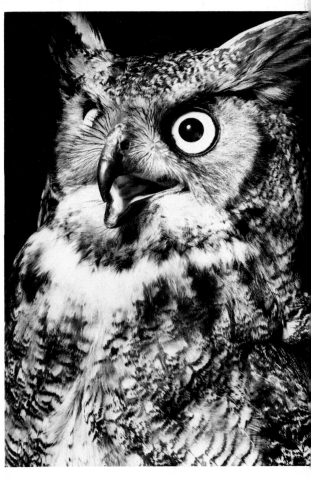

Golden Eagle, 1940

These two portraits are from a series of animal
studies made for PM, a brilliant but short-lived
picture newspaper in New York.

Praying Mantes, 1939

For three years Bourke-White photographed the life
cycle of these fearsome looking insects—even
carrying their egg cases on assignments in hopes
of catching the delicate moment when they hatched.
Once, while she was away, a colony hatched in
her LIFE office creating near havoc when they
migrated to the adjoining darkrooms.

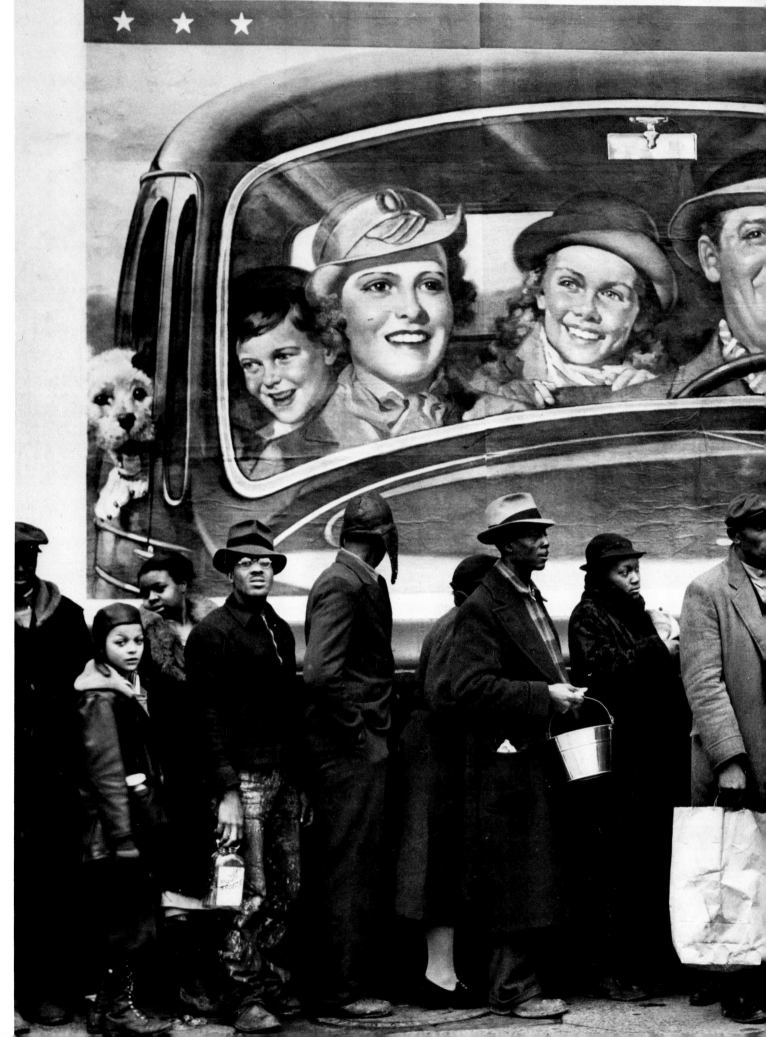

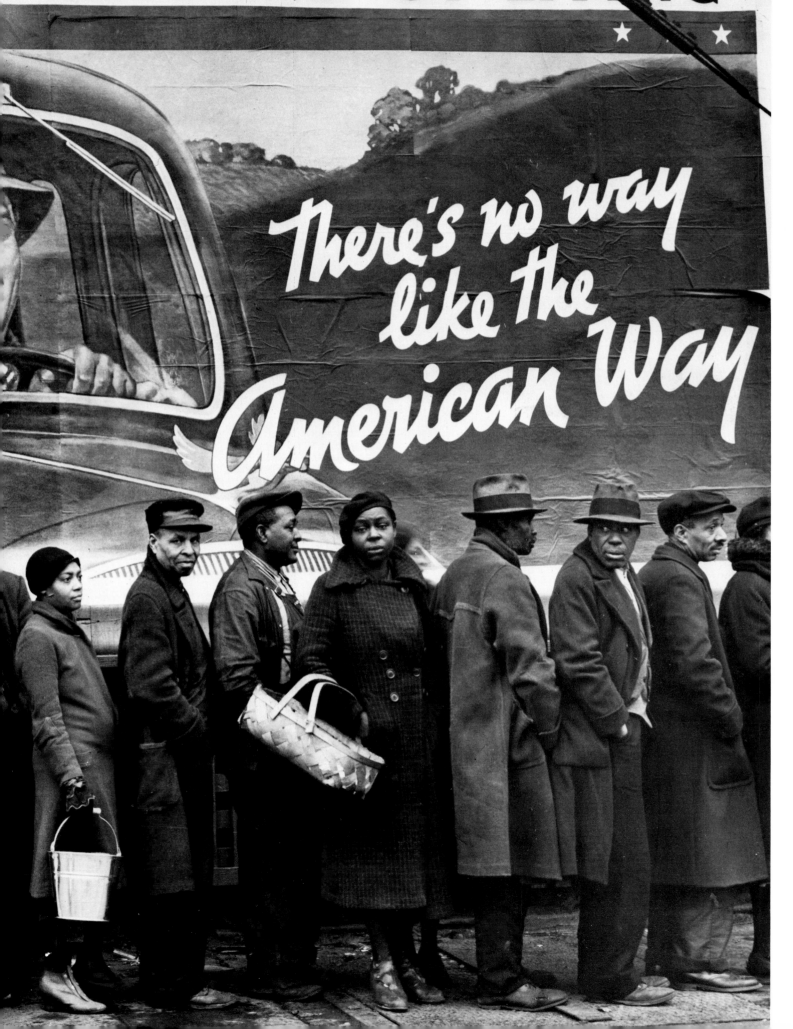

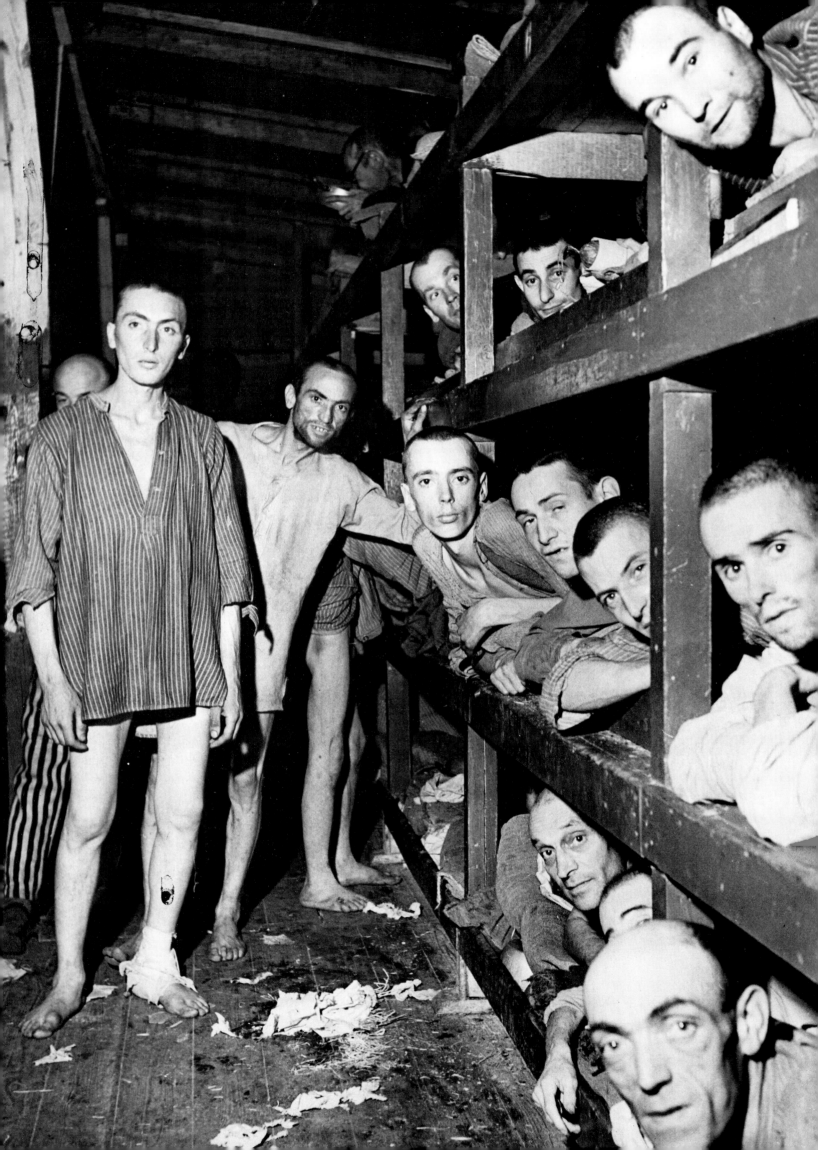

The War in Europe

1941-1945

By 1941 Hitler's easy victories in eastern Europe had brought the German armies up to the Russian border, where they stopped because of a non-aggression pact with the Soviets. Most people thought Hitler's expansionist appetite was satisfied. One who didn't was LIFE's executive editor Wilson Hicks, who asked Bourke-White if she would go back to Russia. His hunch was that hostilities would soon break out, and if they didn't, she could make a valuable comparison of Soviet life today with what she saw a decade earlier when she photographed the Five-Year Plan. Caldwell accompanied her and in what she described as his "defiantly free-lance way," would report for LIFE and CBS radio "if and when he got around to it."

They entered Russia by the back door after hopping across the Pacific on a Clipper, and visiting war-torn China, had tea with Generalissimo and Madame Chiang Kai-shek. Flying across China took weeks because of bad weather and missed connections. In those moments Bourke-White would curl up with one of the twenty-eight detective stories she had brought and Caldwell would amuse fellow travelers with his favorite game, Chinese Checkers,—apparently unknown in China.

They spent the first six weeks photographing the people making tense preparations for war. On July 22 the first bombs fell on Moscow, and Bourke-White was the only foreign photographer present. The next night they holed up in the deserted American embassy and watched the beginning of the air raid from the roof. Then Caldwell hurried to the radio station where he made a live broadcast to New York. Bourke-White mounted her cameras on the balcony outside their hotel room and made time exposures of the raid. For a while, she also alternated behind the microphone with her husband, who had earlier cracked a long-standing prohibition by making the first live broadcast by a foreigner from Soviet Russia.

Being above ground was not just dangerous, but illegal, and civilian guards continually inspected buildings for violators. Bourke-White would have as many as four cameras on time exposure pointed to the sky from her hotel room window. As guards came down the hall she would roll under the bed still keeping careful count of her exposure as the guards searched the room. After they left she would rush out to cap her lenses hoping to save the exposure. More frequently bombs sent her scurrying but she always emerged with just scratches. This was her first scoop for LIFE and she felt that it deserved treatment beyond what a magazine could give. She compiled her adventures into an illustrated book called *Shooting the Russian War* (1942) that was a publishing success. Two years later she produced a similar book on the Italian campaign and followed it with a diary on the fall of Germany called *Dear Fatherland, Rest Quietly* (1946). Although she was able to photograph the death camps, when she saw the pictures developed she wept and couldn't go near them for several days. *Dear Fatherland* was in part her attempt to examine the German character that allowed such atrocities to happen.

Essen Steel Worker, Germany, 1945
Five generations of Krupps made them docile and obedient while they extracted their labor in the munitions works. Essen was the only major city not to have municipal bomb shelters to protect its citizens from Allied bombings.

Buchenwald Inmates, Germany, 1945
The few who survived try to affect a smile of relief when the death camp is liberated.

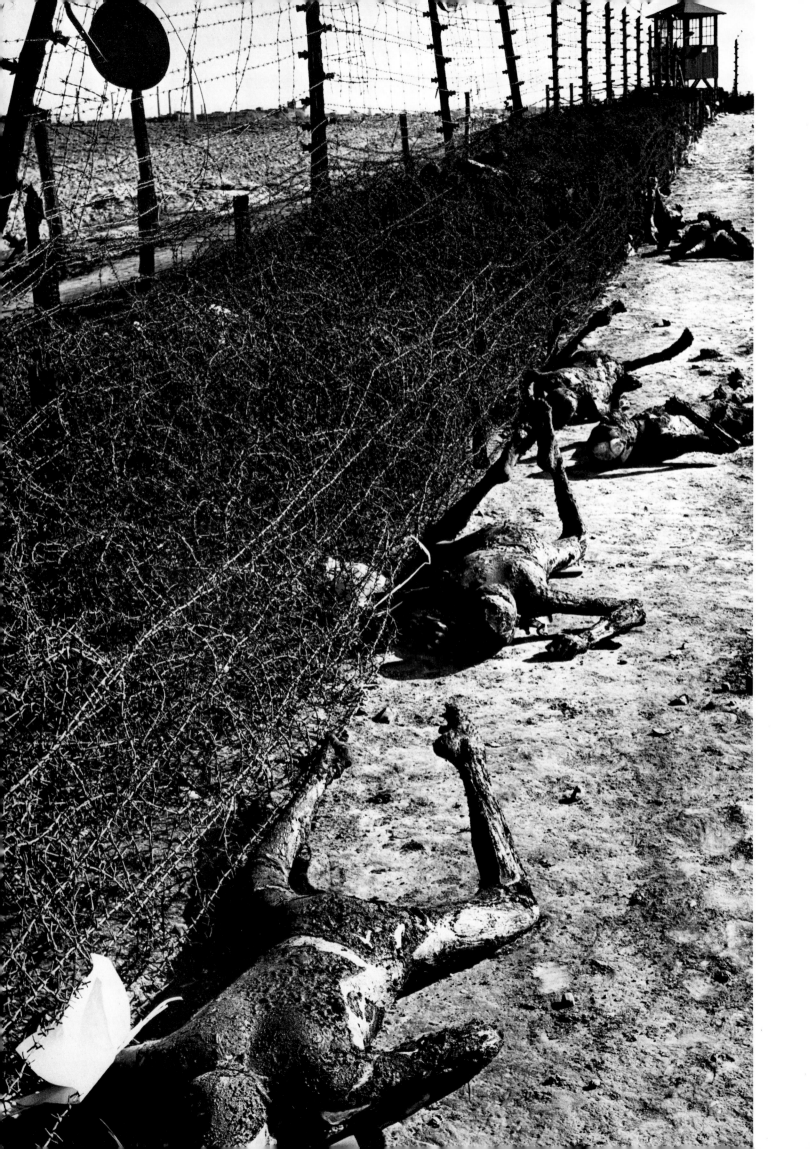

Buchenwald, 1945 (right)
When Patton saw Buchenwald, he ordered his MP's to bring 1000 civilians from nearby Weimar and make them see the horrors that Nazi leaders had perpetrated. The MP's brought back 2000. Many people refused to look and the cry ''We didn't know, we didn't know,'' echoed through Germany.

Leipzig-Mochau, 1945 (left, below)
On the outskirts of Leipzig, Bourke-White discovered a slave labor camp that the retreating Germans had destroyed earlier. Guards had thrown flaming acetate into the mess hall. Some inmates, their clothing ablaze, were able to flee the building, but, reaching the fence, they were machine-gunned. Some former inmates returned to the camp the day she was photographing to look for friends and to weep.

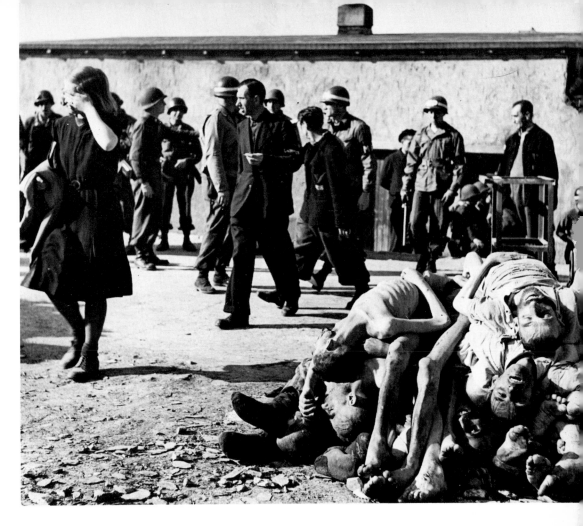

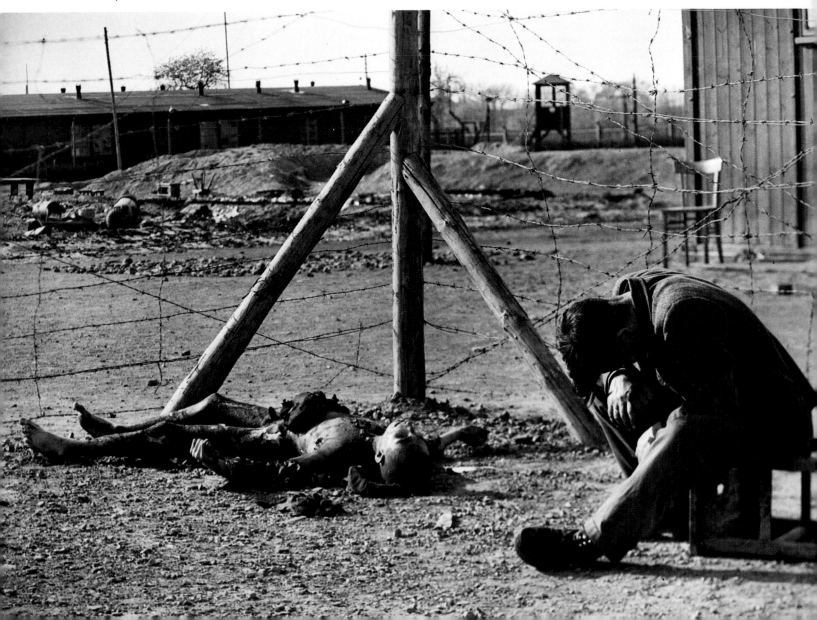

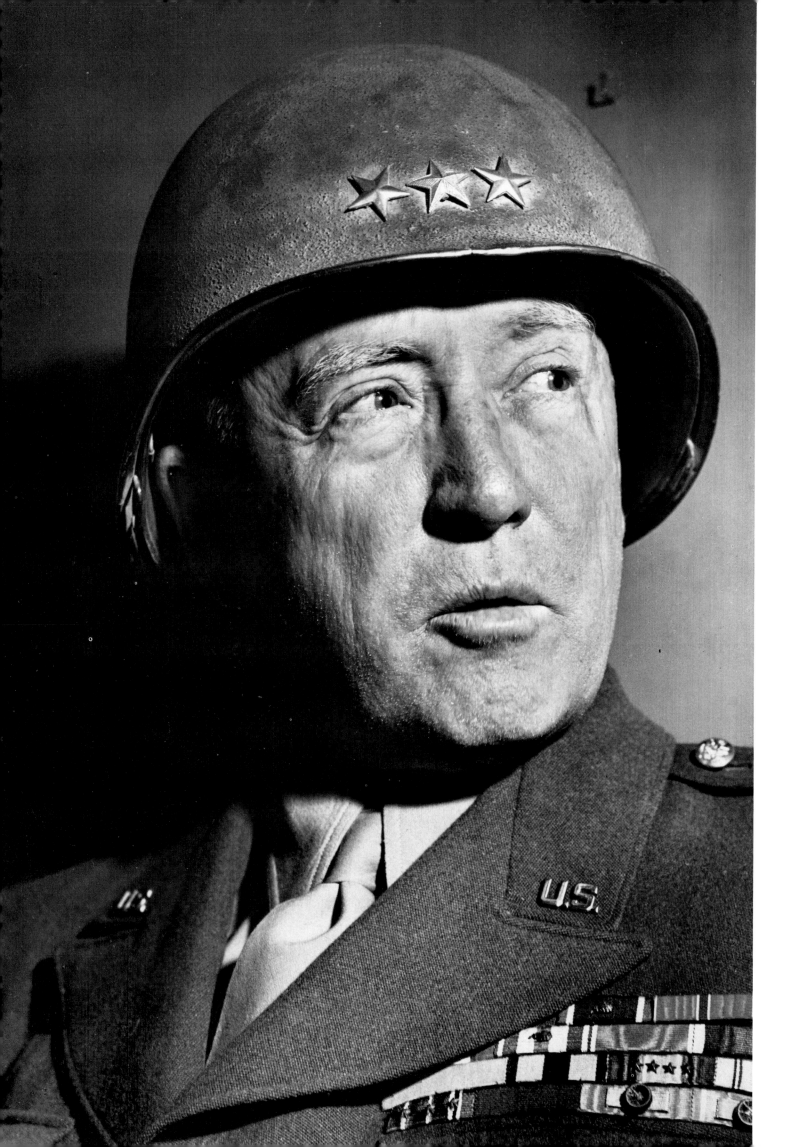

General George S. Patton, Luxemburg, 1945 (opposite)
The flamboyant American leader was photographed as elements
of his Third Army were crossing the Rhine in a daring midnight
assault at the Lorelei Rock.

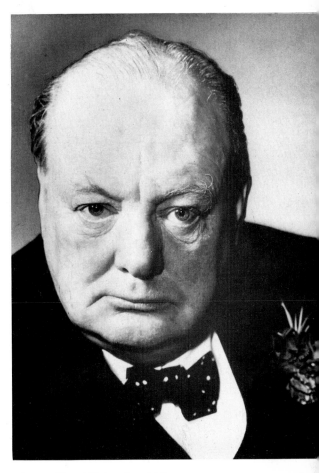

Winston Churchill, London, 1940
This photograph was made in the spring before
the Battle of Britain, when Churchill was First
Lord of the Admiralty and in charge of the
Supreme Defense Council.

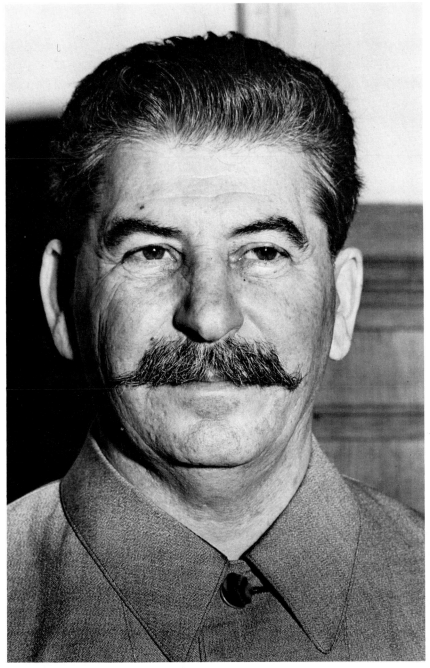

Stalin Smiling, Moscow, 1941
The Soviet Premier reluctantly agreed to have his portrait
taken, but proved a difficult subject throughout the session.
Bourke-White could not relax him or draw him into conversation.
Even when she told of photographing his mother and great-aunt
years before, it evoked only a polite response. While down on
her hands and knees searching for a different camera angle,
some flash bulbs spilled out of her bag. The incongruity of an
attractive American woman scurrying around on all fours in the
Kremlin evoked a smile from the Russian leader. Noticing it,
Bourke-White rose quickly and made two exposures as the
smile faded from the great stone face.

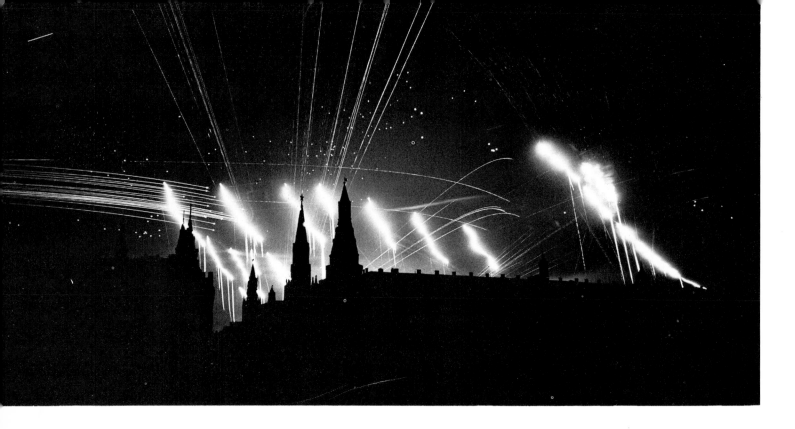

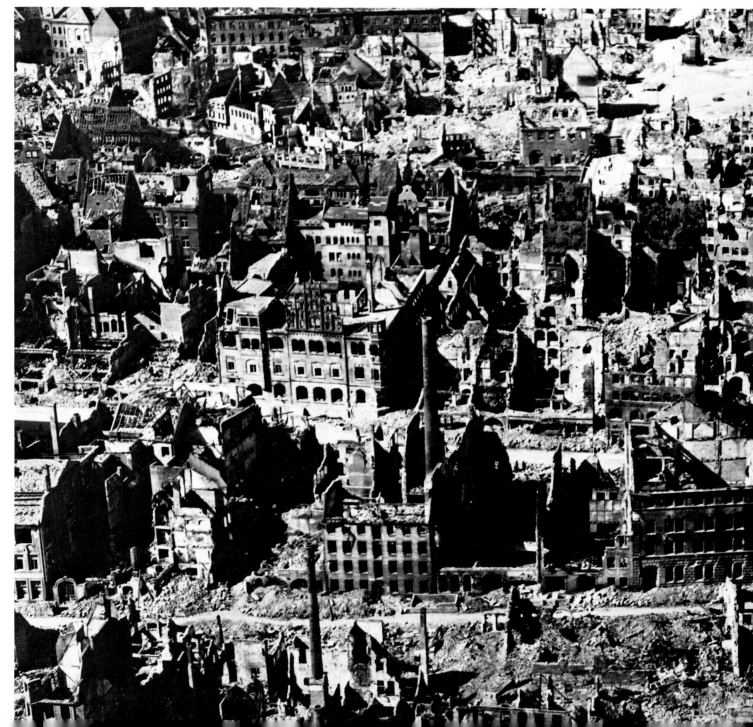

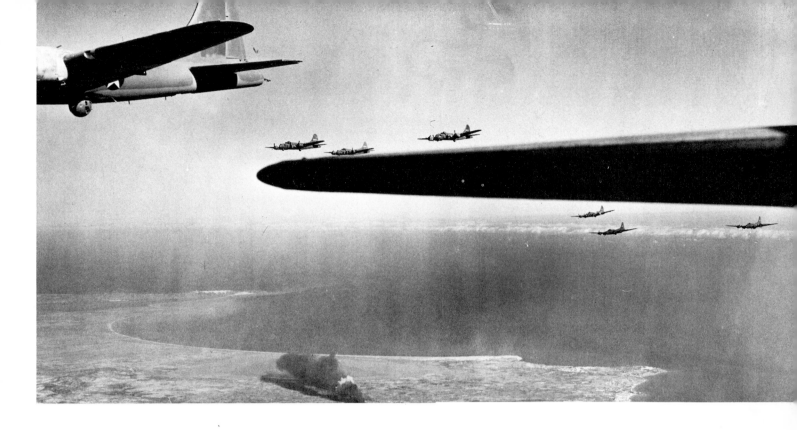

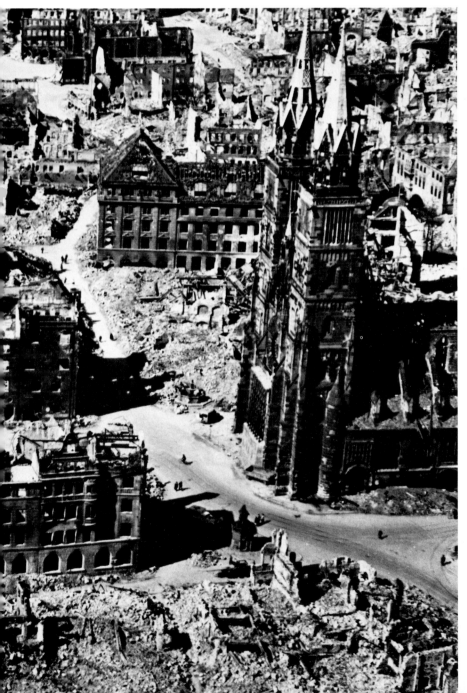

Bombing of Moscow, 1941 (top left)
Tracer bullets etch the sky seeking the German planes that have dropped streaking parachute flares used to identify targets.

Air Raid over Tunis, 1943 (above)
Lumbering B-17's return from a raid over a German-held air field during the North African campaign.

Nuremberg, 1945
The once placid city in Bavaria known for beer, toys, and Gothic churches, during the war was a center for manufacturing diesels and dynamos—hence, it was a prime target. Allied bombing obliterated thirty per cent of the city.

Göring in Defeat, 1945

A few days after his surrender Reichsmarschall
Hermann Göring met the Allied press in the back
yard garden of a home near Augsburg. A year later
he committed suicide at his trial as a war criminal.

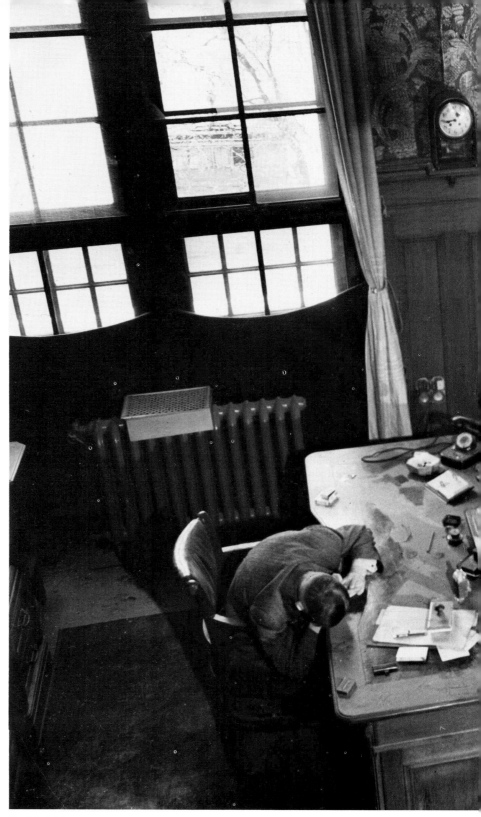

Nazi Suicides, 1945

Dr. Kurt Lisso, Leipzig's City Treasurer, and his wife and
daughter (in Red Cross uniform) took poison just as American
tanks rolled into the city. As a high ranking city official he
would have been tried and punished by the military government.
In the closing moments of the war Nazi propagandists told
the German people to expect savage treatment from the
conquering Americans: the action produced hundreds of
suicides like these.

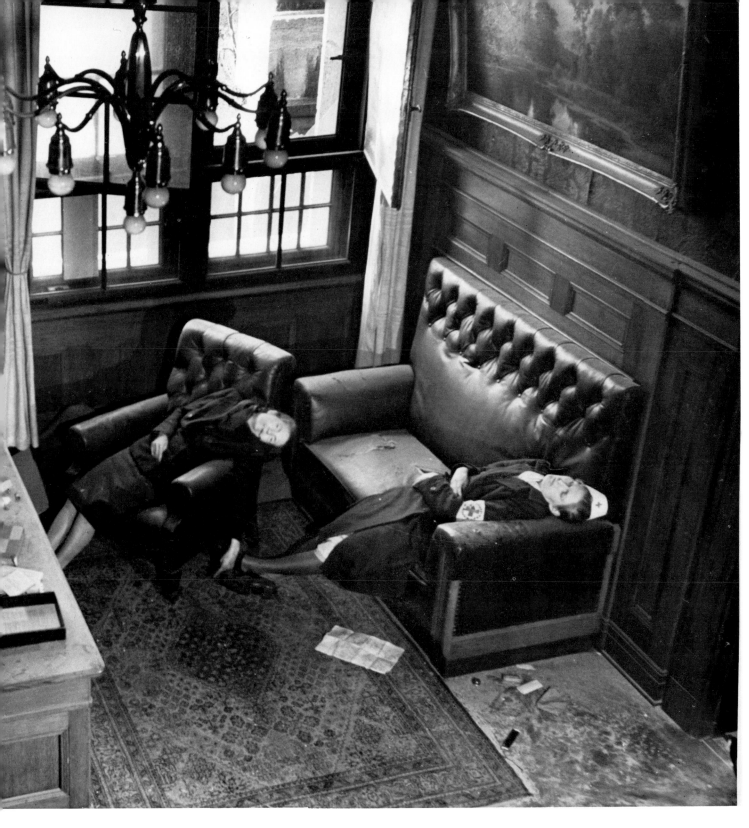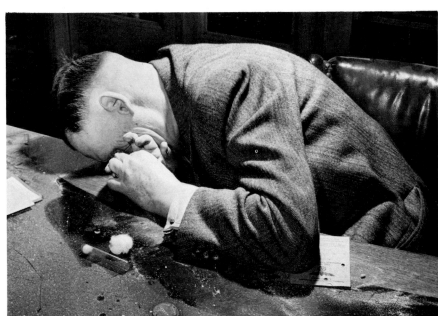

Benediction, Moscow, 1941

Metropolitan Alexander Vvedensky was head of the
New Orthodox Church in Russia.

Zhukov Shows his Medals, Berlin, 1945

Soviet Marshal Zhukov, festooned with honorary
medals, beams during the Allied victory parade.

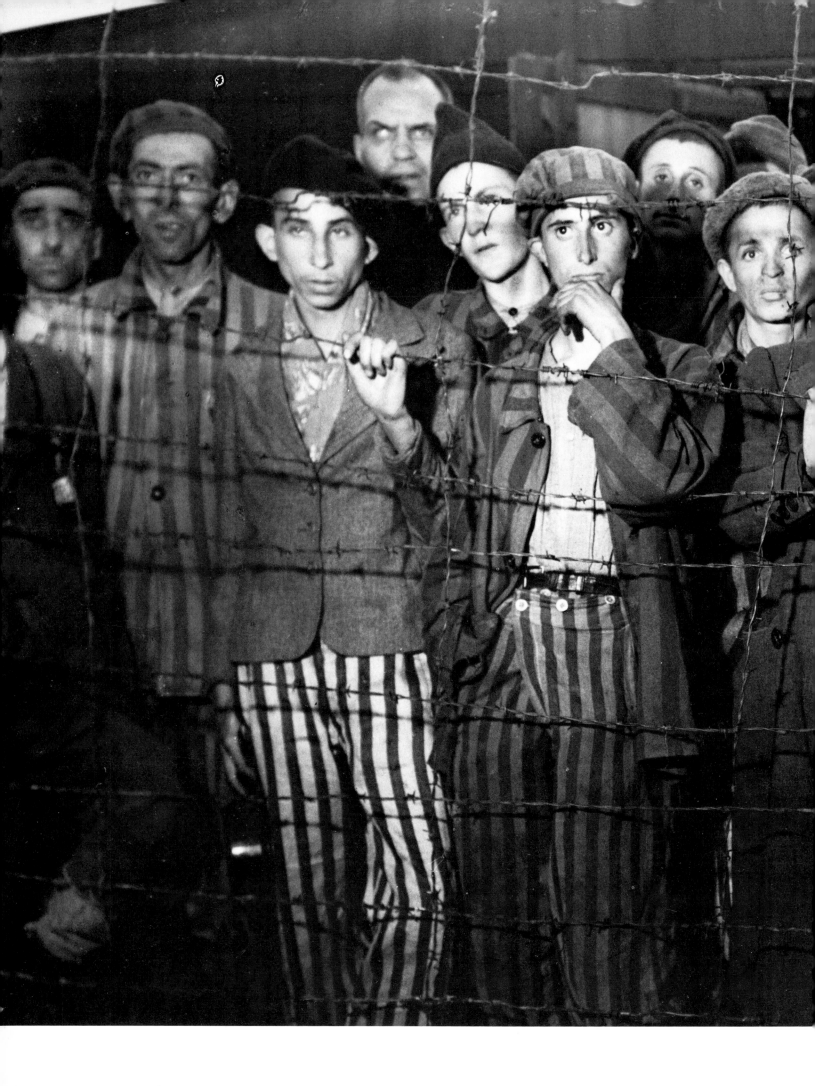

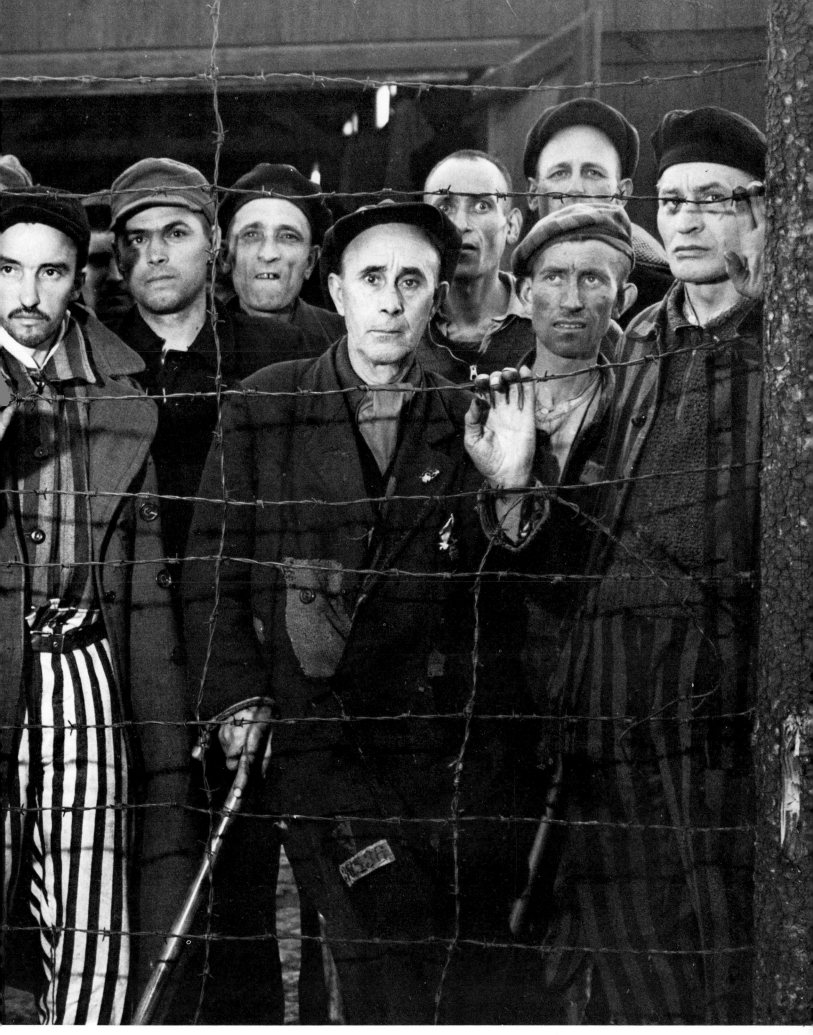

The Living Dead of Buchenwald, April, 1945

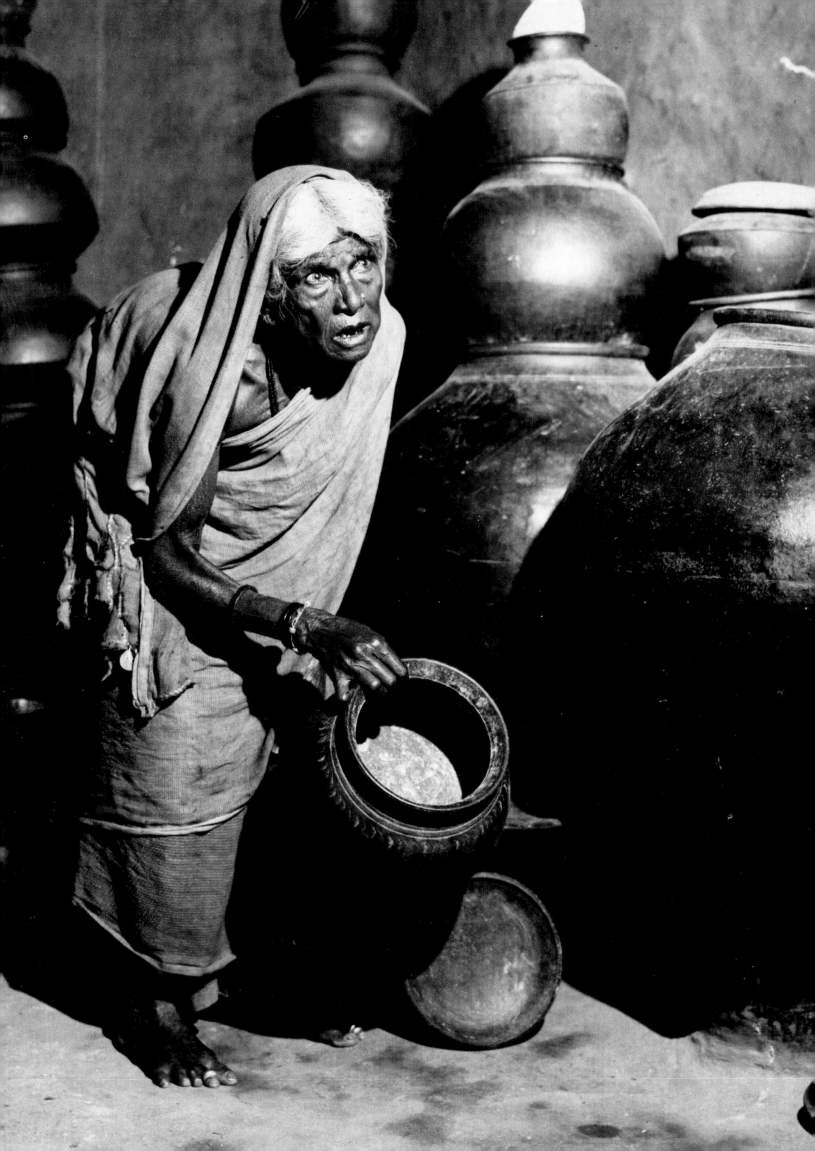

The India Years

1946-1948

In 1946 the prescient Wilson Hicks again sent Bourke-White to record a great global drama—the twin births of the nations of India and Pakistan. She arrived early in 1946 when the groundwork was being laid for independence, and over the next two years she sent back stories on the events, the countries, their peoples and cultures. The period was the most stimulating of her life, producing her best series of pictures. For the first time she seemed aware of the historical import of her work when she wrote: "The seething conflicts, the ferment and growth, the powers of medievalism clinging to ancient privilege while the people struggle upward to reach the light . . . when new nations rise from the debris of an outworn order and begin drawing up democratic laws, it marks an important step not only for them but for the whole forward march of the world." Unlike *Faces*, which was a collaboration growing out of frustration and coincidence, and Moscow in 1941 which was blind luck, India was a story wholly shaped by Bourke-White. It allowed her to demonstrate every facet of her genius.

Before she photographed Gandhi for the first time, his secretaries had her learn to use the charkha, the primitive spinning wheel which had become symbolic of his patient fight for independence. When she was finally permitted to see him, she was restricted to three flash bulbs because bright lights bothered him. To complicate her problem, sunlight was streaming through a window behind her subject and straight into the lens. She tried the first bulb, but the sickening delay between its pop and the shutter's click told her that the humidity was fouling the synchronization of exposure and flash. On her second effort she forgot to pull the slide to expose the film. She then tried some time exposures without flash, but the tripod legs locked, making it inoperable; hand-holding her bulky view camera was impossible. Desperate, she hazarded the last bulb and, miraculously, it worked. Sweeping up her balky equipment, she fled the room with a profound appreciation of the simplicity of the spinning wheel. Although she photographed Gandhi many more times, it never became easier. He dubbed her "The Torturer," with an affectionate chuckle, sensing perhaps that it was he who was the torturer.

On her last day in India she interviewed Gandhi. She asked if, as he had once claimed, he still hoped to live to 125. "I have lost that hope," he said, "because of the terrible happenings in the world. I do not want to live in darkness and madness. But if my services are needed . . . if I am commanded, then I shall live to be 125 years old." Some hours later when she was a few blocks from his home, he was assassinated. Bourke-White stayed on to photograph the massive outpouring of grief that swept India, and, for a moment, united the Indian people. She was nearly crushed by the crowds numbering over a million who came for a farewell sight of the father of their country. Returning to her home on a rocky Connecticut hill she wrote a book on the Indian years, *Halfway to Freedom*.

Princely India, 1947
Even in the face of their country's poverty, maharajas paraded elephants draped with gold and silver.

The Monsoon Failed This Year, India, 1946 (opposite)
When the annual rains failed to replenish the parched earth in southern India, the meager rice stores were soon depleted and thousands of people became living skeletons.

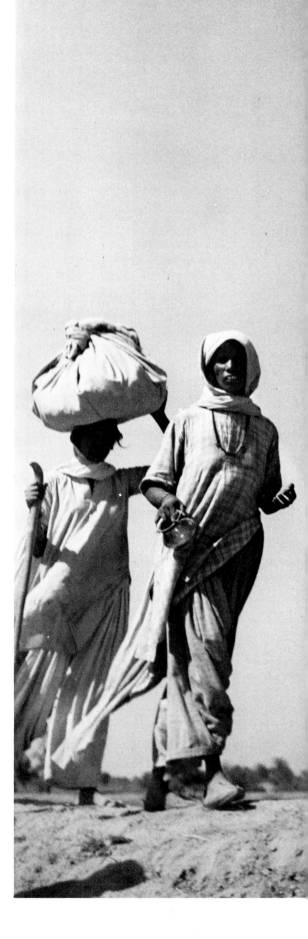

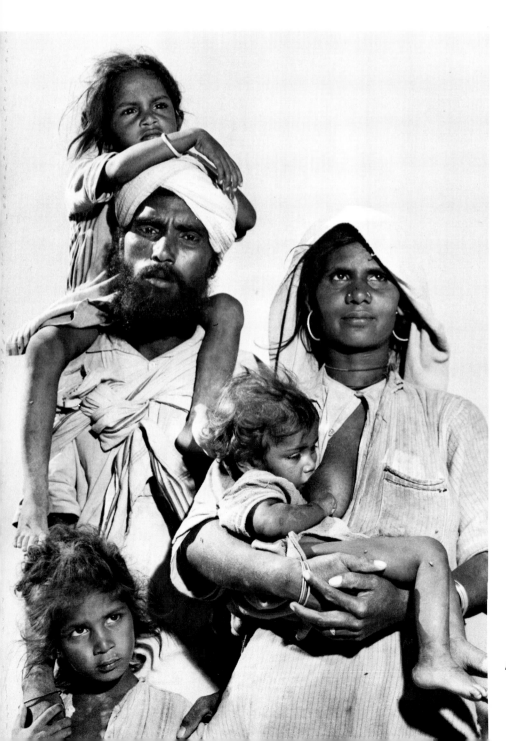

A Sikh Family, Pakistan, 1947

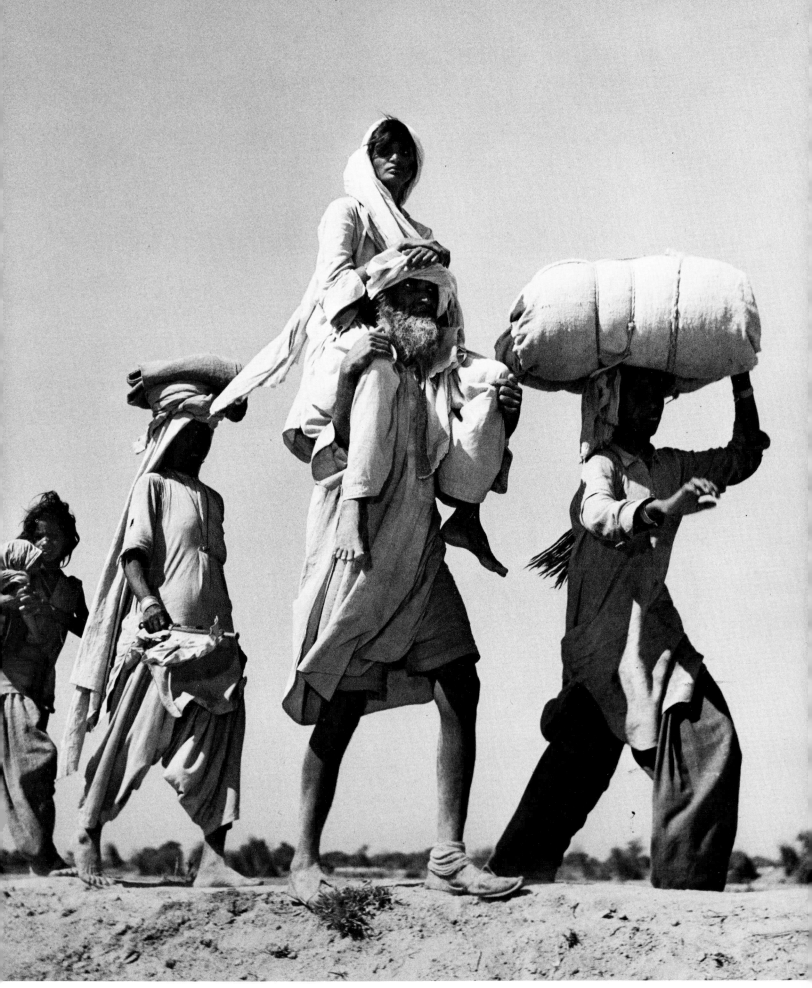

The Great Migration, Pakistan, 1947
A spindly but determined old Sikh (right), his ailing
wife on his shoulders, leads his family to the new
Indian border and hoped-for sanctuary.

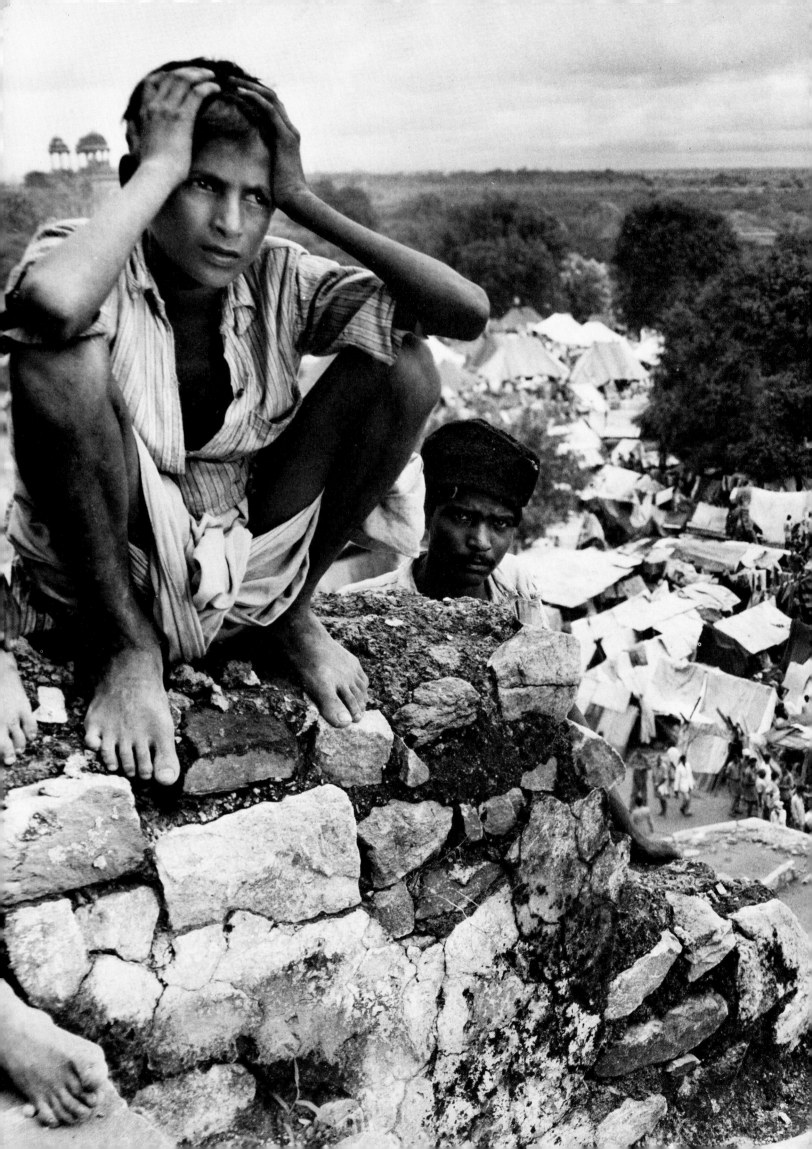

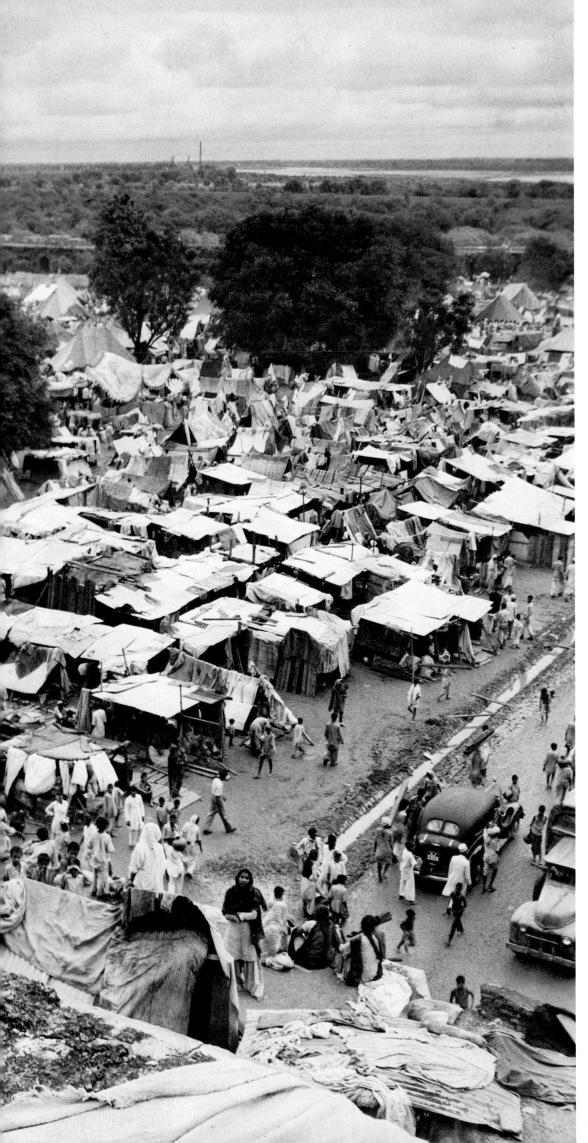

**Misery of the Dispossessed,
India, 1947**

Fleeing retribution, the refugees
herd together for protection.
Hundreds of squalid tent cities,
like this one outside New Delhi,
sprang up wherever they
stopped to rest.

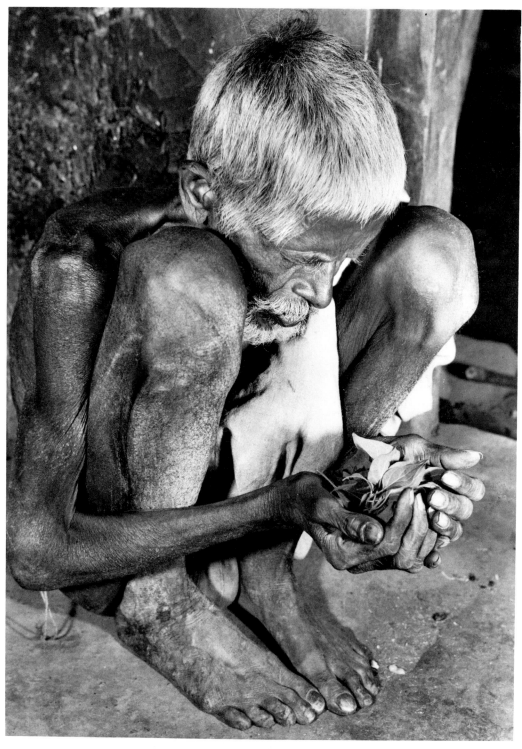

Too Weak to Stand, India, 1946

When the rains come late, famine follows quickly in undernourished India. After the rice goes, even leaves and weeds become edible.

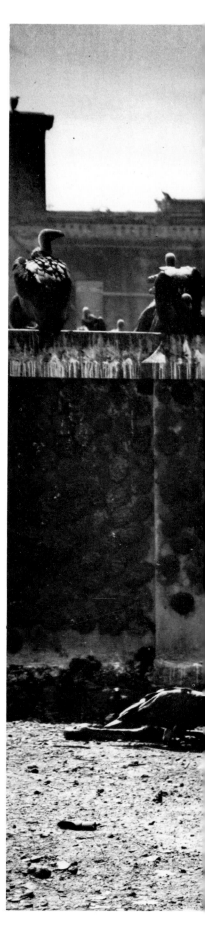

Vultures of Calcutta, India, 1946

Aftermath of a four-day riot between Hindus and Muslims, leaving nearly 7,000 dead on the streets—prey to these feasting vultures. Many birds became so bloated with human flesh that they couldn't fly.

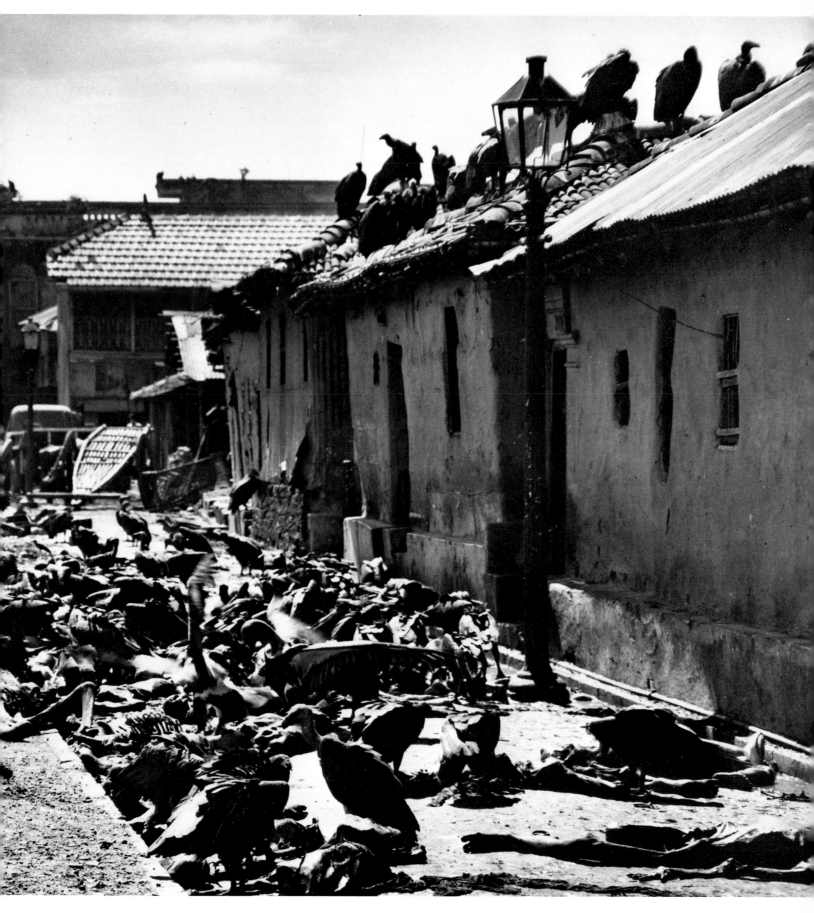

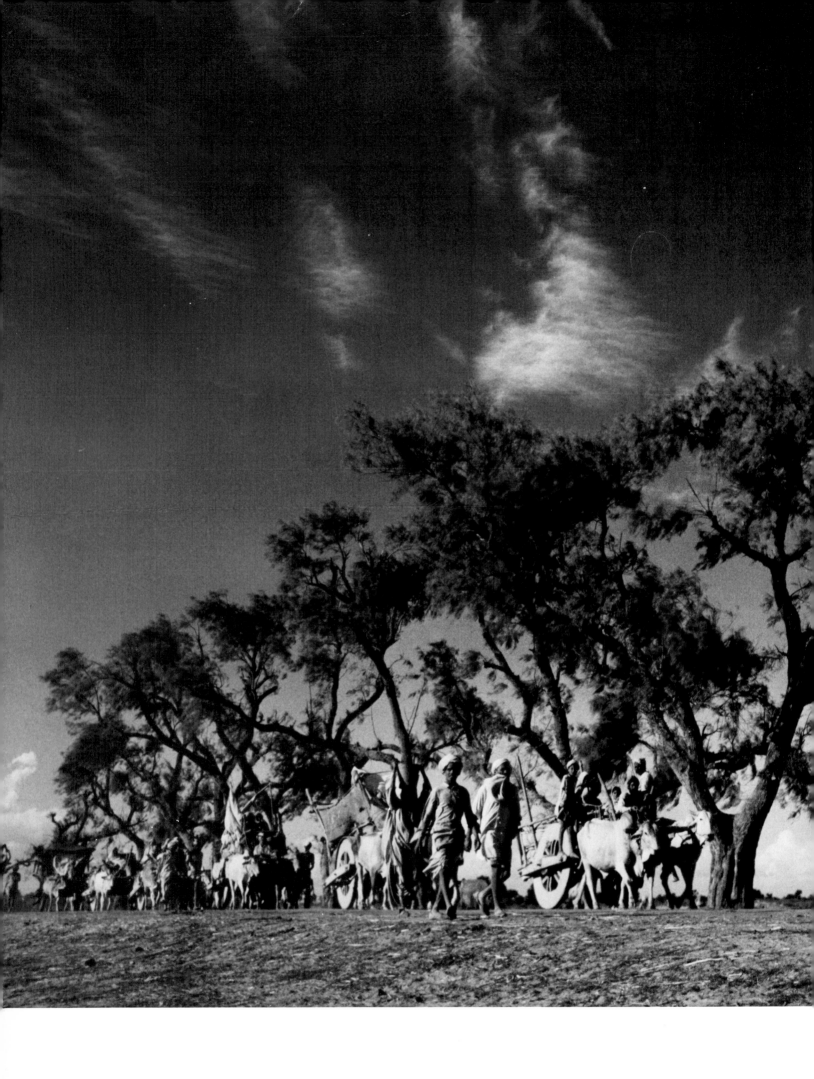

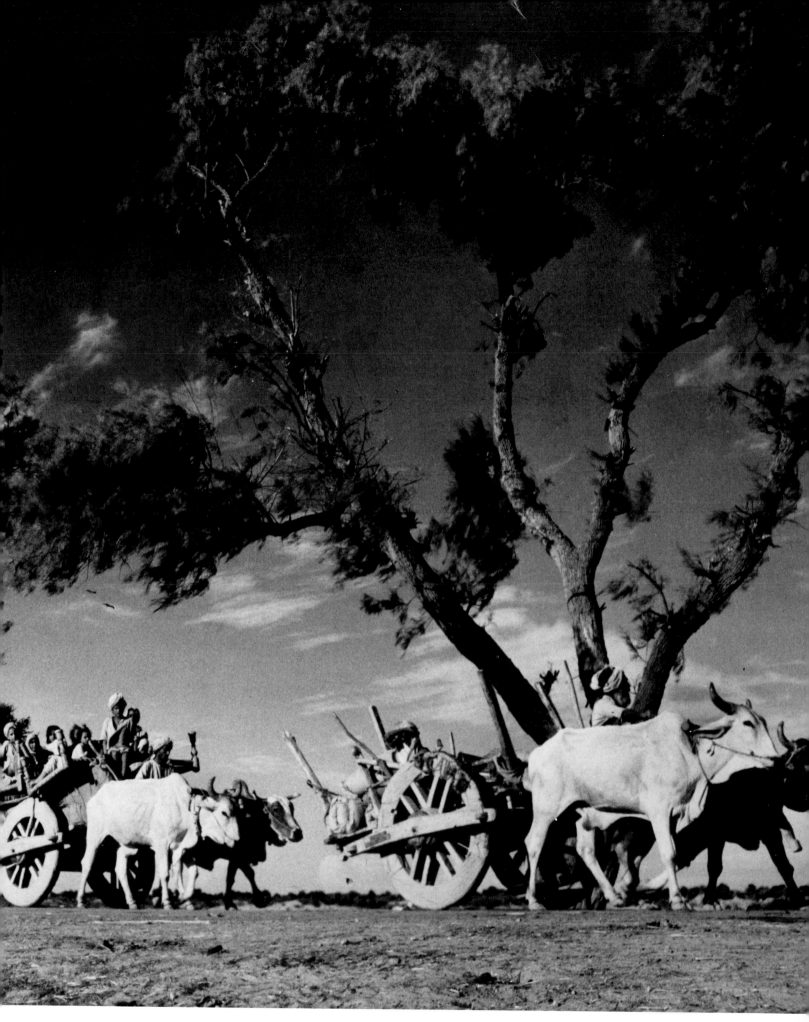

The Emigrant Train, Pakistan, 1947
Crude wooden carts dragged by bullocks clatter
across the dry Punjab plains. This procession of
uprooted Sikhs was 45,000 refugees long.

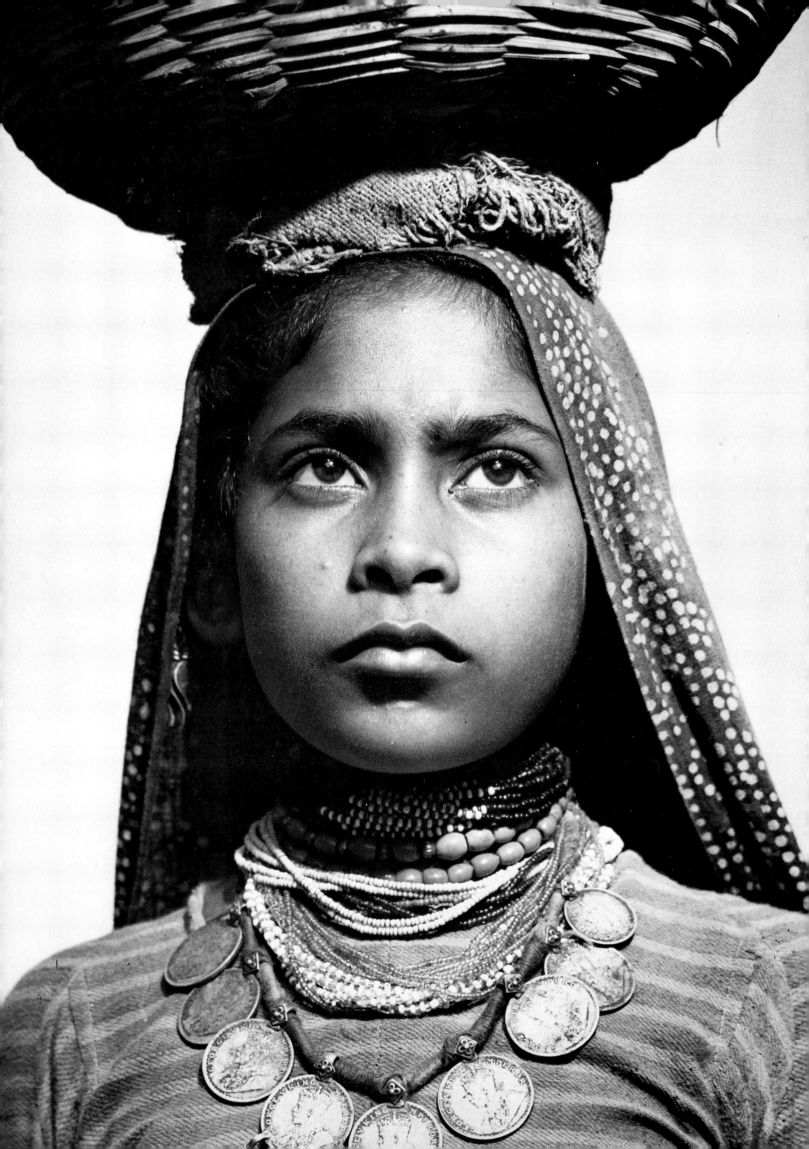

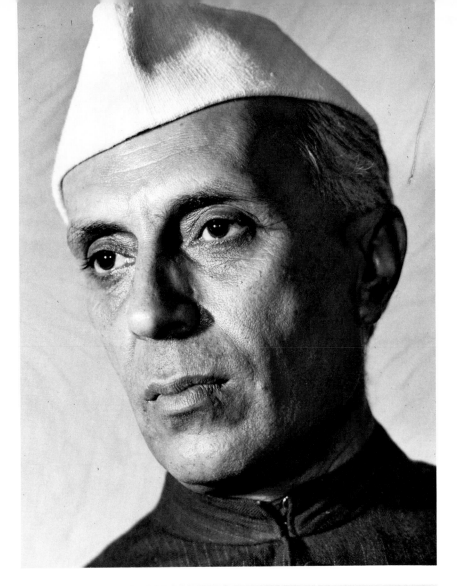

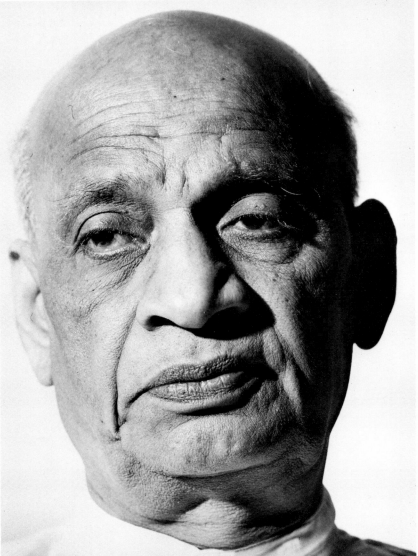

Vallabhbhai Patel, India, 1946 (left)

Jawaharlal Nehru, India, 1946 (above, left)
At the time of independence, Patel was Deputy
Prime Minister. He was a conservative, friendly
with businessmen and the rajas, and was Nehru's
chief rival. Prime Minister Nehru was a liberal
and long-time follower of Gandhi. An erudite,
Cambridge-educated Brahman, he formed the
bridge between India's past and the modern
western world.

Mohammed Ali Jinnah, Pakistan, 1948 (above)
The Muslim apostle of discord who carved the
two Pakistans out of India.

A Village Beauty, India, 1946 (opposite)
In the small fishing villages near Bombay a
young girl's necklace represents her life savings.

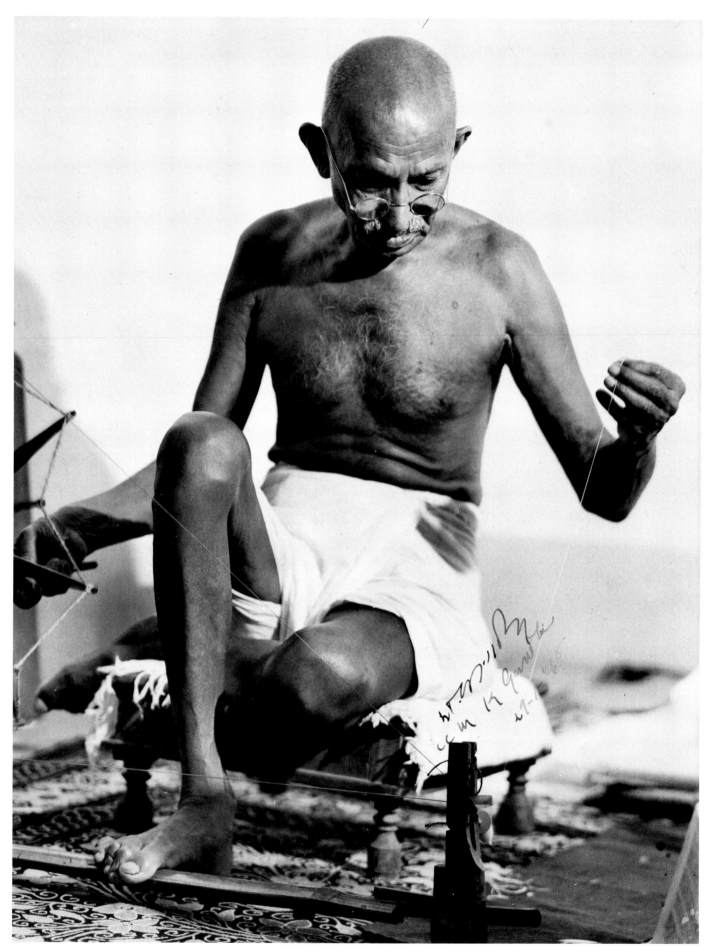

Gandhi Spinning, India, 1946

The charkha, a simple domestic spinning wheel, became
Gandhi's symbol for Indian independence. Bourke-White
interviewed him on her last day in India, bringing this print for
him to autograph. A few hours later he was assassinated.

The Village Well, India, 1946

The people of Venkatapuran descend ancient stone steps worn
smooth by the unshod feet of generations who have fetched
water at the village well.

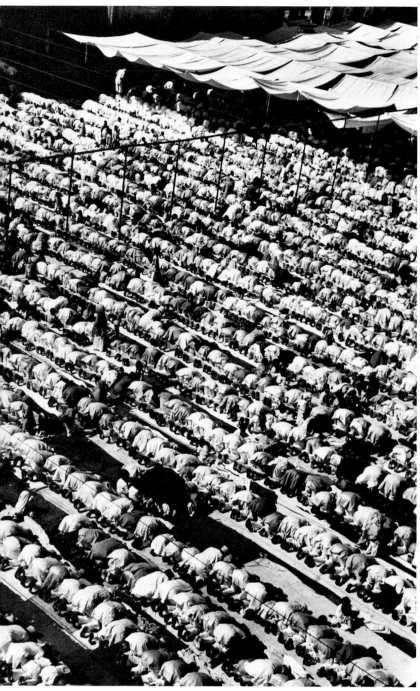

Toward Mecca, India, 1946

Devout Muslims gather in Delhi at Jami' Masjid, the
country's largest mosque, to offer prayers to Allah.

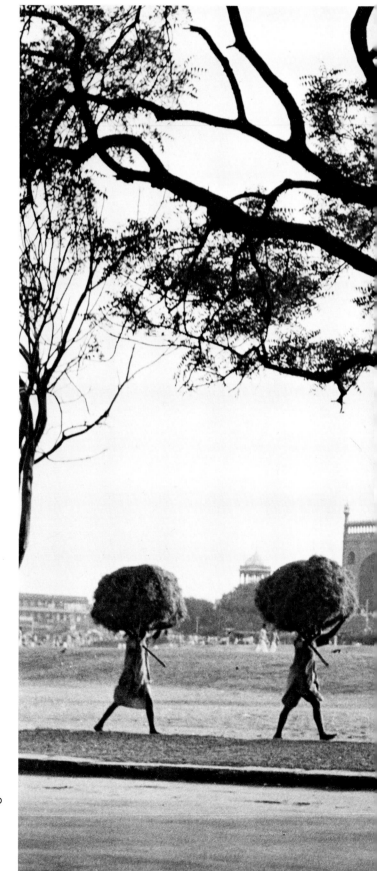

Grass Sellers, India, 1946

A procession of men bearing bundles of grass to
sell in the market of Delhi pass by the mosque.

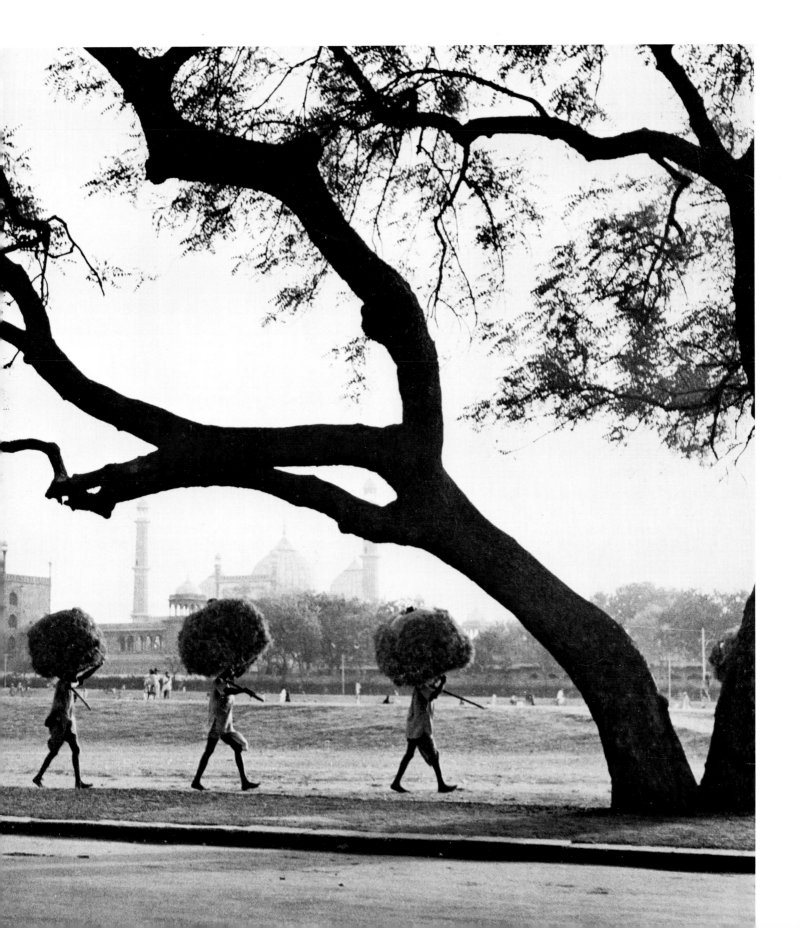

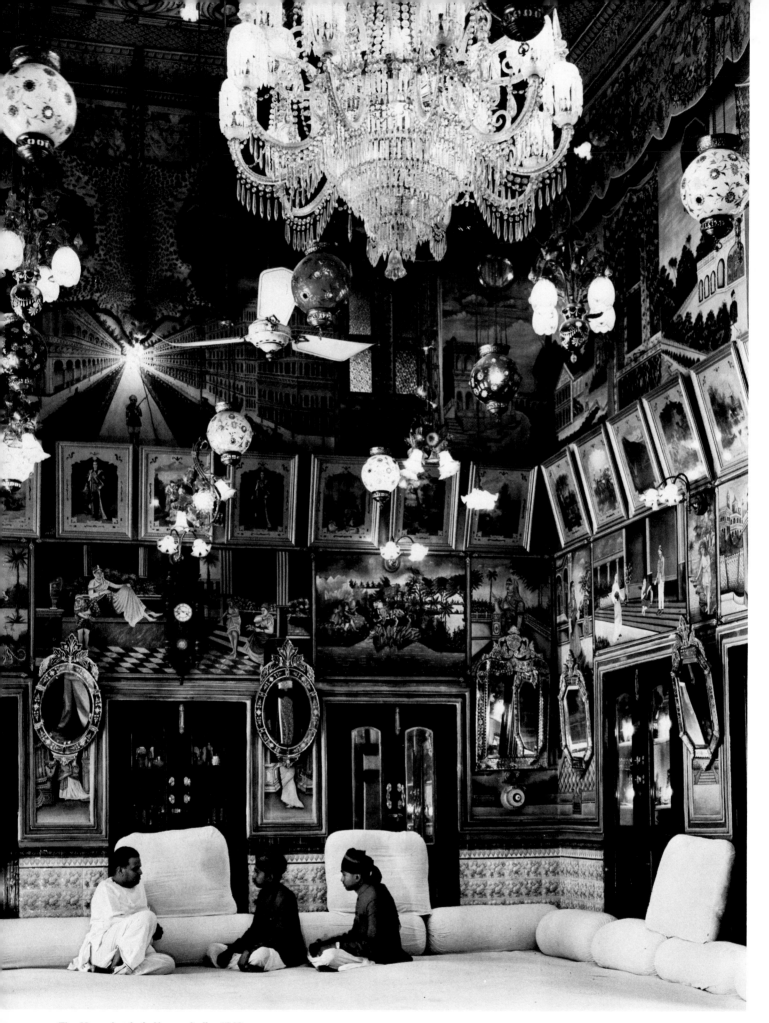

The Moneylender's House, India, 1946
Surrounded in gaudy luxury achieved by milking the
peasantry, Bhanwar Rampuria entertains his
brothers, who want to be moneylenders too.

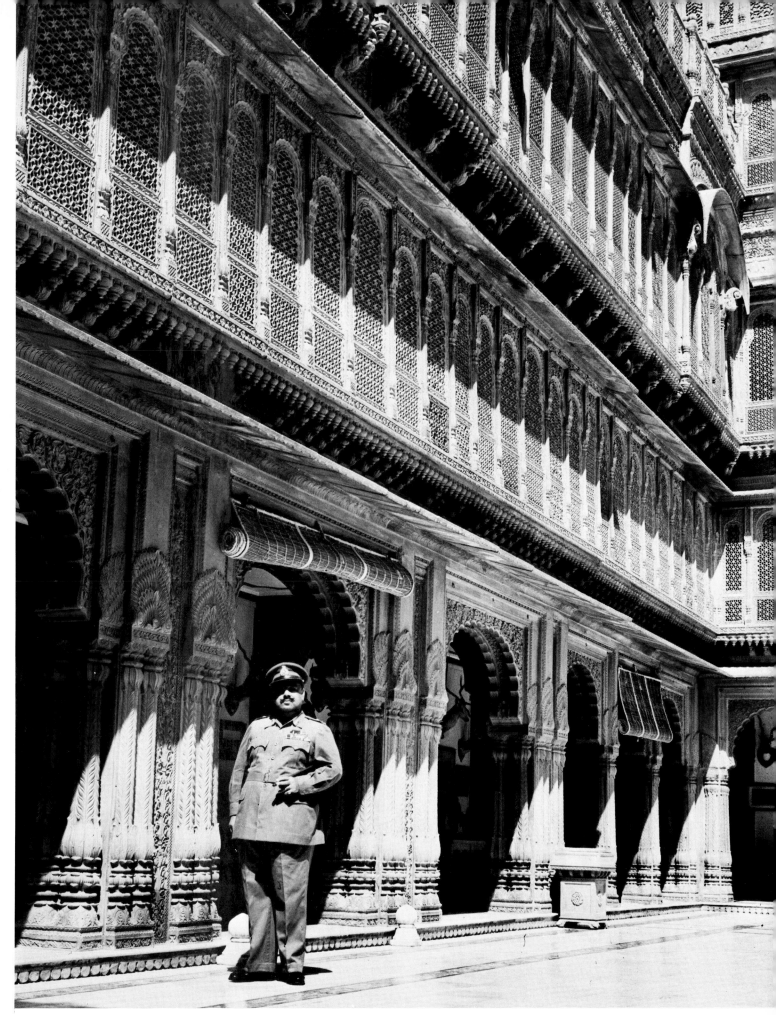

The Maharajah of Bikaner, India, 1946
The Raj stands proudly before his red sandstone palace. Behind the latticework above him are the sequestered cells of his many concubines.

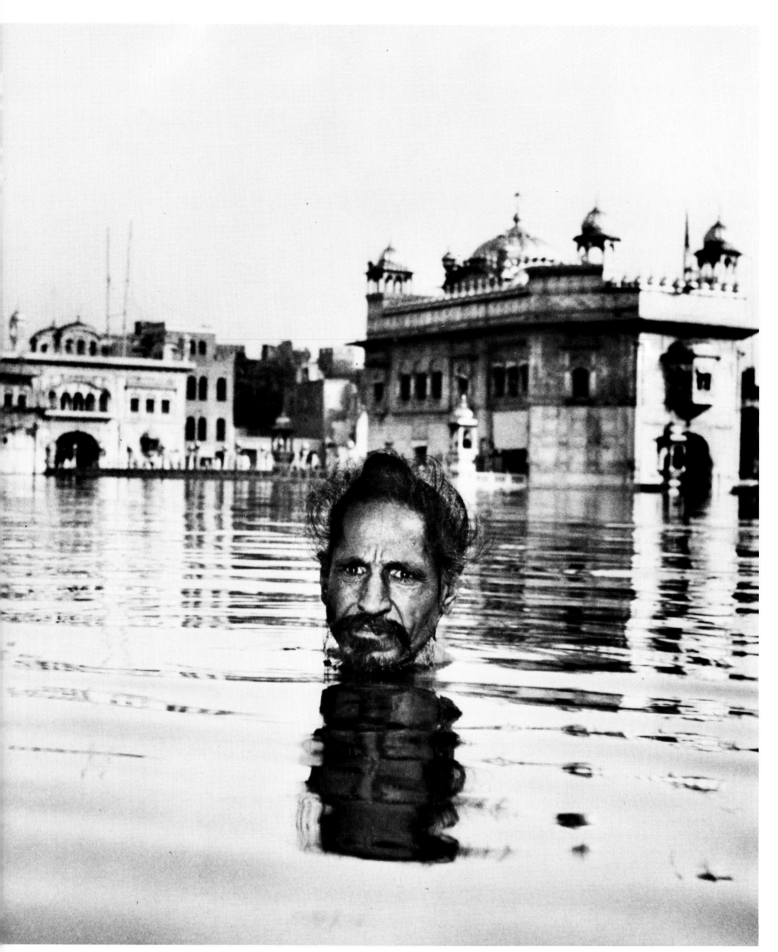

Sikh Bathing, India, 1946

A bearded Sikh refreshes both body and soul in the
Pool of Immortality that surrounds the Golden
Temple at Amritsar.

Death's Tentative Mark, India, 1946

During the famine this woman lived on cattle fodder.
When that ran out she existed for two months on a
diet of boiled leaves. A lifetime on the land spent in
grim poverty led at the end to starvation.

172

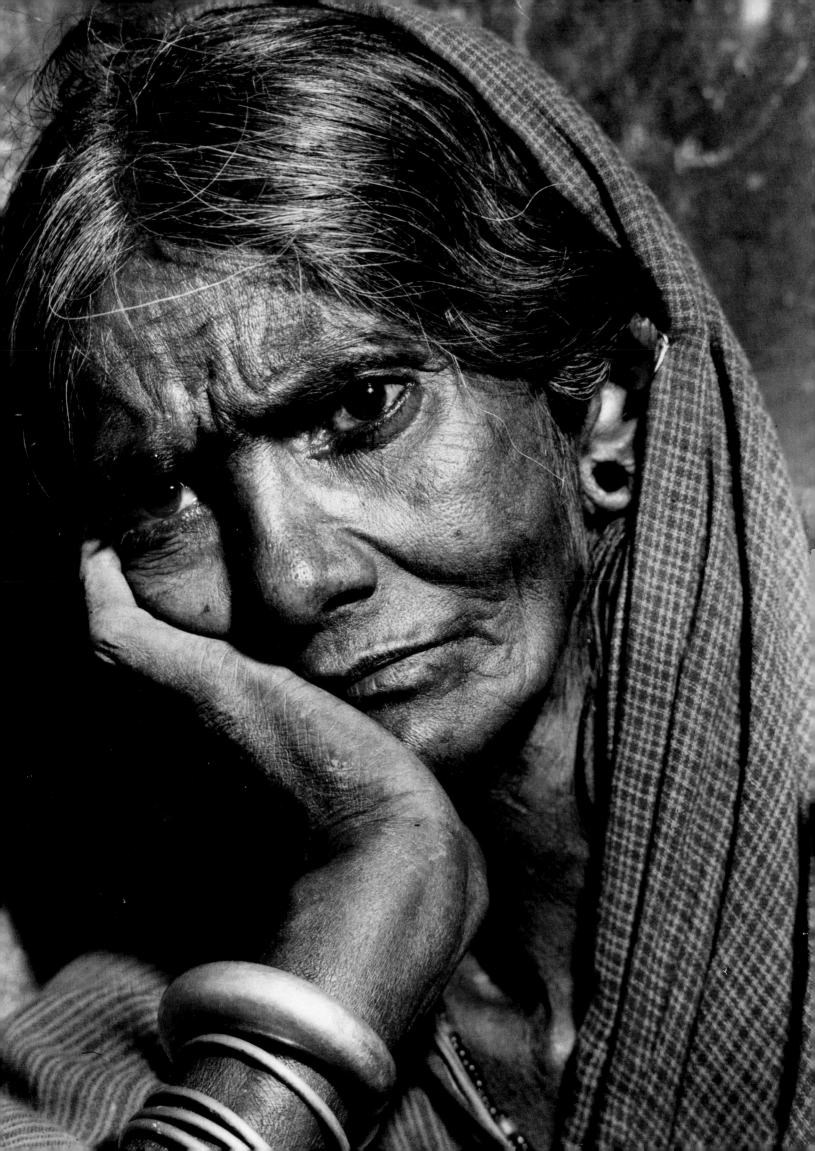

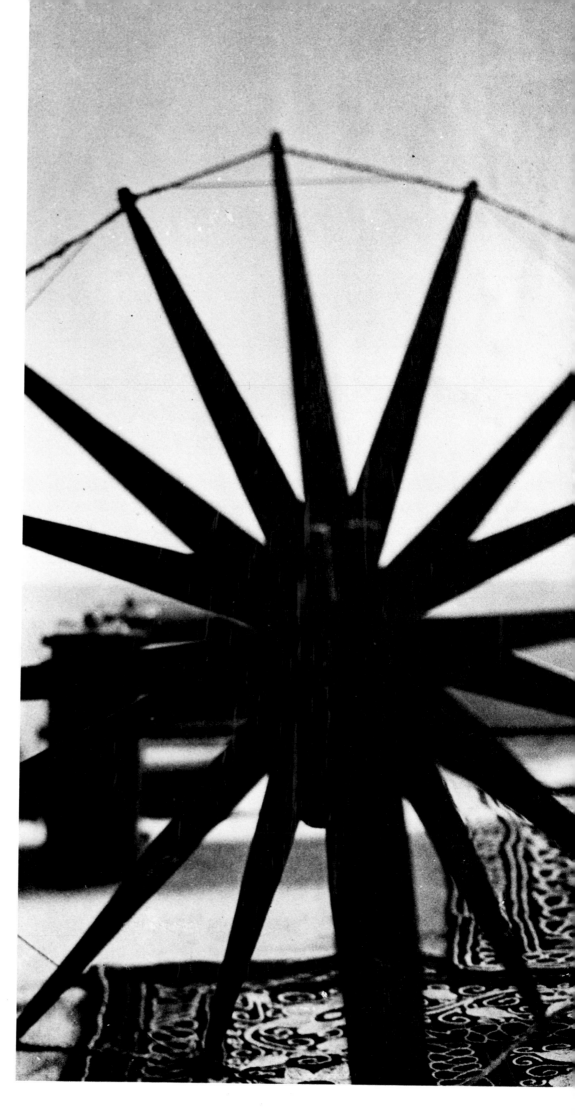

The Spinner, India, 1946

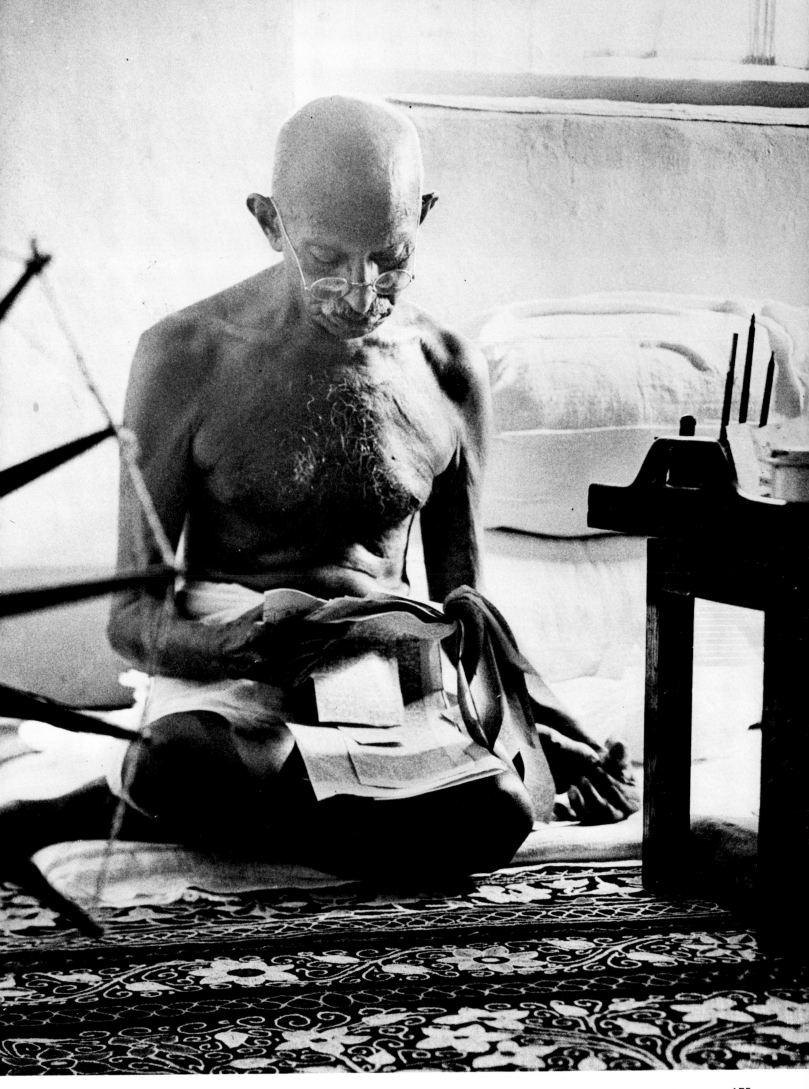

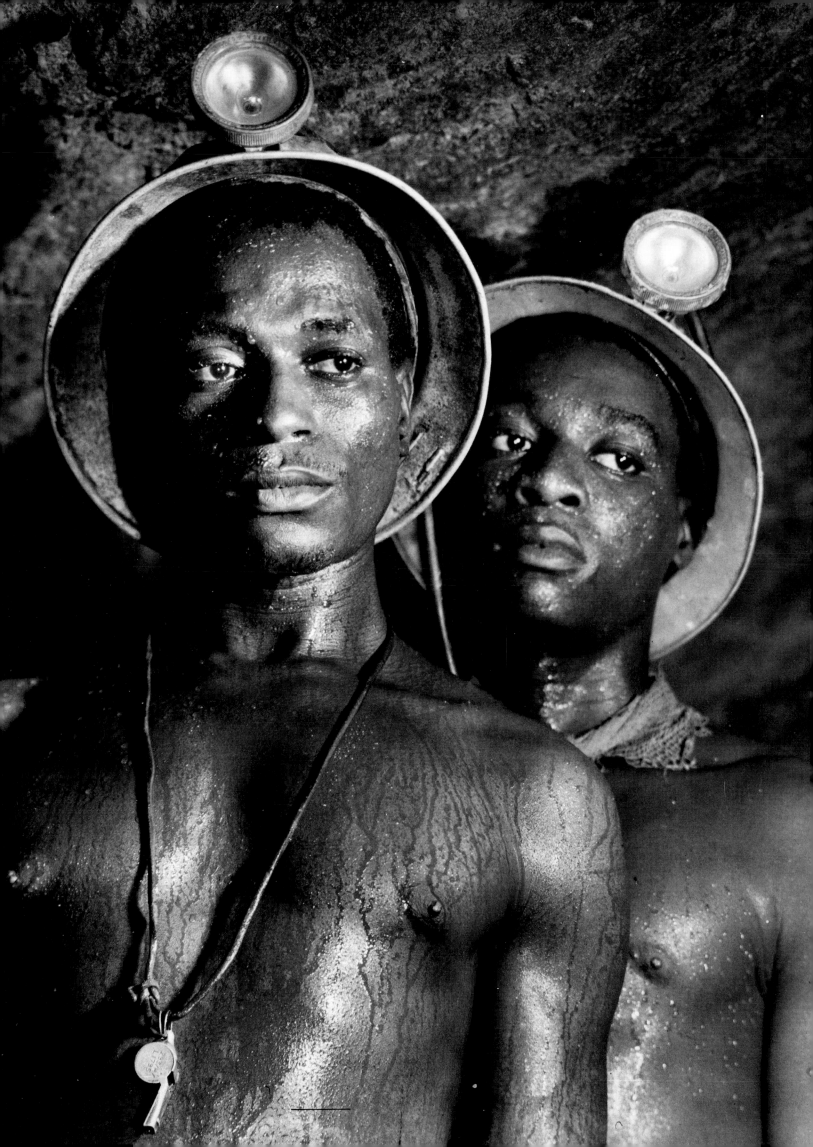

The Later LIFE Years
1950-1956

From her earliest days Bourke-White had a love for flying and a special affection for pilots. During the thirties she did the advertising for many of the major airlines. In the war she was assigned to the Air Forces, where she was on bombing raids led by generals and flew with Mosquito pilots in their rickety Cubs behind enemy lines. By the time she returned to the regular LIFE staff in 1950 she had become quite adept at aerial photography. If on any story there was a possibility of considering an aerial picture, she would immediately find a local pilot and charter his plane. Her stories on the New South, The Connecticut River Valley, Korea and SAC contained memorable pictures from the air. Finally a story was tailored to her taste called "A Helicopter View of the U.S.A." From this floating platform Bourke-White ranged across the continent for a startling new view of the nation. Her persistence at getting "just one more" or "just a little closer, please" produced numerous air violations that kept the editors on edge. Once while photographing a simulated rescue mission her chopper crashed and she had to be rescued herself.

During the Korean War LIFE was getting superb combat coverage from David Douglas Duncan, Carl Mydans, Mike Rougier and Howard Sochurek, to name a few. Bourke-White felt that there was something different about this war and spent three months there finding it. Korea was a guerrilla war fought by a people turned against themselves in the name of political ideology—a new and confusing concept for Americans. Bourke-White told the story by focusing on a Communist guerrilla who surrendered and was repatriated. She followed him back to his village where his family thought him long dead and photographed the tearful reunion in a rice paddy. The story, published in 1952, is a microcosm of the kind of coverage that later came out of Vietnam. To do it she operated in the guerrilla's mountain strongholds and was ambushed once but emerged unharmed. The only discomfort suffered was on her last night in Korea, spent in a cheap hotel in a tiny mountain village that, unknown to her, was in the midst of an encephalitis epidemic. The driving monsoon rains poured in and she got a chill. The next day she began a frantic forty-eight-hour dash to get her story back to New York. Writing in her memoirs about her losing battle with Parkinson's disease, she said: "I have a deep-rooted feeling that my illness dates from the night spent in the paper hotel in Korea with the mosquitoes and the pounding rain and the unknown epidemic. Parkinson's disease and encephalitis are very close. (Since she wrote this in 1968, medical research has proved a connection exists between the two that may someday unlock the secrets of both.) It is believed that Parkinson's may lie dormant for many years until some stress calls it forth. Whether my nerve-racking, frantic efforts at the airport did anything to precipitate Parkinson's, I will never know. One thing I do know, if I had been in a position to make a choice between getting my photographs in the fog, rain and wild mountains of Korea set against the risks involved, I would still choose to get my story—Parkinson's or no Parkinson's."

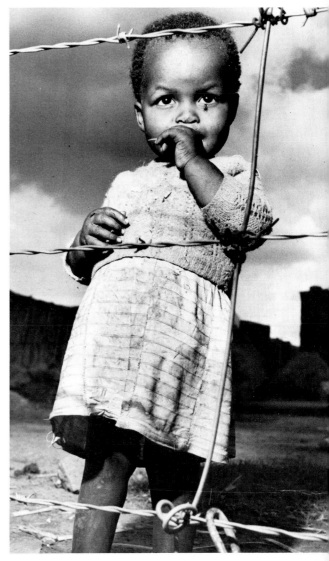

Shantytown Dweller, South Africa, 1950
A three-year-old slum dweller stands behind the barbed wire enclosure that surrounds her home at a camp for black squatters in Johannesburg.

South African Miners, 1950 (opposite)
Miners no. 1139 and 5122 stand in the sweltering heat of a tunnel more than a mile underground in a Johannesburg gold mine.

Johannesburg, South Africa, 1950 (overleaf)
The city made prosperous by the mining industry surrounds itself with mountains of waste gutted from the mines. Nothing grows there but heaps of yellow dust that spread out for 50 miles across the veldt.

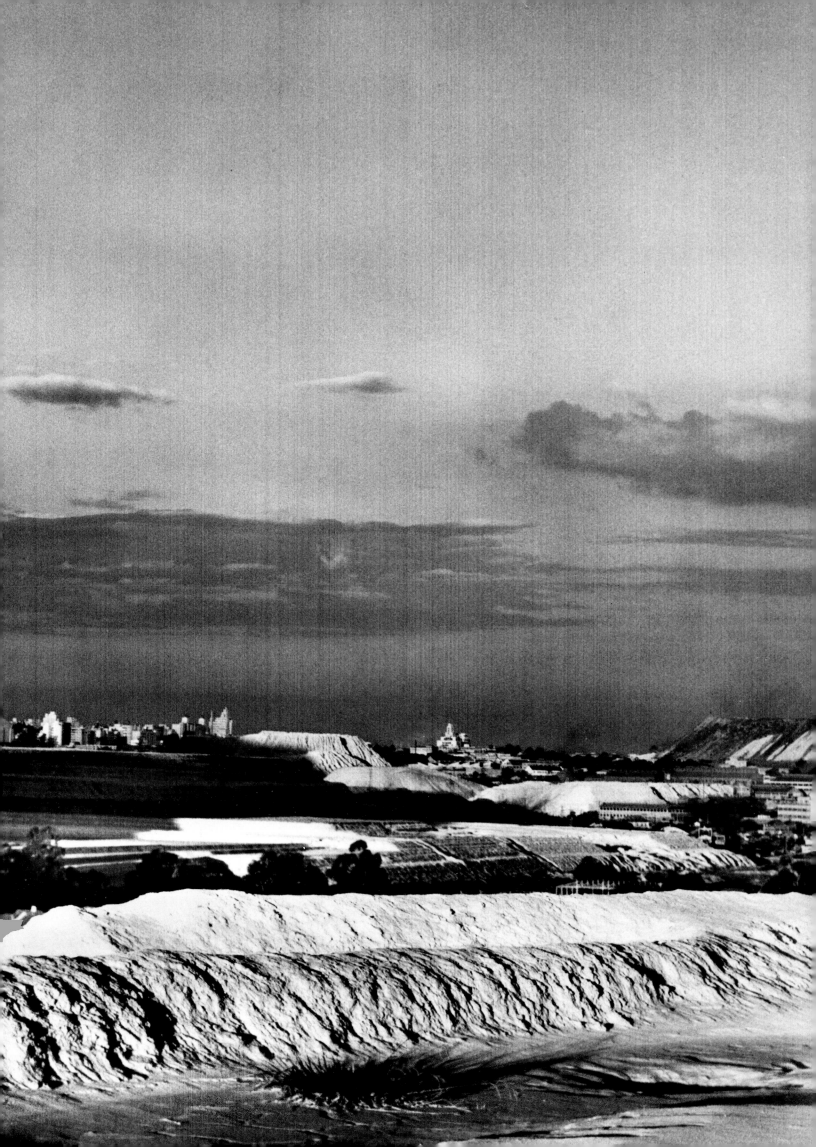

Round Barn, Piermont, New Hampshire, 1950
Ernest L. Stevens stands proudly before the 16-sided
barn he built in 1906. It houses 70 Holstein cows.
Stevens and his son-in-law Henry Dearborn run
Sunnybrook Farm which Bourke-White photographed
as part of an essay on the Connecticut River Valley.

Dairy Farmers, Piermont, New Hampshire, 1950

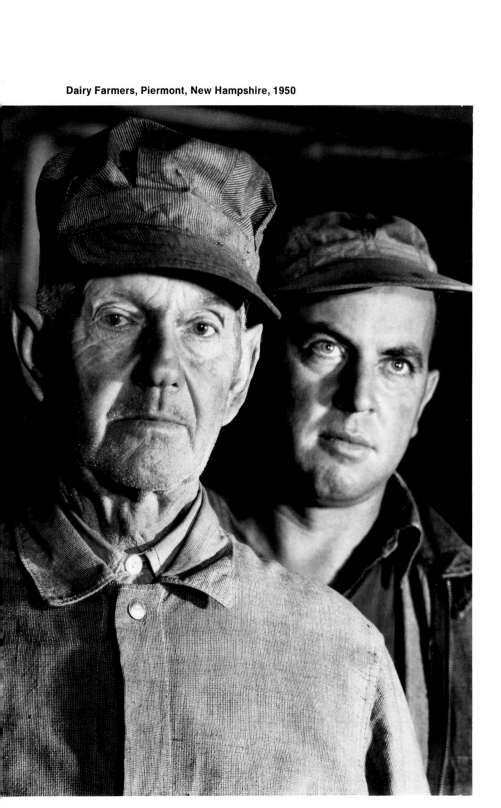

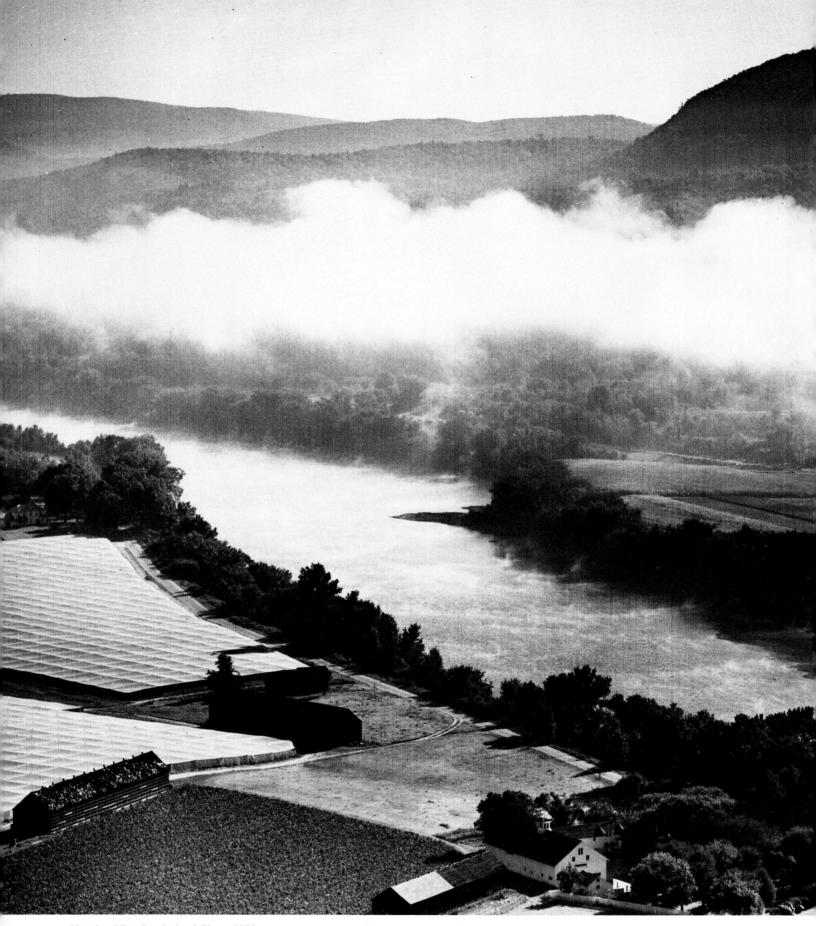

Morning Mist, Sunderland, Mass. 1950

A blanket of mist lifts off the Connecticut River to let
the morning sun warm cloth-shaded tobacco fields.

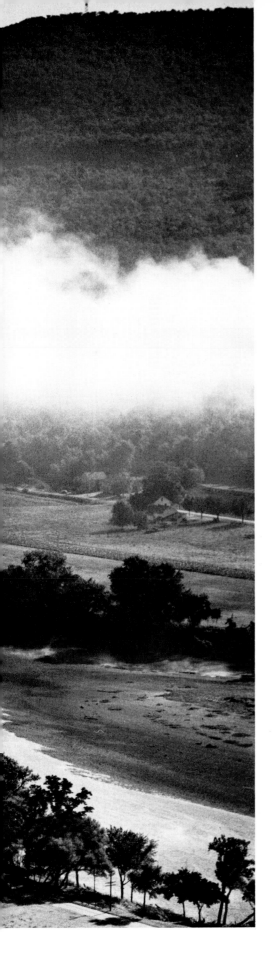

The Orderly River, Hadley, Mass., 1950

Protective Pattern, Walsh, Colorado, 1954

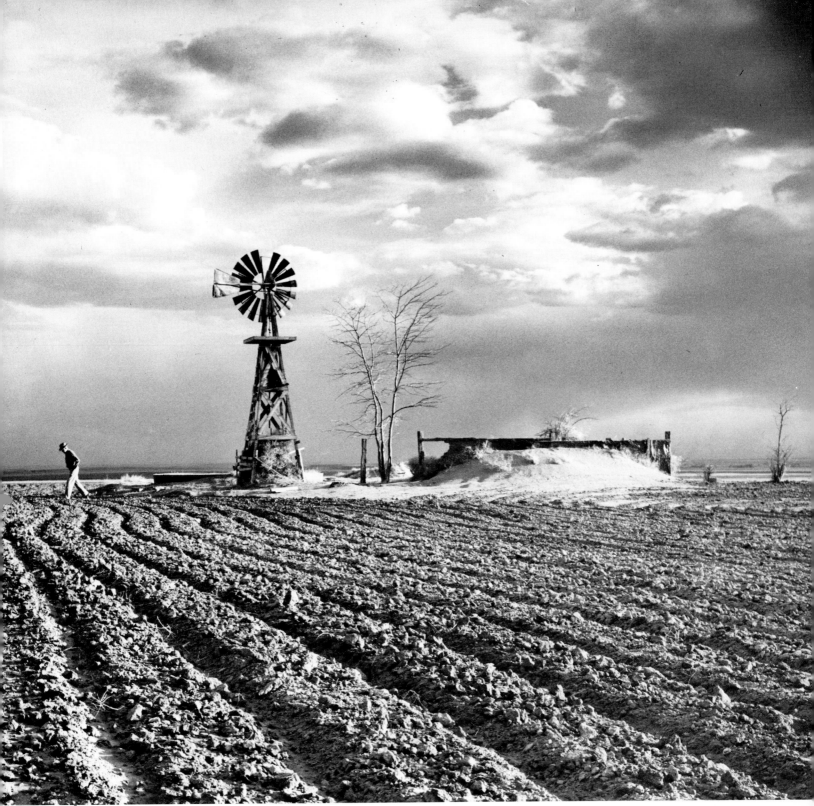

Theatening Storm, Hartman, Colorado, 1954
Twenty years after her "Drought" essay for
FORTUNE Bourke-White was photographing
another drought, this time in the Southwest for
LIFE. Mismanagement of marginal land had created
a dust bowl of 16 million acres. Farmers tried to stem
the drought with heavily chiseled furrows *(above)*
and contour plowing *(left)* but it grew to be a
nightmarish sequel more costly than the crisis
during the depression years.

South Korean Villages, 1952

At harvest time their impeccably manicured rice
fields looked like needlepoint from the air. Villagers
were defenseless in the face of marauding
Communist guerrilla forces and had to be protected
by police patrols (above).

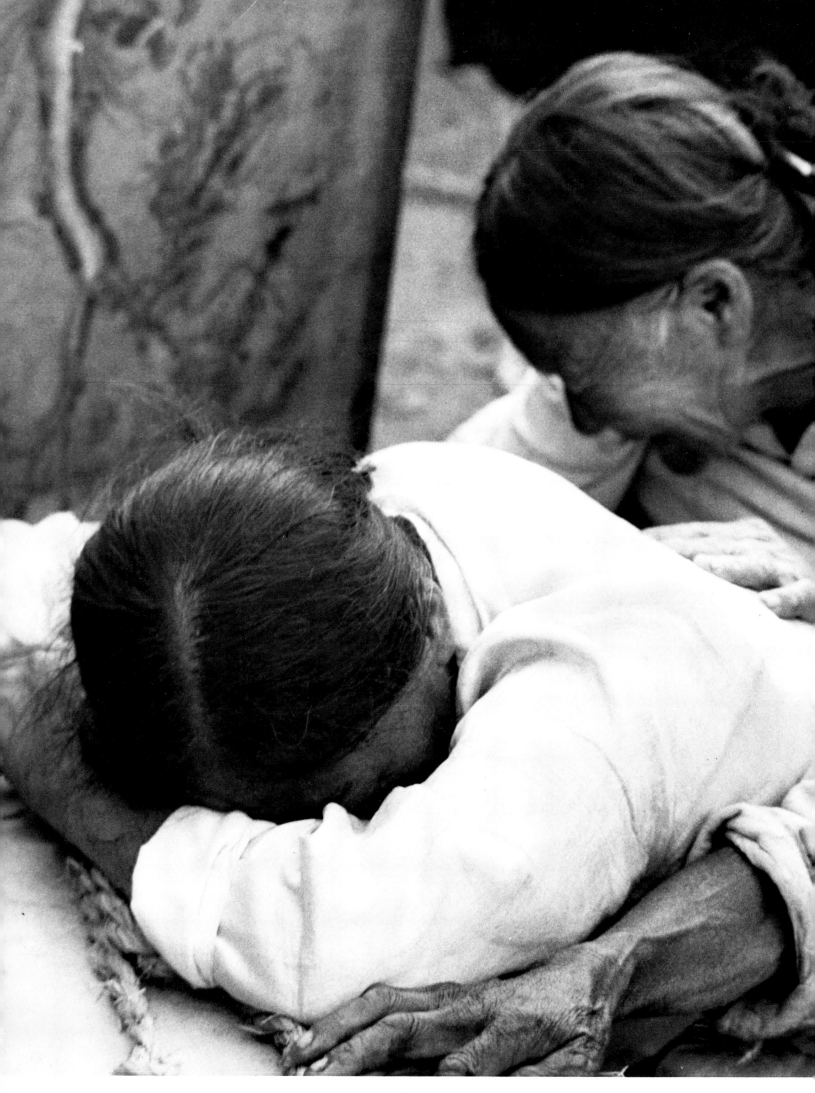

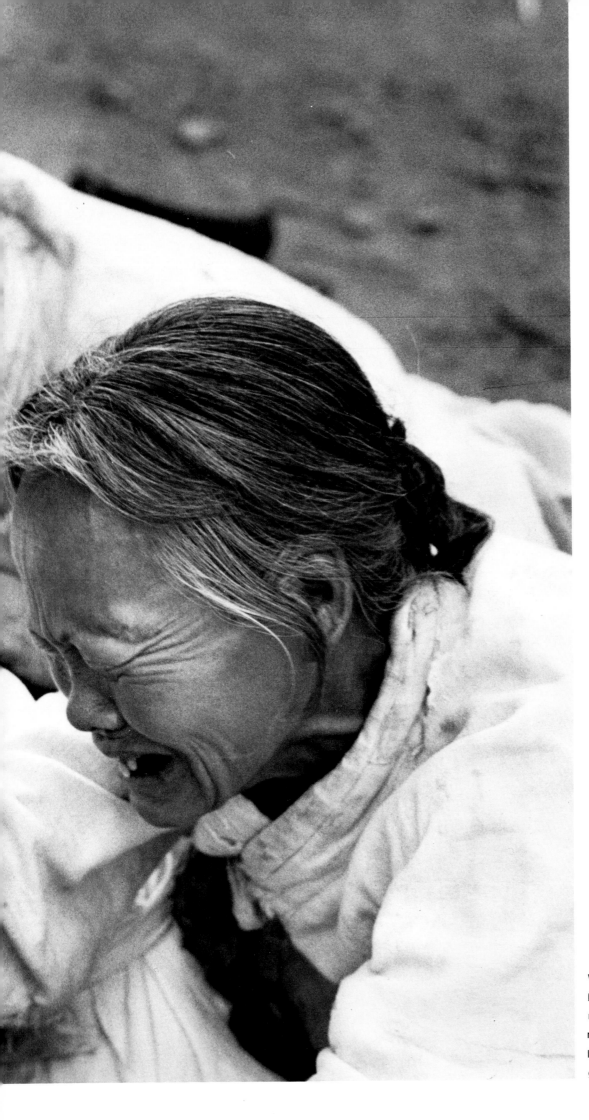

Weeping Women, Korea, 1952
Huddled in grief over a
rude coffin, the women of a small
mountain village mourn the
loss of a young man killed by
guerrillas in a firefight.

189

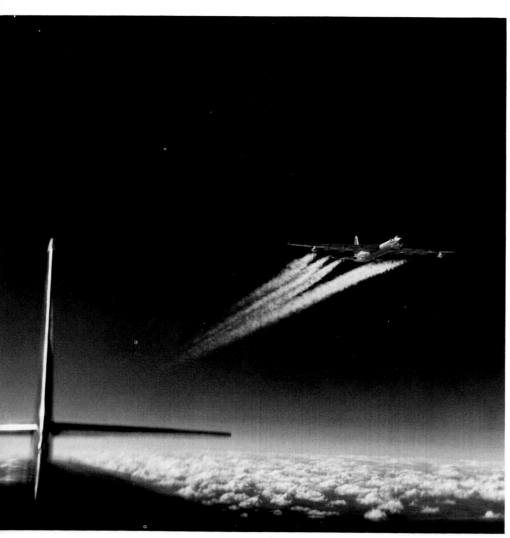

B-36 at High Altitude, 1951

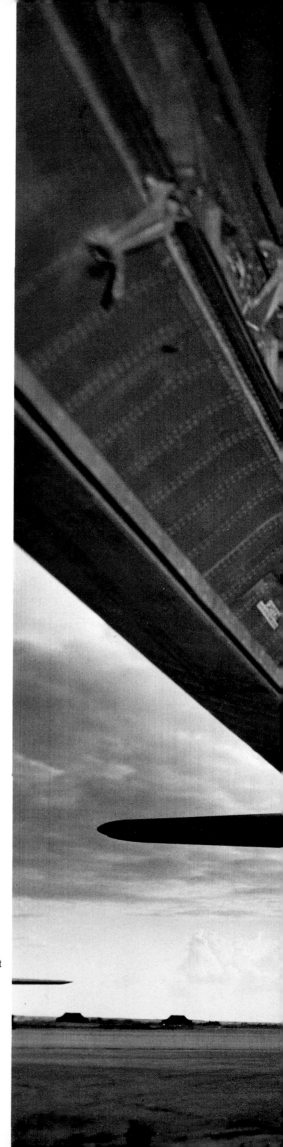

Bomb Bay of B-36, 1951

One of the most awesome forces ever assembled in U.S. military history was the Strategic Air Command. Its mainstay in the early fifties was the lumbering B-36, one of the largest aircraft ever built. It was a long-range bomber which, with mid-air refueling, could stay in the air indefinitely and deliver a nuclear payload anywhere on the globe. A brilliant and highly advanced concept for the day, SAC was the main U.S. deterrent during the Cold War. Bourke-White wanted to convey the size and power of the operation and symbolized it with this picture of the business end of the bomber at Carswell Field in Fort Worth, Texas. On the same assignment, at 41,000 feet over Wichita, Kansas, she photographed the plane from the cockpit of a B-47.

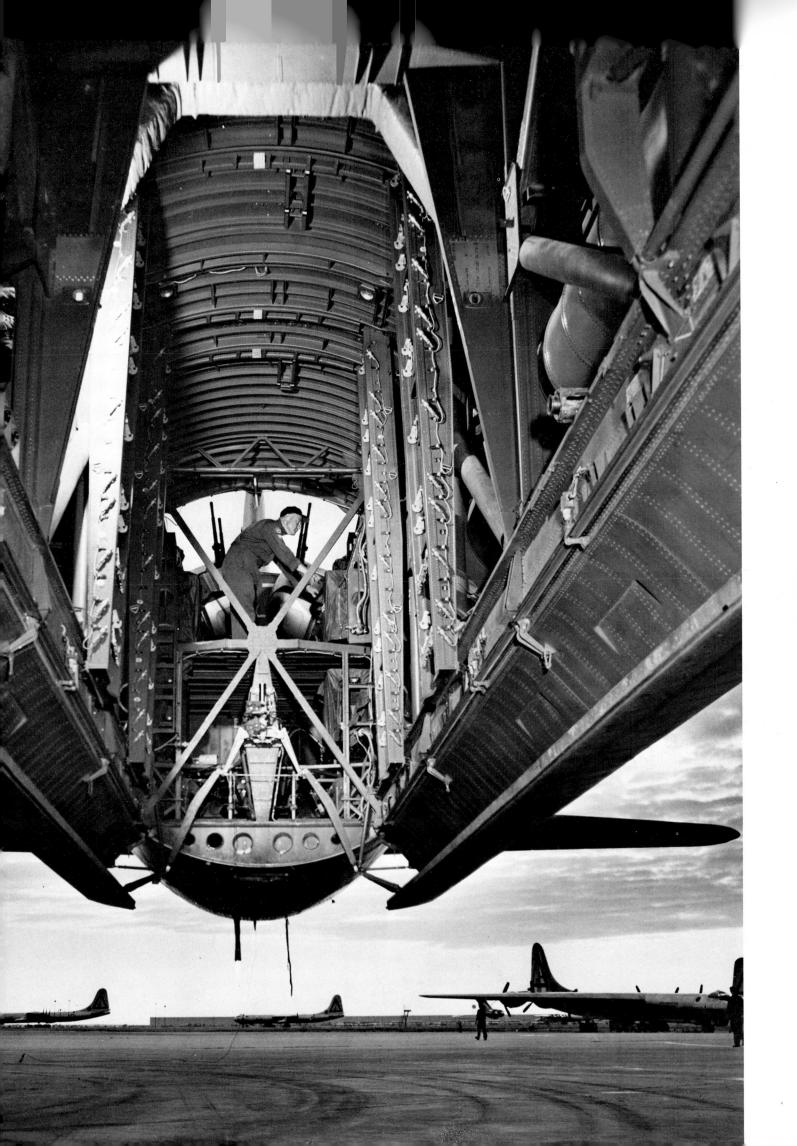

The Face of Liberty, New York, 1952
One of the most exciting aircraft developments to
come out of the Korean War was the helicopter.
Bourke-White was one of the first to see it as a
photographic tool, using it as a camera platform to
obtain a fresh point of view on the look of the U.S.

San Jacinto Monument, Texas, 1952

The Jesuits, Florissant, Missouri, 1954
Twice a day as they walk, seminarians examine their
consciences in a prescribed spiritual exercise.

Beach Riders, Fort Funston, California, 1952
Horsemen trot along a deserted beach lapped by
long, low Pacific rollers that throw up a cottony
surf pattern.

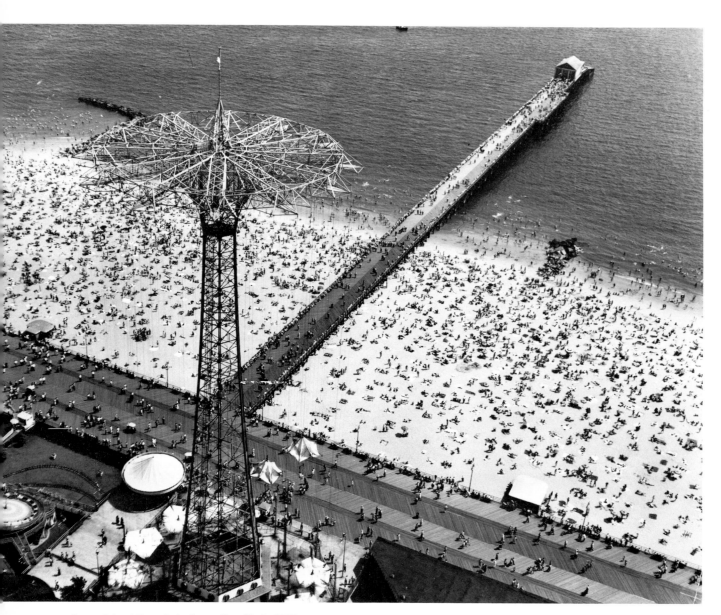

Coney Island Parachute Jump, New York, 1952

Beach Accident, Coney Island, New York, 1952
While photographing New York's popular
amusement park and beach area, Bourke-White
chanced upon a swimming accident and captured
the pattern of a curious crowd encircling the
life-saving efforts.

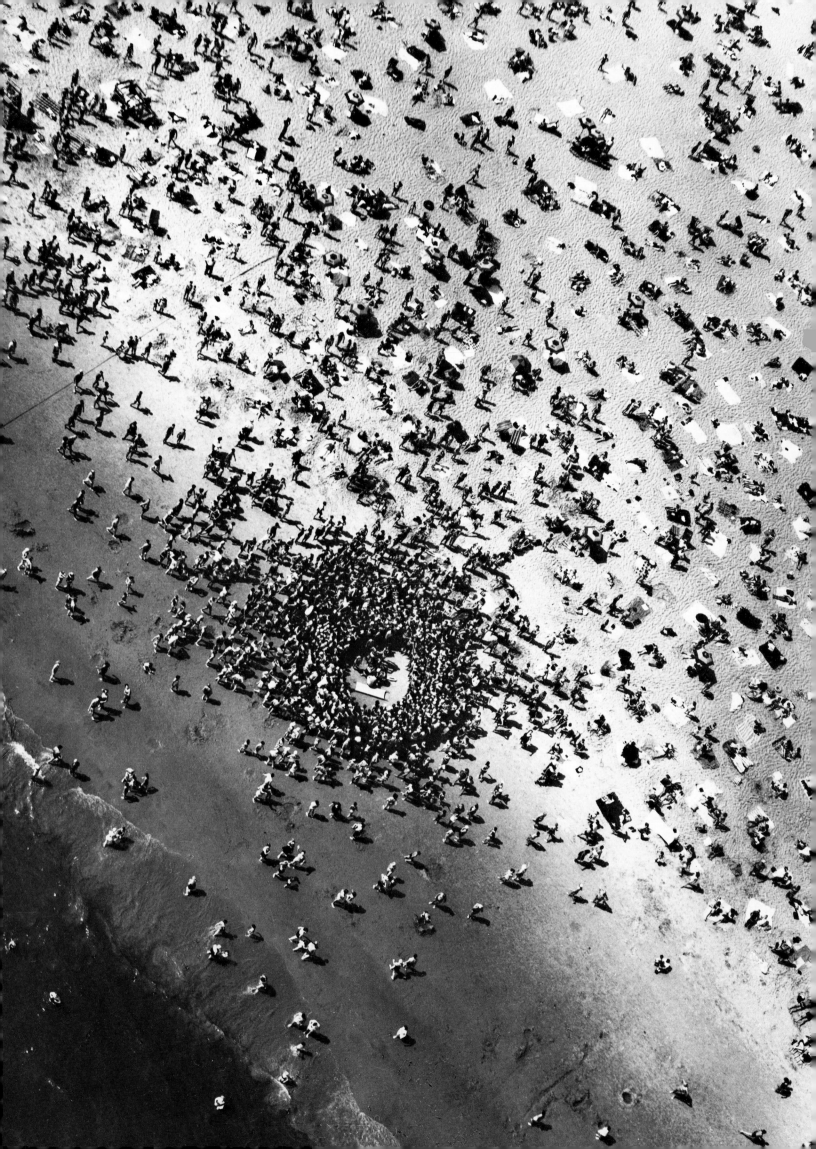

Queen Elizabeth, New York Harbor, 1952

A team of scuttling tugboats noses the giant liner

into her Hudson River berth.

San Francisco Bay, 1952

Sailboats cruise in dappled waters framed by the
shadow of the Golden Gate Bridge.

Snow Geese, Back Bay, Virginia, 1952 (overleaf)

199

Acknowledgments

This book began a little more than a year before the death of Margaret Bourke-White so it is to Margaret that I'm most grateful for her faith in me as her editor and collaborator. I'm indebted to her brother Roger B. White and his family for their contribution in giving me access to the estate after her death. The editors of LIFE, in particular Ron Bailey, Director of Photography, and his predecessor, Dick Pollard, I thank for giving me the time and facilities to complete this project. Thanks to Paul Welch of Time Inc.'s Editorial Services, Doris O'Neil and her staff in the Picture Collection, and George Karas and his Photo Lab crew who assisted in the production. Special thanks to such able technicians as Gerald Lowther, Marty Olsen, Carmine Ercolano and Jules Zalon, to name but a few, who worked long hours coaxing fresh images out of faded old negatives.

I'd like to thank M. L. Pacent, my assistant during the research stage of the book, who spent many hours going through the negative files in the Time Inc. sub-basement. Thanks to Ted Brown for his fine introduction and constant encouragement. To Gjon Mili and Carl Mydans, distinguished photographers and long-time friends of Bourke-White, my thanks—to Gjon for his wise counsel and to Carl for his affectionate foreword. Credit is to be given to gallery owner Lee Witkin, whose interest in Bourke-White has led to a new appraisal of her work as an artist. I'm grateful to Peter Schwede of Simon and Schuster who published many of Margaret's books for permission to excerpt portions of her previously published text. And thanks to New York Graphic Society editor Bob Morton for his support and to Ed Hamilton for his splendid design of this book.

S. C.

Selected Bibliography

compiled by Theodore M. Brown

Books by Margaret Bourke-White

1931

Eyes on Russia, Simon and Schuster, New York.

Reviews

Krutch, J. W., "Photography as an Art," *The Nation,* January 20, 1932, pp. 77-78.

"Pictures of Russia," *The Cornell Alumni News,* Vol. 34, No. 18 (February 18, 1932), p. 220.

"Seeing Russia," *The Saturday Review of Literature,* Vol. 13, No. 21 (December 12, 1931), p. 367.

"Soviets by Camera," *Time,* Vol. 18, No. 24 (December 14, 1931), p. 56.

1934

U.S.S.R. Photographs, The Argus Press, Albany, N.Y.

1937

(with Erskine Caldwell) *You Have Seen Their Faces,* The Viking Press, New York.

Reviews

"The Book Forum," *Forum,* Vol. 98, No. 6 (December 1937), p. vii.

"Books in Review," *The New Republic,* Vol. 93, No. 1199 (November 24, 1937), p. 78.

Cousins, N. B., "The World Today in Books," *Current History,* Vol. 47, No. 3 (December 1937), p. 8.

Davidson, D., "Erskine Caldwell's Picture Book," *The Southern Review,* Vol. 4, No. 1 (Summer 1938), pp. 15-25.

Gelder, Robert van, "A Compelling Album of the Deep South," *New York Times Book Review,* Sunday, November 28, 1937, p. 11.

Marshall, M., "Their Faces," *The Nation,* Vol. 145, No. 23 (December 4, 1937), p. 622.

"Share-Cropper Saga," *St. Paul Sunday Pioneer Press,* January 9, 1938.

"Speaking Likenesses," *Time,* Vol. 33, No. 20 (November 15, 1937), pp. 94-96.

"The Story of the Share-Cropper," *The Minneapolis Sunday Tribune,* November 28, 1937.

Thompson, R., "Books of the Times," *New York Times,* Wednesday, November 10, 1937, p. 29.

1939

(with Erskine Caldwell) *North of the Danube,* The Viking Press, New York.

Reviews

Stone, S., "Miss Bourke-White and Mr. Caldwell Saw the Czechs," *New York Times Book Review,* Sunday, April 2, p. 9.

Thompson, R., "Books of the Times," *New York Times,* Wednesday, April 5, p. 29.

1941

(with Erskine Caldwell) *Say, Is This the U.S.A.,* Duell, Sloan and Pearce, New York.

Reviews

Crandell, R. F., "Come Back Mr. and Mrs. Caldwell," *New York Herald Tribune,* June 29, 1941.

"Graphic Story of the Face of the Nation," *The Herald Tribune,* Durham, N.C., June 29, 1941.

Patterson, A., "Say, Is This the U.S.A.," *Evening Times-Herald,* Washington, D.C., June 29, 1941.

"Ten Thousand Miles Over the U.S.A.," *New York Times Book Review,* Sunday, July 6, 1941, p. 7.

Thompson, R., "Books of the Times," *New York Times,* Thursday, June 26, 1941, p. 21.

1942

Shooting the Russian War, Simon and Schuster, New York.

Reviews

Chamberlain, J., "Books of the Times," *New York Times,* Thursday, July 2, 1942, p. 19.

Duel, W. R., "With the People of Russia as They Fight the War," *New York Times Book Review,* July 19, 1942, p. 3.

Gayn, M., "With Notebook and Camera in Russia," *Saturday Review,* Vol. 25, No. 34 (August 22, 1942), p. 10.

1944

They Called It "Purple Heart Valley," Simon and Schuster, New York.

Reviews

Hackett, F., "Books of the Times," *New York Times,* Thursday, December 7, 1944, p. 23.

Hailey, F., "Cassino Corridor," *New York Times Book Review,* Sunday, November 26, 1944, p. 7.

1946

"Dear Fatherland, Rest Quietly," Simon and Schuster, New York.

Reviews

Prescott, O., "Books of the Times," *New York Times,* Wednesday, December 4, 1946, p. 29.

White, W. L., "In the Ruins of the Third Reich," *New York Times Book Review,* Sunday, December 15, 1946, pp. 1 and 28.

1949

Halfway to Freedom, Simon and Schuster, New York.

Reviews

Fischer, L., "Across India with a Camera and Typewriter," *Saturday Review,* Vol. 32, No. 26 (June 25, 1949), pp. 12-13.

"India Halfway to Freedom," *Toronto Daily Star,* Saturday, June 4, 1949.

Isaacs, H. R., "Liberated India in Words and Pictures," *New York Herald Tribune Book Review,* June 26, 1949, p. 3.

Kilbourn, J., "Epic of the New India," *New York Times Book Review,* May 29, 1949, p. 5.

Prescott, O., "Books of the Times," *New York Times,* Wednesday, May 25, 1949, p. 27.

Stead, R., "In the History of Nations: the Rare Birth of Twins," *The Christian Science Monitor,* June 9, 1949.

1956

(with John La Farge) *A Report of the American Jesuits,* Farrar, Straus and Cudahy, New York.

1963

Portrait of Myself, Simon and Schuster, New York.

Reviews

Bigart, H., "A Shutter open on the World," *New York Times Book Review,* Sunday, July 7, 1963, pp. 7, 20, and 21.

Brunn, R. R., "Miss Bourke-White," *The Christian Science Monitor,* Wednesday, July 3, 1963, p. 11.

"Courageous Woman," *Atlantic Monthly,* Vol. 212, No. 2 (August 1963), pp. 122-124.

Deschin, J., "A Self Portrait," *New York Times,* sect. II, Sunday, August 25, 1963, p. 14.

La Farge, J., "Portrait of Myself," *America,* Vol. 109, No. 7 (August 17, 1963), p. 174.

Parton, M., "The Lady of the Lens," *New York Herald Tribune, Books,* June 30, 1963, p. 3.

Rivers, W. L., "Focussing a Wide Angle Lens on Life," *Saturday Review,* Vol. 46, June 29, 1963, pp. 24-25.

Articles by Margaret Bourke-White

1932

Series on the Soviet Union, *New York Times Magazine,* Sundays, February 14, pp. 4 and 5; March 6, 4 and 5; March 13, 8 and 9; March 27, 8,9, and 23; May 22, 8 and 9; September 11, 7 and 16.

1934

"The Market Place," *American Photography,* Vol. 28, No. 9, September, pp. 585-589.

1935

"Dust Changes America," *The Nation,* Vol. 140, No. 3646, May 22, pp. 597-598. Reprinted in this book.

1936

"Photographing This World," *The Nation,* Vol. 142, No. 3685, pp. 217-218. Reprinted in this book.

1938

"Your Business as the Camera Sees It," *Nation's Business,* Vol. 26, April, pp.30-32.

1941

"Trip to the Front," *Life,* Vol. 11, No. 20, November 17, p. 37.

"How I photographed Stalin and Hopkins Inside the Kremlin," *Life,* Vol. 11, No. 10, September 8, 26-27.

1942

"Photographer in Moscow," *Harper's Magazine,* Vol. 184, No. 1102, March, pp. 414-420.

1949

"A New Day Dawns for India's Women," *The Star Weekly,* Toronto, June 18.

"The Nizam Capitulates," *The Star Weekly,* Toronto, May 7.

1951

"I'll Monitor Your Breath," *Life,* Vol. 31, No. 9, August 27, pp. 92-93.

1952

"Shooting from a Whirlibird," *Life,* Vol. 32, No. 15, April 14, p. 140.

1957

"My First Job," *Ladies Home Journal,* Vol. 74, April, p. 197.

"Best Advice I Ever Had," *Reader's Digest,* Vol. 70, May, pp. 84-86.

1959

"They Called Me Incurable," *Reader's Digest,* Vol. 75, October, pp. 91-95.

1963

"Assignments for Publication," *The Encyclopedia of Photography,* Vol. 2, New York, pp. 274-280.

"Excerpts from Portrait of Myself," *Life,* Vol. 54, June 28, pp. 85 ff.

1964

"Portrait of Myself," *U.S. Camera Annual, 1964,* pp. 183-190.

1968

"Mahatma Gandhi," in Yelen, W. and Giniger, K. S., *Heroes For Our Times,* Harrisburg, Pa., pp. 88-109.

Published Photographs by Margaret Bourke-White

Architectural Forum
1932

"Office and Studio of Margaret Bourke-White," Vol. 56, No. 1, January, pp. 28-32.

Architectural Record
1929

"Portfolio of Five Industrial Photographs," Vol. 66, No. 6, December, pp. 504-508.

1934

"Photomurals in N.B.C. Studios," Vol. 76, No. 2, August, pp. 129-138.

1935

"George Washington Bridge," Vol. 78, No. 2, August, p. 74.

Arts and Decoration
1936

"Night View of an American City," Vol. 45, No. 3, p. 12.

The Cleveland District Golfer
1928

February, cover.

The Cleveland Plain Dealer
1928

Sunday, April 29.

1929

Sunday, May 12.

The Clevelander
1928

January and February.

1929

January, March, and April.

The Cornell Alumni News
1926

Vol. 29, No. 13, December 23, p. 161.

1927

Vol. 29, No. 15, January 13, p. 183; No. 16, January 20, p. 195; No. 19, February 10, 229; No. 32, May 19, p. 395; No. 34, June 2, p. 423; No. 37, June 23, p. 463; No. 40, August, p. 496.
Vol. 30, No. 1, September 20, p. 3.

Fortune
1930

"Hogs," Vol. 1, No. 1, February, pp. 54-61.

"Sand Into Glass," pp. 68-71.

"Trade Routes Across the Great Lakes," pp. 77-81.

"When Wall Street Buys Orchids," pp. 95-96.

"The Unseen Half of South Bend," Vol. 1, No. 2, March, pp. 52-57 and 102-111.

"Aluminum Company of America," pp. 68-71.

"Petroleum," Vol. 1, No. 3, April, pp. 46-48 and 122.

"Bottled Time," pp. 88-91.

"Times vs. Times," Vol. 1, No. 4, May, pp. 56-64.

"Paper and Power," Vol. 1, No. 4, May, pp. 65-72.

"Cloak and Suit," Vol. 1, No. 5, June, pp. 92-100.

"Skyscrapers," Vol. 2, No. 1, July, pp. 32-37.

"Columbia and United," pp. 77-82.

"Temple of the Dollars," Vol. 2, No. 2, August, pp. 67-71 and 110-116.

"Parke, Davis & Co.—E. R. Squibb & Sons," Vol. 2, No. 3, September, pp. 68-73 and 110-112.

"Nitrogen," Vol. 2, No. 4, October, pp. 55-63 and 105-108.

"Germany in the Workshop: an Industrial Portfolio," Vol. 2, No. 6, December, pp. 89-94 and 126.

1931

"Soviet Panorama," Vol. 3, No. 2, February, pp. 60-68.
"Hard Coal," pp. 72-83 and 126-130.
"The Grand Central Terminal," pp. 97-99.
"A Day at the National City Bank," Vol. 3, No. 3, March, pp. 70-76.
"The U.S. Organ," Vol. 3, No. 4, April, pp. 73-78 and 121-128.
"Niagara Hudson," Vol. 3, No. 6, June, pp. 42-48 and 106-118.
"Steel I, II, III," Vol. 3, No. 5, May, pp. 84 ff, Vol. 4, No. 1, July, pp. 52 ff. Vol. 4, No. 3, September, pp. 41 ff.
"Limestone—A Portfolio," Vol. 4, No. 3, September, pp. 66-72.

1932

"Billions of Bottles," Vol. 5, No. 4, April, pp. 70-73 and 136.
"William Wrigley, Jr., American," pp. 84-86.
"Copper in the Mills," Vol. 6, No. 1, July, pp. 43-46.
"The Forgotten Animal," Vol. 6, No. 4, October, pp. 38-39.
"Competition not Cartelization," pp. 62-63.
"Fifteen U.S. Corporations, A.D. 1932," Vol. 6, No. 5, November.

1933

"Germany's Reichswehr," Vol. 7, No. 1, January, pp. 49-57.
"International Silver Co.," Vol. 7, No. 4, April, pp. 70-75.
"Speakeasies of New York," Vol. 7, No. 6, June, pp. 53-58.
"Port of New York Authority," Vol. 8, No. 3, September, pp. 22-31.
"The Steel Rail," Vol. 8, No. 6, December, pp. 42-47 and 152-153.

1934

"Management by Morgan," Vol. 9, No. 3, March, pp. 82-89.
"So Big," Vol. 9, No. 6, June, pp. 58-68.
"The Aluminum Co. of America," Vol. 10, No. 3, September, pp. 46-52.
"The Drought," Vol. 10, No. 4, October, pp. 76-83.
"Here are the Steinways and how They Grew," Vol. 10, No. 6, December, pp. 99-105.

1935

"The Stores and the Catalogue," Vol. 11, No. 1, January, pp. 69-74.
"A $28,600,000 Loss," Vol. 11, No. 6, June, pp. 65-75.
"Campbell's Soup," Vol. 12, No. 5, November, pp. 69-76.
"Success Story," Vol. 12, No. 6, December, pp. 115-126.

1937

"Grand Coulee," Vol. 16, No. 1, July, pp. 78-89.
"The Leviathan," Vol. 16, No. 3, September, pp. 68-73.
"Economics of Paper," Vol. 16, No. 4, October, pp. 110-113.

1955

"Tomorrow's Inland Seaports," Vol. 52, No. 2, August, pp. 92-101.

House and Garden

1928

February, April and July.

1929

May.

The Illustrated London News

1941

"The Evil Face of War," Vol. 199, No. 5349, October 25, p. 517.
"Moscow's Calm Citizens," Vol. 199, No. 5349, October 25, pp. 526-527.
"People in Arms," Vol. 199, No. 5350, November 1, pp. 546-547.

Impact

1945

"Strategic Air Victory in Europe," Vol. 3, No. 7, July, *passim.*

Life

1936

"Dam at Fort Peck, Montana," Vol. 1, No. 1, November 23, cover.
"Franklin Roosevelt's Wild West," pp. 9-17.

1937

"Floods Aftermath," Vol. 2, No. 7, February 15, pp. 9-13.
"Supreme Court," pp. 20-23.
"Steel Raises Wages," Vol. 2, No. 11, March 15, pp. 13-21.
"Parachute Dummy," Vol. 2, No. 12, March 22, cover.
"Parachutes," pp. 28-31.
"Muncie, Indiana," Vol. 2, No. 19, May 10, pp. 15-25.
"U.S. Senator," Vol. 2, No. 24, June 14, cover.
"Senate and Senators," pp. 17-27.
"Flight to Bermuda," Vol. 2, No. 26, June 28, pp. 21-24.
"Portfolio on Paper," Vol. 3, No. 1, July 5, pp. 24-29.
"Weir of Weirton," Vol. 3, No. 11, Sept. 13, cover.
"Grand Coulee Dam," Vol. 3, No. 15, Oct. 11, p. 36 ff.
"Leviathan," Vol. 3, No. 15, October 11, pp. 23-25.
"With Canada's Governor General to the Arctic Ocean," Vol. 3, No. 17, October 25, pp. 40-47.
"The Strange Adventure of Archibald the Arctic," pp. 114-118.
"The Universe Through Mt. Wilson's Telescope," Vol. 3, No. 19, November 8, pp. 44-53.
"Caldwell and Bourke-White Look at the Cotton Country," Vol. 3, No. 21, November 22, pp. 48-52.
"U.S. Capitol Dome," Vol. 3, No. 22, November 29, cover.
"Riverside Church," Vol. 3, No. 25, December 20, pp. 35-38.
"A Long Look at Hollywood," Vol. 3, No. 26, December 27, pp. 39-46.

1938

"Mrs. Theodore Roosevelt Jr.'s Needlework," Vol. 4, No. 3, January 17, pp. 42-45.
"New York's 1939 Fair," Vol. 4, No. 5, January 31, pp. 9-15.
"Mayor Frank Hague and His Jersey City," Vol. 4, No. 6, February 7, pp. 44-51.
"Vice-President Garner," Vol. 4, No. 18, May 2, cover.
"Czechoslovakia," Vol. 4, No. 22, May 30, pp. 50-65.
"Pattern of War," Vol. 4, No. 24, June 13, pp. 32, 35.
"Road Signs," Vol. 4, No. 26, June 27, pp. 4-6.
"A Prussian in Hungary," Vol. 5, No. 11, September 12, cover.
"Hungary," pp. 50-61.
"Czech Soldier," Vol. 5, No. 14, October 3, cover.
"The Ak-Sar-Ben in Omaha," Vol. 5, No. 17, October 24, pp. 58-61.
"Life Goes to a Party with the Binghamton Lions," Vol. 5, No. 22, November 28, pp. 64-67.
"President Roosevelt Carves up a Turkey," Vol. 5, No. 23, December 5, pp. 13-17.
"Music," Vol. 5, No. 24, December 12, pp. 49-52.

1939

"France's No. 1 Soldier," Vol. 6, No. 8, February 20, cover.
"Aerosol Makes Even Ducks Sink," Vol. 6, No. 9, February 27, pp. 41-42.
"Life Goes to a Paper Festival," Vol. 6, No. 20, May 15, pp. 82-85.
"Hyde Park," Vol. 6, No. 22, May 29, pp. 61-66.
"The DC-4," Vol. 6, No. 25, June 19, pp. 32-33.
"England's Halifax," Vol. 7, No. 3, July 17, cover.
"The Telephone Company," pp. 56-63.
"Life Cycle of the Praying Mantis," Vol. 7, No. 8, August 21, pp. 56-57.
"Cordell Hull," Vol. 7, No. 14, October 2, cover.
"The Hudson River," pp. 57-65.
"The Archbishop of Canterbury," Vol. 7, No. 26, December 25, pp. 48-51.

1940

"Rumania," Vol. 8, No. 8, February 19, p. 66 ff.
"Turkey," Vol. 8, No. 15, April 18, 76-89.

"Britain's Warlord," (Winston Churchill, still First Lord of the Admiralty), Vol. 8, No. 18, April 29, cover.

"Weygand," Vol. 8, No. 21, May 20, cover.

"Syria," pp. 86-93.

"England," Vol. 8, No. 23, June 3, p. 70 ff.

1941

"Anzac Conquerors," Vol. 10, No. 8, February 24, cover.

"East of Suez," Vol. 10, No. 17, April 28, pp. 92-95.

"Turkey: Will it Fight?" pp. 96-97.

"China Relief," Vol. 10, No. 25, June 23, pp. 59-60.

"China's Madame Chiang," Vol. 10, No. 26, June 30, cover.

"Moscow," Vol. 11, No. 6, August 11, pp. 17-27.

"Moscow Fights off Nazi Bombers," Vol. 11, No. 9, September 1, pp. 15-21.

"How I Photographed Stalin and Hopkins Inside the Kremlin," Vol. 11, No. 10, September 8, pp. 26-27.

"Hopkins Meets Josef Stalin," pp. 25-29.

"Religion in Russia," Vol. 11, No. 15, October 13, pp. 110-121.

"Muscovites Take up Their Guns as Nazi Horde Approaches Russian Capital," Vol. 11, No. 17, October 27, pp. 27-33.

"Russian Mud and Blood Stall the German Army," Vol. 11, No. 20, November 17, pp. 33-39.

"Trip to the Front," p. 37.

"Life Calls on a Russian Movie Star," Vol. 11, No. 22, December 1, pp. 118-121.

1942

"Stalin's Birthplace," Vol. 13, No. 8, August 24, pp. 72, 74.

"British Censor Conceals Old Castle," Vol. 13, No. 13, September 28, pp. 12-14.

"U.S. High-Altitude Bombers Hit Nazis," Vol. 13, No. 16, October 19, pp. 29-33.

"General Eisenhower," Vol. 13, No. 19, November 9, p. 112.

1943

"Women in Lifeboats," Vol. 14, No. 8, February 22, pp. 48-54.

"Tunis Bombing: Life Photographer Margaret Bourke-White Accompanies Bombing Mission," Vol. 14, No. 9, March 1, pp. 17-23.

"Special Issue: USSR," (Stalin), Vol. 14, No. 13, March 29, cover.

"Spring Offensive," Vol. 14, No. 15, April 12, pp. 26-27.

"Steel Worker," Vol. 15, No. 6, August 9, cover.

"Women in Steel," pp. 74-81.

1944

"It's a Big War," Vol. 16, No. 2, January 10, pp. 35-42.

"Naples," Vol. 16, No. 4, January 24, pp. 17-23.

"War in Italy," Vol. 16, No. 7, February 14, pp. 21-27.

"Evacuation Hospital," Vol. 16, No. 8, February 21, pp. 88-95.

"Look at America," Vol. 17, No. 13, September 25, pp. 21-33.

1945

"Congressmen Inspect the War," Vol. 18, No. 2, January 8, pp. 26-27.

"Papal Christmas," Vol. 18, No. 3, January 15, pp. 26-28.

"Yank Football Game in Italy," Vol. 18, No. 5, January 29, pp. 74-75.

"The Backwash of Battle," Vol. 18, No. 16, April 16, pp. 30-31.

"Forgotten Front: Italy," pp. 79-87.

"Suicides," Vol. 18, No. 20, May 14, pp. 32-33.

"The People," pp. 33-34.

"The Battered Face of Germany," Vol. 18, No. 23, June 4, pp. 21-27.

"Pisa's Leaning Tower," Vol. 18, No. 25, June 18, pp. 106-108.

"The Krupp Family," Vol. 19, No. 9, August 27, pp. 80-83.

1946

"India's Leaders," Vol. 20, No. 21, May 27, pp. 101-107.

"Dr. Gandhi," Vol. 21, No. 3, July 15, p. 17.

"The Vultures of Calcutta Eat Indian Dead," Vol. 21, No. 11, September 9, pp. 38-39.

"Life Visits the Sikhs of India," pp. 134-137.

"Indian Airline Hostesses," Vol. 21, No. 14,

September 30, pp. 129-133.

"Moslem Prayers Celebrate End of Fast," Vol. 21, No. 14, September 30, pp. 47-49.

1947

"Student Veteran," Vol. 22, No. 16, April 21, cover.

"Veterans at College," pp. 105-114.

"The Caste System," Vol. 22, No. 20, May 19, pp. 105-112.

"The Great Migration," Vol. 23, No. 18, November 3, pp. 117-125.

1948

"Pakistan Struggles for Survival," Vol. 24, No. 1, January 5, p. 16 ff.

"India Loses Her 'Great Soul,' " Vol. 24, No. 6, February 9.

"Gandhi Joins the Hindu Immortals," Vol. 24, No. 7, February 16, pp. 21-29.

1949

"American Community," Vol. 27, No. 11, September 12, pp. 108-119.

"The New South," Vol. 27, No. 18, October 31, pp. 79-89.

1950

"South Africa Enshrines Pioneer Heroes," Vol. 28, No. 3, January 16, pp. 21-27.

"The White Queen," Vol. 28, No. 10, March 6, pp. 95-101.

"Nobody Came to the Meeting," Vol. 28, No. 14, April 3, pp. 39-42.

"South Africa and Its Problems," Vol. 29, No. 12, September 18, pp. 111-126.

"The Connecticut River," Vol. 29, No. 19, November 6, pp. 123-133.

1951

"Strategic Air Command," Vol. 31, No. 9, August 27, pp. 86-100.

1952

"A New Way to Look at the U.S.," Vol. 32, No. 15, April 14, pp. 128-139.

"A Savage Secret War is Waged in Korea," Vol. 33, No. 22, December 1, pp. 25-35.

1954

"Dusty Plague Upon the Land," Vol. 36, No. 18, May 3, pp. 34-41.

"The Long, Long Road," Vol. 37, No. 3, July 19, pp. 75-80.

"The Jesuits in America," Vol. 37, No. 15, October 11, pp. 134-145.

1955

"The Base of Abundance—The Land," Vol. 38, No. 1, January 3, pp. 4-14.

"Missouri Family Busch," Vol. 38, No. 18, May 2, pp. 127-135.

1956

"Mellon's Miracle," Vol. 40, No. 20, May 14, pp. 151-159.

Nation's Business

1929

January, May, and August.

New York Times Magazine

1932

McCormick, A. O., "The Future of the Ford Idea," Sunday, May 22, pp. 1-2.

Maurois, A., "The New Era that is Before Mankind," Sunday, September 11, p. 3.

See "Series on the Soviet Union," in *Articles by Margaret Bourke-White, 1932.*

Rotarian

1933

"Russia," Vol. 43, No. 4, October, pp. 14-16.

Theatre Guild

1929

March.

Town and Country Club News

1928

Covers for April, May, June, and July.

Trade Winds

(Union Trust Co., Cleveland, monthly)
c. 1928—c. 1931: *passim*.

Vanity Fair

1932

Huxley, J., "A Scientist Views the Russian World,"
 Vol. 38, No. 1, March, pp. 46-47 and 78.
Scheffer, P., "Dictators—The Soviet Answer,"
 Vol. 39, No. 1, September, pp. 34-35 and 66.
"Trapping the Magical Waves of Sound," Vol. 42, No. 3,
 May, pp. 26-27.

World's Work

1929

"Blast Furnaces," Vol. 58, No. 9, September, p. 43.

1932

"Muzhiks and Machines," Vol. 61, No. 2, February, pp. 30-32.

Book Illustrations

1928

The Story of Steel, Cleveland.

1930

Beasley, N., *Freighters of Fortune*, New York and London.

1934

Terhune, A. P., *The Book of Sunnybank*, New York and London.

1936

Eds. of Time, *Four Hours a Year*, New York, frontispiece;
 pp. 36 and 54-55.

1937

Terhune, A. P., *The Terhune Omnibus*, New York and London.

1939

Newsprint, International Paper Co., Montreal.
See *Books by Margaret Burke-White, 1931-1963*.

Movies

1931

"Eyes on Russia"

1934

"Red Republic"

About Margaret Bourke-White

1930

"Beauty in Industry Is Shown by Photographer,"
 The Dayton Daily News, Monday, May 26, p. M-27.
Blake, E., "She's Sitting on Top of the World,"
 The Chicago Daily News, August 16, p. 4.
Cox, D., "Girl's Camera is $25,000 Income,"
 The Cleveland Press, Sunday, February 2.
Driscoll, H., "Via Photography: From College Campus to
 Soviet Russia," *The Cleveland Press*, Saturday, July 12.
"Germany in the Workshop," *Fortune*, Vol. 2, No. 6,
 December, pp. 89 ff.
Jewell, E. A., " 'Men and Machines' Exhibition Challenges Art,"
 New York Times, sect. VIII, Sunday, October 26, p. 15.
Webster, E. R., "This Daring Camera Girl Scales Skyscrapers
 For Art," *American Magazine*, Vol. 110, No. 5,
 November, p. 66.

1932

"Office and Studio of Margaret Bourke-White,"
 The Architectural Forum, Vol. 56, No. 1, January, pp. 28-32.

1933

Sartain, G., "Margaret Bourke-White, Regarded as a Poor
 Insurance Risk," *New York World-Telegram*, Tuesday,
 December 26.
"They Stand Out From the Crowd," *Literary Digest*, Vol. 116,
 October 21, p. 11.

1934

Driscoll, C. B., "Photographer," *Washington Pa. Reporter*,
 January 16.
"Fair Photographer Invades Industry for Best Subjects,"
 New York American, Wednesday, January 10.
Fortiner, V. J., "Outstanding Woman Photographer Banked on
 Industry," *Newark Evening News*, Thursday, September 13.
Kirkland, W. M. and F., "Margaret Bourke-White, Photographer
 of Steel," in *Girls Who Became Artists*, Freeport, N.Y.,
 chap. 4, pp. 34-45.
Sprackling, H.M., "Child of Adventure," *Pictorial Review*,
 December, pp. 4 and 62-63.
Tighe, D., "Girl Translates Machinery into Photographic
 Murals," *Washington Herald*, Sunday, January 14.

1935

"Dangler," *American Magazine*, Vol. 120, October, p. 59.
Mabie, J., "Snapshotting a Snapshotter," *The Christian Science
 Monitor*, Wednesday, September 25, pp. 5 and 12.

1936

"Portrait," *Independent Woman*, Vol. 15, October, p. 317.

1937

Nall, T. O., "Camera is a Candid Machine," *Senior Scholastic*,
 Vol. 30, May 15, pp. 18-19.

1938

Langevin, E. K., "Bourke-White at Ball," *Life*, Vol. 5, No. 20,
 November 14, p. 70.
Mok, M., "Camera Ace gets Pictures of Henlein and Parents,"
 New York Post, Saturday, September 17, p. 22.

1939

"Bourke-White Exhibit," *New York Times*, sect. X, Sunday,
 December 31, p. 6.
"Erskine Caldwell and Margaret Bourke-White, Honeymoon
 Over, Ready to Tackle New Jobs," *New York
 World-Telegram*, April 17.

1940

Block, M., ed., "Margaret Bourke-White," *Current Biography*,
 New York, pp. 862-863.

1942

"Camera," *Calling All Girls*, No. 5, April, pp. 1-4 and 61-64.

1943

Sherburne, E. C., "Lady Not-In-A-Rut," *The Christian Science
 Monitor*, Weekly Magazine, Saturday, May 29, p. 5.

1946

"She Covers the World," *Today*, August, pp. 53-56.
Raymond, M. T., "Girl With a Camera," in Stoddard, A., ed.,
 Topflight Famous American Women, New York, pp. 163-178.

1947

"Lady With a Lens," *Real Comics*, No. 8, May, June.

1948

"Gandhi Didn't Want to Live," *Journal American*, February 15.

1951

McCrary, Tex & Falkenburg, Jinx, "New York Close-Up,"
 New York Herald Tribune, July 13.
"Rescuing Helicopter Rescued," *New York Times*, Saturday,
 September 8, p. 19.
Pegler, W., "Margaret Bourke-White and Her 'Sponsorships,' "
 Journal American, September 4.
_____, "More on Background of Margaret Bourke-White,"

Journal American, September 6.

————, "More on Bourke-White and Photo Assignments," *Journal American,* September 9.

————, "Margaret Bourke-White Versus Angela Calomiris," *Journal American,* September 18.

————, "Girl Spy for FBI Recounts Insult by a Picture Editor," *Journal American,* September 19.

1952

"Covering News with a Camera is a Good Way to get into Trouble," *Life,* Vol. 32, No. 24, June 16, pp. 2 and 3.

Kelley, E. M., "Margaret Bourke-White," *Photography,* Vol. 31, No. 2, August, pp. 34-43 and 85.

1953

Beckley, P. V., "Lady with a Lens," *Senior Scholastic,* Vol. 63, October 28, p. 4.

"Margaret Bourke-White Tells Experiences with her Camera," *New York Herald Tribune,* Sunday, Ocotber 25.

1955

"Bourke-White's Twenty-Five Years," *Life,* Vol. 38, No. 20, May 16, pp. 16-18.

Rayfield, S., "How a Woman Covered a War," and *"Shooting from a Whirlbird,"* in *How Life Gets the Story,* New York, pp. 26-27 and 34-35.

Webster, E. R., "Tells the Story of Our Times in Photographs," *Independent Woman,* Vol. 34, No. 3, March, pp. 85-87 and 115-116.

1956

"Majestic Migration," *Life,* Vol. 40, No. 18, April 30, pp. 10-11.

1957

Fanizzi, K., "Margaret Bourke-White—Chronicler of History," *News Workshop,* July, pp. 13-14.

1959

Fields, S., "Lady Photog Snaps Fear, Aims at Moon," *New York Mirror,* December 10.

"To Know Parkinson's," *Life,* Vol. 46, No. 25, June 22, pp. 2 and 101-109.

1960

Barry, L., "What about the Future," *Popular Photography,* Vol. 46, June, pp. 104-5 and 123.

"Brave Story Retold," Vol. 48, No. 1, January 11, pp. 78-79.

"Case History," *Time,* Vol. 75, No. 2, January 11, p. 36.

1963

"Awards Revived," *New York Times,* sect. II, Sunday, October 27, p. 24.

Bigart, H., "A Shutter Open on the World," *New York Times,* July 7, pp. 1 and 20.

Ehrlich, P., "Margaret Bourke-White: Still Aiming for the Moon," *New York Times,* June 27, p. 26.

"Great Lady With a Camera," *Life,* Vol. 54, June 28, pp. 3 and 85-98.

"Margaret Bourke-White," *The Encyclopedia of Photography,* Vol. 3, p. 462.

Rivers, W. L., "Focussing a Wide Angle Lens on Life," *Saturday Review,* Vol. 46, No. 26, June 29, pp. 24-25.

1965

Parshalle, E., "Margaret Bourke-White—Picture the Story," in *The Kashmir Bridge-Women,* pp. 123-126.

1966

Ethridge, J. M. and Kopala, B., *Contemporary Authors,* Vols. 15-16, Detroit, p. 54.

1967

Forsee, A., "Globe-Trotting Photo-Journalist," in *Headliners,* Philadelphia.

Hood, R. E., "The Compleat Bourke-White," in *12 at War,* New York, pp. 52-65.

1968

Phillips, M., "Miss Bourke-White: A Portrait of Zeal," *New York Times,* Thursday, October 10, p. 49.

1969

"Ohio U. Journalism School to Give Van Anda Awards," *New York Times,* Sunday, March 23, p. 49.

Graves, R., "Incredible Will of Creativity," *Life,* Vol. 66, No. 25, June 27, p. 3.

Pollack, P., "Margaret Bourke-White: Roving Recorder," in *The Picture History of Photography,* New York, pp. 388-400.

1971

"Bourke-White Retrospective," *Life,* Vol. 70, No. 3, January 29, pp. 6-9.

Thornton, G., "From Machinery to People in Misery," *The New York Times,* Sunday, sect. 2, January 10, p. 25.

Whitman, A., "Margaret Bourke-White Dead," *The New York Times,* Saturday, August 28, pp. 1 and 28.

"Margaret Bourke-White Dies at 65," *The Boston Globe,* Saturday, August 28, p. 2.

"Photographer Dies," *The Ithaca Journal,* Saturday, August 28, pp. 1 and 10.

Thornton, G., "Great Star of a Great Era," *The New York Times,* Sunday, sect. 2, September 5, p. 16.

"The Great Achiever," *Time,* September 6, p. 46.

Graves, R., "A Relentless Quest for Perfect Pictures, *Life,* Vol. 71, No. 11, September 10, p. 3.

"Margaret Bourke-White," *Life,* Vol. 71, No. 11, September 10, pp. 34, 34B, and 34C.

Knox, S., "Miss Bourke-White Receives Tributes at Memorial Here," *The New York Times,* Sunday, September 12, p. 80.